Clement Greenberg
LATE WRITINGS

Clement Greenberg
L A T E W R I T I N G S

Clement Greenberg

Edited by Robert C. Morgan

University of Minnesota Press
Minneapolis / London

Copyright 2003 by Janice Van Horne and Robert C. Morgan
Introduction copyright 2003 by Robert C. Morgan

Published by the University of Minnesota Press
111 Third Avenue South, Suite 290
Minneapolis, MN 55401-2520
http://www.upress.umn.edu

Library of Congress Cataloging-in-Publication Data

Greenberg, Clement, 1909–1994
 Clement Greenberg, late writings / Clement Greenberg ; edited by Robert C.
 Morgan
 p. cm.
 Includes bibliographical references.
 ISBN 0-8166-3938-8 (alk. paper)
 1. Modernism (Art) I. Title: Clement Greenberg. II. Morgan, Robert C.,
 1943– III. Title.
 N7445.2 .G737 2003
 709'.04—dc21

 2002151562

Printed in the United States of America on acid-free paper

The University of Minnesota is an equal-opportunity educator and employer.

12 11 10 09 08 07 06 05 04 03 10 9 8 7 6 5 4 3 2 1

Contents

IV. Interviews

Acknowledgments

PREPARING A COLLECTION OF THE LATE WRITINGS of the esteemed American critic Clement Greenberg was not an independent task but rather required the assistance of several individuals. Most significantly, I must extend my warm gratitude to Janice Van Horne Greenberg for inviting me to take on the task of assembling these essays, reviews, and interviews. She has been supportive and intelligent, always with steady humor and wisdom, through the many years of work necessary to complete this project. Without her consultation, the manuscript would never have come to a resolution. I offer my deepest gratitude for her belief in the importance of this book.

I am further grateful to Douglas Armato, director of the University of Minnesota Press, for accepting this manuscript and for his encouragement during the various stages of its evolution. Eric Lundgren has attended to the many details that make a collection of this sort function as a book; he has provided fine-tuning and a special sensitivity. Jen Auh of the Andrew Wylie Agency was important in facilitating the manuscript from its inception through its acceptance, and I am grateful for her efforts on my behalf.

I wish to thank all of the superb writers, critics, and art historians who

have provided insight into the work of Clement Greenberg and thus have helped me see his work in a more objective light. My former assistants Cynthia Roberts and Stefano Pasquini performed much of the initial work in researching the writings and interviews from Greenberg's late period. The German scholar Dr. Ingeborg Hoesterey proved indispensable in reading Karl Lüdeking's interview of Greenberg and in recommending its translation into English.

Finally, I must thank Clement Greenberg, albeit posthumously, for the many hours we spent together during the last three years of his life. My visits to his Upper West Side apartment, surrounded by the works of artists he admired (even though I may have disagreed with some of his choices), were always hospitable, informative, and very special. I have fond memories of sitting together in deep discussion, beginning in midafternoon and often going until midnight. One memory in particular I cannot forget: that stormy winter evening when Greenberg expressed that the way a person feels is ultimately more relevant than art. At that moment I began to understand his profound role as a critic. I only hope this book reflects some of those feelings and transmits the importance of his remarkable achievements.

—R. C. M.

Introduction

• •

THE CRUX OF MODERNISM

• •

Robert C. Morgan

THE "LATE" PERIOD IN GREENBERG'S CAREER begins in 1970 and concludes with the critic's death in 1994, a duration of nearly twenty-five years. In many ways, this period represents the summation of a highly formidable career. His essays, writings, and interviews give evidence of an unremitting commitment in pursuit of modernism. His defense of the issues he believed were important, often presented in a highly polemical vein, is the theme that pervades these years. The present volume of writings is dedicated to this period.

One of the curious dilemmas confronting the reputation of individuals of cultural renown is how quickly the personality becomes the subject of hearsay. We read about them. We are told stories about them. They become larger than life, even larger than art. In the process of fetishizing the personality, whether it be in positive or negative terms, we may tend to dismiss the intellectual achievements that present a cohesive reflection of cultural values in favor of more newsworthy delectations. In the last decades of the twentieth century, a new consensus and conformism in critical writing began to emerge. Instead of offering original, albeit controversial judgments about works of art, the overwhelming temptation among critics was to give in to the neutral biases of an emerging theoretical

establishment. Criticism became standardized through a type of protocol, submerged beneath layers of institutional red tape, diluted by editorial boards, and molded into corporate (museum) ideologies. When the attention drifted away from the ideas, the focus turned to worldly matters, trivialities, gossip, and stereotypes that finally proved peripheral or unrelated to the real substance of art. Like it or not, Clement Greenberg found himself being swept into the hurricane. He was on the cusp between one era and another, between politics and art, between the modern and the postmodern, where the momentum of cultural change appeared inevitable.

I recall a painter telling a group of art historians at Princeton one summer in 1980 that Greenberg was under siege, that he was being attacked from the right and the left by artists, critics, curators, the lot. To some extent this was true, but not entirely. It was a complex and conflicted moment in American art and history in general. There were factors both in and outside art that were influencing the change in cultural attitudes. The country was turning back the clock politically. The liberal reforms of the sixties were starting to vanish. The political paranoia of the fifties was reemerging, and the cultural tide was also on the wane in its turn toward a new conservatism. Greenberg himself was reconsidering many of his ideas about art and aesthetics, but the legacy of his past was still with him, including his own conflicts and indulgences as well as various public perceptions of his dogmatic arrogance.[1]

Few recognized that it was during this period of Greenberg's career that some of his most clearly articulated aesthetic statements were published; but it didn't seem to matter. The tide was turning, and he was suddenly being "deconstructed" by legions of academic critics and museum curators using methodologies borrowed from postmodern philosophies, the French poststructuralists, and the writings of the Frankfurt School, specifically those of Theodor Adorno and Walter Benjamin.[2] Art criticism was being replaced by "cultural criticism" under the justification that art and media were on equal terms within the larger spectrum of culture; therefore, judgments based on quality, originality, or individual "taste" were considered not only irrelevant but also authoritarian—an interference rather than a compliance, a diversion that steered away from the mainstream ideological discourse.

Why have the late critical writings of Clement Greenberg been so largely neglected? At a time when modernism was becoming the subject of extreme controversy, Greenberg produced some of his most crafted and en-

gaging essays. His late writings and lectures were the means by which he clarified, revised, and updated many of his earlier positions. In the throes of conflict, his characteristic precision was even more evident, his deceptively casual writing style notwithstanding. Yet art historians, theorists, artists, critics, biographers, collectors, and curators, with varying points of view, coming from different backgrounds and nationalities, have entered into fierce contention, intellectual pyrotechnics, and critical controversies with ponderous footnotes about Greenberg.

Many of the critic's followers staunchly upheld his position, that "quality" in art was important—that for art to exist, there must be quality—whereas others condemned what they believed was a kind of cultural elitism, asserting that Greenberg's aesthetic appraisals were naive or irrelevant in an age of explicit irony, neoconservative angst, multiculturalism, and identity politics. While some lauded him as the greatest critic in the history of American art, others tried—often with desperate intentions—to unravel his categorical approach to modernism through densely argued eruditions combined with ad hominem attacks, often incapable of separating the two.[3] Those motivated against Greenberg's position were usually intent on revealing his formalist agenda as a kind of dogmatism by challenging his notion of Kantian self-criticism with regard to empirical experience. His repeated emphasis on "taste" was presumably demonstrated to have an irrational or vulgar basis, especially in relation to the critic's choice of works or his immense praise for certain artists.[4] These challenges— including Greenberg's often caustic and incisive rebuttals—have largely accounted for the controversy surrounding his career.

But with all the controversy of recent decades, few critics have clearly taken the pulse of his enormous achievements. Somehow the assumption persists that while Greenberg had once mined the depths of the European avant-garde and "American-type" painting, and given attention to the color-field painters, by the outset of the seventies, he had run his course. Thus, the critical writings after 1970 were deemed less important than those of the earlier years.[5] While often controversial, Greenberg was never oblique in his appraisals and never dependent on a consensus of what others believed. He took matters into his own hands. He believed he had a superb, though not infallible eye and could make respectable judgments on what he believed to be the best art of his time. In spite of his lack of emphasis on the moral dimension of art, he was arguably a moral critic in the sense of his consistency—through his unwavering and outspoken judgments—

and was determined to make a defense for modernism on the basis of aesthetic taste.[6]

During the seventies the art world was not only moving away from a singularly pervasive or dominant style in advanced art, but also away from a clearly defined linear course of stylistic development.[7] Contemporary art was heading in the direction of an expansive institutional involvement, including new museums devoted to contemporary art, separate departments within existing museums, new art galleries, and popular magazines devoted to high-profile marketing and reportage. The emphasis had shifted toward art as a business. This was propelled by an erupting marketplace, especially in contemporary art, and a concomitant awareness of promotion through the media. Art was becoming increasingly pluralistic, and the avant-garde, envisioned earlier by Greenberg, no longer held a viable reality.[8] The theoretical proclamations given by academic historicists were insistent on proving the limitations of formalist modernism in confronting the ever-widening concerns of marginal ideologies and new narrative structures that began to define postmodernism.[9]

Greenberg's earlier affiliation as an art and cultural critic for the leftist magazine *Partisan Review* in the forties had consequences for that decade, but by the mid-fifties the ideological dissensions within the editorial board would eventually transform the Marxist position for which it stood.[10] Greenberg's transformation and his disillusion with communism were suggested in a famous quote from 1957: "Some day it will have to be told how 'anti-Stalinism,' which started out more or less as 'Trotskyism,' turned into art for art's sake, and thereby cleared the way, heroically, for what was to come."[11] Few statements by Greenberg have been argued as frequently as this one. At the time, it seemed implausible that a Marxist-leaning critic would break from his former political agenda in favor of "pure art."[12]

One interpretation of Greenberg's change of heart with regard to Marxism was his infuriation with the self-righteousness of his colleagues, specifically Dwight Macdonald and Delmore Schwartz. Another less personal reason might be the need to protect his aesthetic interests, which he believed were representative of the endurance of culture. To do this required acknowledging the separation of art from political ideology. Upon recognizing Stalin's disingenuousness in using socialist realism to control the masses, Greenberg saw how easily art could be manipulated and chose instead to look at modernism from the perspective of "taste"—as aesthetic experience that is capable of sustaining itself despite the context of ide-

ology surrounding it.[13] For Greenberg, modernism could survive only by remaining autonomous from issues of political identity and control. As another Marxist philosopher, Herbert Marcuse, wrote in *The Aesthetic Dimension:* "The sensuous substance of the Beautiful is preserved in aesthetic sublimation. The autonomy of art and its political potential manifest themselves in the cognitive and emancipatory power of this sensuousness."[14] The relinquishment of political control in relation to the sensuality of art was, for Marcuse, the best way to secure art's longevity as a sustained revolutionary force. Although Greenberg would not have embraced a notion so mystical as "sensuality," especially in relation to politics, he would most likely have agreed that the autonomy of art—"art for art's sake"—was in part necessary as a paradoxical means for sustaining a socially responsible society.[15]

Throughout his career, Greenberg was never oblivious to the existence of reactionary forces that lay in abeyance even during the liberal-minded political protests against the Vietnam War. The political tensions within this atmosphere framed the cultural context in which an ideological shift away from the Left was becoming increasingly apparent. By the early seventies, the situation had changed radically from the early years at *Partisan Review* and the *Nation.* Greenberg was suddenly confronted with a diametrically different set of parameters. The role of the independent critic was being challenged, if not assaulted, through new economic pressures on art-world institutions that were being forced to succumb to the escalating market value of contemporary art. The escalation was most visibly generated through the auctions and, in general, by the marketing demands of a new breed of collector-investors.[16] As this new investment-driven "art world" was being propelled by a rising price structure for works of contemporary art, a professional, media-driven apparatus willing to promote this market became increasingly necessary. Thus contemporary art was quickly being transformed into a showcase for fashionable investment and client competition.

While Greenberg never believed that marketing factors were responsible for "bad art," he appeared to miss the covert connection between the expansion of these interests and the accompanying loss of interest in the critical issues that were important to him. He refused to see or to accept the cause-and-effect relationship.[17] Concerns for aesthetics and taste in art were beginning to appear obsolete—to paraphrase Greenberg's longtime rival, Harold Rosenberg.[18] Within this arena of accelerating trends, Greenberg would seem to have been neither entirely aware of

the "pluralism" that was eroding public faith in modernism (at least, the kind of modernism he supported), nor was he fully unjustified in his retorts. With the decline of a hierarchy of values in art came the lateral spread of revivalist styles—surreptitious forms of painting, installation, and new media—that opened the threshold of art, ready-made for investment.

Occasionally one could detect some recognition in Greenberg's writings on the changing relationship between art and culture. The following passage is prophetic with regard to the new direction that art magazines and other periodicals were beginning to pursue. A general shift in editorial policies became evident, giving new emphasis to the academicizing of art and thus providing fuel for the engine of the marketplace:

> Look at the magazines devoted to contemporary visual art and see how more and more of the articles that fill them are scholarly or would-be scholarly, would-be highbrow in the academic way: explicative and descriptive, or historical, or interpretative, but hardly at all judicial, evaluative. Notice the proliferation of foot- and endnotes, and how they attest to recondite reading, most of which has nothing to do with art as art. Meanwhile the value judging is pocketed off in the spot reviews (where even so, there's always a certain coyness enforced by the art magazines' large dependence on art dealers' advertising—for which, things being as they are, the magazines can't be censured).[19]

Although many have tried, few could justifiably impeach Greenberg for his refusal to embrace postmodernism as a theoretical model. He saw it as a heightened form of academicized "theory" used to accommodate mediocrity. "Aesthetic quality as such," he continued, "is no longer enough to warrant praise; other, extraaesthetic values have to be invoked: historical, political, social, ideological, moral of course, and whatnot."[20]

Greenberg's decision to remain outside the "discourse"—as postmodernism was euphemistically called—was as much a self-willed decision in defense of modernism as it was on his part an unmistakable insistence that the making of aesthetic judgments was endemic to the history of art. These judgments, he believed, were less a matter of criteria than of taste. In "Counter-Avant-Garde" (1971), Greenberg clarifies what he means by "taste" in art:

> Superior art comes, almost always, out of a tradition—even the superior art that comes early—and a tradition is created by the interplay of expectation and satisfaction through surprise as this interplay operates not

only within individual works of art, but between them. Taste develops *as* a context of expectations based on experience of previously surprised expectations. The fuller the experience of this kind, the higher, the more truly sophisticated the taste. At any given moment the most sophisticated, the best taste with regard to the new art of that moment is the taste which implicitly asks for new surprises, and is ready to have its expectations revised and expanded by the enhanced satisfactions which these may bring.[21]

"Taste" was the word that seemed to give both followers and detractors a great deal of trouble. It was either condemned or championed, and usually misunderstood. The issue of taste in art prompted endless streams of volatile reaction in symposia, ranging from university art departments to museological conferences. Greenberg may have underestimated the degree to which postmodernism, as it applied to art criticism, was largely a reaction to his own canon—a canon that was, in critical terms, ultimately justified by taste. Yet, no matter how seamless the logic employed by emerging theorists who referred to themselves as "cultural critics," schooled in university art history departments that were quickly being transformed into departments of visual culture, or by seasoned converts whose work was indebted to various apostles of postmodern theory, or by lesser-known abstract painters, few of these diatribes—whether earnest or contrived—could compete with Greenberg's offhand manner, or could muster with equal force the authenticity, intelligence, and certainty found in his critical language.

The straightforward, vernacular flow of his writing resonates with a velocity of experiential meaning. It moves in contrast to the imposition of quotation, the repetition of terms, the solipsistic pronouncements, and the "intertextual" jargon that came to characterize theoretical writing in art-world publications of the eighties. There were other academic writers with a more learned and sophisticated "objective" use of French post-structuralist terminology. For example, Rosalind Krauss, a former acolyte of Greenberg's, employed a discursive style that was less a surrogate for criticism than a highly informed "deconstructive" methodology, more in line with linguistic philosophy, semiotics, and psychoanalysis than with pure aesthetics.[22]

Even so, the hardened academic writing of the eighties and nineties contrasted significantly with Greenberg's style—not only from the perspective of pivotal ideological and ideational differences, but also in the systematic application of language. In Greenberg's longer essays, the arguments

move between thought and reference, with an engaging, sometimes quanderous momentum, laminated against a systematic focus. Even when his style turns vernacular, quirky, or eccentric, as many of his interviews tend to do, his willingness to openly state a position, without disguising it, is, by today's standards, exceptional for a critic. Regardless of whether one agrees or disagrees with his point of view, Greenberg's unusual manner of delivery is always tendentious. His attention to the meaning and specificity of language retains a clear continuity of pervasive authority.

The essays that constitute what I call the "late" period are a composite of both written and spoken texts produced over twenty-four years and encompassing aesthetics, criticism, reviews, comments, and interviews. Whereas the writings of the early and middle periods represent the years that Greenberg worked as a regular critic for *Partisan Review,* the *Nation,* and *Commentary,* the significant work of the late period is in the longer essays that concentrate on analyzing specific aesthetic issues in defense of modernism.[23] The few critical pieces from the late period were written either in relation to artists in whom he had a special, ongoing interest—Picasso, Matisse, Pollock, Clyfford Still—or reviews of non-Western art, such as "Old India: Her Monuments" and "The Golden Floating World of Sotatsu."

Given the paucity of Greenberg's critical writing (in contrast to aesthetics) after 1970, there is little of real significance. In his short essay on the early-seventeenth-century Japanese screen painter Tawaraya Sotatsu, Greenberg says little that provides a basic critical context or a cultural framework for the intentions of the artist. Such an absence clearly reveals Greenberg's limitations in trying to move outside a Western aesthetic, dominated by formalism, into a more challenging multicultural perspective. The formal language in the essays on Indian statuary and Sotatsu reveals the critic's limitations in dealing with criticism that is clearly outside the parameters of modernism.

Whereas the bulk of critical reviews of the early and middle periods, included in John O'Brian's four-volume anthology, was written during Greenberg's ascendancy and apogee, the later period reveals the critic coming to grips with his opposition, specifically with those who refuted his formalist canon. This is apparent in the late interviews and in longer essays, such as "Counter-Avant-Garde," "To Cope with Decadence," and "Modern and Postmodern." This would suggest that while Greenberg's focus was primarily aesthetic in the later years, the weight of the argument against him came less from his writings than from his endorsement of cer-

tain artists and his less than tactful rejection of others. The issue at large was less related to the occasionally brilliant and subtle passages found in these essays than in the magnified rumors about his personal relationships with artists and other professional colleagues. In some cases, the inability of the art media to make the distinction between fact and fiction only exacerbated the problem. The point is not to deny that Greenberg had his foibles and imperfections—this would be absurd. Rather it is to make an argument for the importance of his aesthetic essays as being the crux of the matter. This is where he makes an incisive contribution to the larger issue of how we think about art.

Greenberg's profound struggle in this period—his serious doubts and relinquishments—is not insignificant to the history of art. As his writings more than indicate, his purpose was to maintain an aesthetic direction for modernism at a time when the art world was shifting and changing under the pressures of an accelerating art market, technological advances in media, and an expanding international art world. Whether or not he grasped the full implications of these changes is something else. Whereas the academic and critical establishment may have been too quick to judge his views on modernism as anachronistic, Greenberg felt that his point had been misunderstood and that his writing needed greater precision. This is why the late writings, particularly those devoted to aesthetic issues, form a necessary summation (rather than closure) to his oeuvre.

What allows these essays, reviews, and statements to be as significant today as when they were written is not only their focus but also the manner in which they were constructed. In many of his reviews, Greenberg set up a thought process that seems nearly parallel to the work under scrutiny, without the slightest hint of imposition. Yet he never embraced the notion of ideas as being implicit to the art under investigation. In contrast to conceptual art and other related postmodern strategies, ideas were never intrinsic to the work but always external to it. Ideas were in the realm of aesthetics but not within the art itself. His most successful writing makes clear this parallel relationship between the formal structure in a work of art and its ability to incite feeling.

For Greenberg, this was the correct means by which to grapple with the underlying intentions of the artist. This subtle yet crucial nuance in his writing has often been misread. It also reveals why Greenberg was unable to accept the emerging avant-garde developments of the sixties,

such as pop, minimal, conceptual, and performance art.[24] The conflict between modernism, as he had defined it, and the popularity of these new media arts implied an inherent destabilization of aesthetic thought. The formal system—indeed, the equivalence between form and feeling as procured in the more sensible expressions of abstract art, specifically painting and sculpture—did not connect with the emblematic and verbal intentions associated with Duchampian-based work, what Greenberg called avant-gardism.[25]

In contrast to the formal language of Greenberg's modernism, the emergent forms of pop, minimal, and conceptual art emphasized the exploration of art as language, a type of language less concerned with the purely visual aspects of form and more given to a dialectical process of thought between the image and its linguistic counterpart. This was, of course, a direct challenge to Greenberg's emphasis on the eye as the means by which one analyzed the formal elements of an abstract painting or sculpture in order to determine the work's coherence. In addition, developments such as conceptual art and performance art were questioning the very definition of art as a physical object and in some cases chose to understand objects only through appropriation. Greenberg saw many of these forms as "not altogether avant-gardist," but more within the province of a "phenomenal novelty."[26]

Still Greenberg wanted to maintain the rigor of his formalist argument, even in the face of such new media, as he explains in his essay "Modern and Postmodern" (1978). While many of his points are cogent, he was not always accurate in terms of his logical or theoretical correctness. The evidence suggests that his earlier philosophical and historical positions had a grip on him and would not relinquish themselves in coming to terms with the theoretical propositions identified with the more open-ended aesthetic ambiguities of postmodernism.

Even so, it is difficult to deny or not to feel his commitment and character of expressiveness given to his economy of language. For Greenberg form was perpetually at the service of signifying content, whether in the art he was writing about or in his method of interpreting it. For all the emphasis given to Greenberg as a formalist, there is scarcely a critic who has been able to deliver significant content as emphatically or as incisively as Greenberg. It is no wonder that his admiration for Matisse would remain as unfailing as it did. In one of his typically illuminating statements

on the painter, he claims that "Matisse's art speaks . . . through the feeling which that 'form' makes manifest."[27] Without deemphasizing the importance of form, the critic makes clear that form must retain its signifying process if it is to remain functional, that is, relevant in the cause of content. Or as stated in "Post-Postscriptum," his terse second addendum to "Necessity of 'Formalism'" (1971), "Quality, aesthetic value originates in inspiration, vision, 'content,' not in 'form.'"[28] Greenberg's criticism works intuitively to parallel the art that he saw, without forsaking his depth of understanding in philosophy and art history. He reveals the manner in which the structure of a painting allows the signifying process to take hold. Here, for example:

> Matisse's larger paintings . . . had a momentous effect on abstract expressionism. I remember his *Bathers by a River*, c. 1916. . . . Its broad vertical bands used to give me trouble: they were too even and made the picture itself too dispersed. My eye was used to concentric, compact, and more closely inflected pictures. This big picture slid my eye over its surface and seemingly out through its sides and corners.[29]

Either the painting is clear or it is not; and if it is not, the evaluation proves unfavorable. But Greenberg was also capable of changing his mind about an earlier position:

> It was years later that I got to see Monet's lily-pad murals in the Orangerie in Paris, and they were even more centrifugal in organization than *Bathers by a River*, but they weren't as "flat" and didn't cause my eye to "slide" nearly as much—though they, too, seemed to leak through their sides and corners. But by that time I knew more of what it was all about and so did my eye.[30]

This, of course, raises the issue as to whether one might be incorrect in one's evaluation of quality. Greenberg argues that taste begins with a response that cannot avoid being historically informed to some degree, but appears on the surface subjective. Over time and through reflection, one may come to understand that there is a consensus that determines how close the critic's judgments come to objectivity. This argument extends from Kant's *Critique of Pure Reason* to Benedetto Croce's *Aesthetic;* but in neither case is the question fully resolved. In a series of interviews with Trish Evans and Charles Harrison (1984), Greenberg states: "People quote

me and show I've changed my mind sometimes. They want to nail me on that and know why I've changed my mind. Greater experience, that's all. It's all about educating oneself in public."[31]

By the seventies, Greenberg was no longer interested in justifying declarations of taste based on established criteria, believing instead that taste was ultimately a more reliable measure. "The objectivity of taste," he noted, "is probatively demonstrated in and through the presence of a consensus *over time*."[32] But consensus over time—a notion that, ironically, Marcel Duchamp would most likely have defended—is a historical process that cannot be easily compressed into a brief encounter with a work of art.[33] Greenberg is not entirely clear as to whether the accuracy of one's aesthetic judgment is either a priori or a posteriori in relation to the qualitative consensus from which objective taste is derived. As the critic rightly reveals, this was a fundamental aesthetic issue that also obsessed his philosophical mentor, Immanuel Kant.

Other than the historical embodiment of taste professed by Greenberg, there is another approach to his critical style. Whether he is addressing the works of Matisse, Picasso, Still, or Sotatsu, there is a certain phenomenological awareness that occurs in the process of perceiving the immanence of the work in question. This could be illustrated in a brief passage based on a folded and painted metal sculpture by Picasso, titled *Woman with Hat* (1961):

> The piece has a compactness unusual in Picasso's constructed sculpture: a happy transposition into three dimensions of Cézannian boxing in. The flat metal bands writhe in front of and protrude a little beyond the edges of the upright sheet of metal to which they're attached—or rather from which they emanate—but still come to rest more or less within the rectangle.[34]

Here, according to Greenberg, the form succeeds and therefore the content appears convincing. But when the signifying process of the medium breaks down, there is no effective transmission of content. He concludes his analysis of *Woman with Hat* by saying: "The explanation I suggest of why Picasso didn't do more sculptures like this one is that his taste had stopped being inspired."[35]

While not altogether surprising in its tone, Greenberg's remark on Picasso appears inconsistent with his earlier position on romanticism. In "Towards a Newer Laocoön" (1940), he notes that by the time the roman-

tic revival had departed the scene, "the confusion of the arts had become worse. The romantic theory of art was that the artist feels something and passes on this feeling—not the situation or thing which stimulated it—to his audience."[36] This, of course, runs counter to Greenberg's mediumistic emphasis on feeling, which he believes modernism restored. What is unclear, however, is his critique of Picasso's taste. From an Eliotic point of view (which Greenberg was known to embrace), he writes later in the same essay: "Purity in art consists in the acceptance, willing acceptance, of the limitations of the medium of the specific art."[37] This functions as the prelude to the essential theme in Greenberg's highly influential, and equally controversial, essay two decades later, "Modernist Painting" (1960). With Picasso, however, the question lingers as to whether Greenberg is referring to the way in which Picasso handles his materials in the medium of sculpture or whether it is a matter of waiting for inspiration.

There is another issue in Greenberg's late criticism that seems in one sense less problematic but fundamentally idealistic, namely, the manner in which he measures the terms of his experience. Given his insistence on art as experience—a reiteration or extension of John Dewey's position— there is the question of exactly how the experience is transmitted through criticism.[38] I would suggest that Greenberg has some exceptional moments in this regard when his descriptive language seems to parallel his experience, as in this passage on the painter Clyfford Still:

> I believe in masterpieces, and they were there, but remained only potential. Still was small in the face of his gift, his vision, his inspiration; he distorted, formed them into the service of effects that would project an image of himself, a crass and worldly image. He made his art reflect too much in himself that didn't belong to art, any kind of art, but only to megalomania.[39]

There have been frequent complaints—not only from disgruntled artists but also from critics and curators—with regard to the perception that Greenberg deliberately distorted the history of modernism to suit his own interests. As suggested earlier, these tabloid rumors have filled the pages of often misguided articles and biographies as if to imply that such puritanical claims constituted some kind of moral proof that Greenberg's ideas should be held in disfavor. These allegations are simply irrelevant to his effectiveness as a critic. Significant criticism is not contingent on whether one agrees with a critic's lifestyle or even his judgments; rather it depends

on how effectively the critical arguments are presented, how cogently the analysis is developed in relation to an exhibition or an artist's work, and the level of maturity at which certain insights emerge in the process.

Contra-Greenbergians still argue that to make a critical judgment on an artist's work is somehow to skew the direction of art history, that a judgment is merely an opinion, a form of subjective favoritism. Postmodern critics seemed to identify with this position. So what does this suggest? Does it mean that criticism should not intervene in the course of some preordained Hegelian trajectory? For criticism to be criticism, it has to intervene. Aesthetic judgments are the culmination of the critical process. For Greenberg, these understandings were essential.

In recent years, I have discovered that few of the students in my graduate seminars who forge through the tomes of academic rhetoric associated with postmodernism have ever read anything substantial about modernism, let alone anything by Greenberg. In one of the seminars I decided to assign *Art and Culture* as a primary text along with other more recent texts dealing with potentially opposing views. While not every student embraced Greenberg's dialectical view of culture, as expressed in "Avant-Garde and Kitsch," or necessarily agreed with his critical analyses of early-twentieth-century artists, most of them were astounded to discover how relevant and refreshing many of his ideas appeared amid the overwhelming cynicism and lack of clarity that have emerged over the past two decades. Indeed, one may consider whether criticism—at least criticism on the order of Greenberg—given to aesthetic experience and judgments of value holds any relevance in the current era, or has art merely become a discourse removed from human experience, an attribute of culture rather than a signifier of its achievements?

This raises a further question as to whether criticism has been totally eclipsed if not usurped by cynicism. In contrast to irony, cynicism functions not inside but outside the domain of art. On the other hand, it could be said that irony was the instigator of avant-gardism, a term Greenberg associates with Duchamp, whom he suggests is largely responsible for the institutionalization of the avant-garde. Still, irony exists within the province of art. Outside the province of art, which might include much of the discourse linked to varieties of postmodernism and poststructuralism, cynicism operates as a hardened, detached, and politicized apologia, removed entirely from aesthetic experience. For significant criticism to exist, in the Greenbergian sense, the aesthetic experience was essential to

the preservation of taste. Thus, responsible criticism relies on aesthetic experience as the source of its value judgments. To make such judgments requires an actively engaged dialogue with a work of art, an inspired provocation, as Greenberg makes clear in his late critical essays. Whether one agrees with the critic's judgment may ultimately be less important than how we come to terms with a critic's experience. In "Abstract, Representational, and So Forth," Greenberg reaffirms: "Art is a matter strictly of experience, not of principles, and what counts first and last in art is quality; all other things are secondary."[40]

Perhaps one of the most revealing and affirmative comments by Greenberg comes in the form of another statement made in an interview where he is questioning his role as a critic: "When it comes to aesthetic experience you're all alone to start and end with. Other people's responses may put you under pressure, but what you then have to do is go back and look again, listen again, read again. You can only modify your judgment by reexperiencing. You don't change your mind on reflection. You may get doubts, but you have to go back and check again."[41]

It is the critic's responsibility to question him- or herself in relation to a work of art; but this self-critical process can happen only as a form of direct experience. This is what makes art, and criticism of the art, valid in relation to one another. Without this kind of reflectivity, criticism ceases to hold relevance. This is where Greenberg stood at the end of his life—firmly on the premise that the best art is always worth sustaining. The best art constitutes the basis of modernism, and herein lies the evidence of what gives a culture meaning. Without excellence in art, cultures become trivialized; and without culture, civilizations disappear.

NOTES

1. These qualities are made evident in the late interviews, such as the one conducted by James Faure Walker for *Artscribe* in part IV of this volume.

2. Robert Storr implies that Benjamin usurped Greenberg's authority as a critic by the late eighties. See Robert Storr, "No Joy in Mudville: Greenberg's Modernism Then and Now," in Kirk Varnedoe and Adam Gopnik (eds.), *Modern Art and Popular Culture: Readings in High and Low* (New York: Harry N. Abrams and the Museum of Modern Art, 1990), 161–90.

3. One of the most articulate critics to position Greenberg fairly in the recent history of art is Thierry de Duve. See Thierry de Duve, *Clement Greenberg: Between the Lines* (Paris: Éditions dis Voir, 1996).

4. Donald B. Kuspit, *Clement Greenberg: Art Critic* (Madison: University of Wisconsin Press, 1979). In the concluding chapter of this ambitious study, Kuspit states: "The rhetoric of cuisine means to get under our skin and preempt our own visceral reaction to the art. This is a species of forcing of feeling, and like all such forcing it undoes, as Greenberg says, the art—in his case, the art of criticism" (180–81).

5. Greenberg's writings, constituting the early and middle periods (1939–69) were compiled in four volumes and edited by John O'Brian in *Clement Greenberg: The Collected Essays and Criticism* (Chicago: University of Chicago Press, 1986 and 1993).

6. My use of "moral" here is a synthesis of both Kant and the French filmmaker Eric Rohmer. Rohmer's series of films, titled in English *Five Moral Tales*, suggests that the French interpretation is less about the puritanical antipodes of right and wrong and more about the complexity of the individual experience; Rohmer implies in his films that morality is a matter of remaining consistent with oneself within the complexity of social relationships. Here I suggest that, as I knew Greenberg in the late period, he was consistent in his responsibility to make judgments that he felt to be valid. This is much different from declaring a work of art to have or not to have moral attributes.

7. Robert C. Morgan, "The Delta of Modernism," in *The End of the Art World* (New York: Allworth Press, 1998).

8. What defined the avant-garde in 1961 at the time *Art and Culture* was published changed radically over the following decades. Some critics and theorists have argued that after the early sixties the avant-garde no longer had meaning and therefore failed to exist.

9. There are numerous examples of philosophers associated with postmodernism at that time, mostly (but not entirely) from France. The variation of viewpoints is astonishing, ranging from those of Roland Barthes to Jean Baudrillard, from Jacques Lacan to Michel Foucault, from Jacques Derrida to Gilles Deleuze, from Maurice Blanchot to Jean-François Lyotard, from Julia Kristeva to Hélène Cixous . . . the list goes on. All of these writers were being fervently translated into English by the mid-1980s. The most important American critic to interpret postmodernism was Craig Owens. In part I of his two-part essay "The Allegorical Impulse: Toward a Theory of Postmodernism" (*October* 12 and 14; spring and fall 1980), he states, "The critical suppression of allegory is one legacy of romantic art theory that was inherited uncritically by modernism." Owens suggests that the implicit literary content of painting that Greenberg rejected should be brought back in the visual arts—including, of course, photography—on the level of explicit allegory. The return to imagism as a means of displacing abstraction in late-twentieth-century art is largely traceable to this statement.

10. This period in Greenberg's career is described in O'Brian's introduction to volume 3 of *The Collected Essays and Criticism*.

11. Clement Greenberg, "The Late Thirties in New York," *Art and Culture* (Boston: Beacon Press, 1961), 230.

12. This further raises the question as to why his newly reformed aesthetic never embraced the work of the painter Ad Reinhardt. It has been asked what Greenberg meant by "pure art" compared to that of Reinhardt, whose work the critic tended to ignore. Reinhardt's quest for "purity in art" is spelled out in Barbara Rose (ed.), *Art as Art: The*

Selected Writings of Ad Reinhardt (New York: Viking, 1975). In fact, Reinhardt's position might be described as ultraformal in comparison with that of Greenberg, thus implying that the critic's concept of modernism is not entirely synonymous with formalism. Greenberg attempts to show this in his essay "Necessity of 'Formalism'" (1971).

13. This may account for the revisions made in "Avant-Garde and Kitsch" upon its republication in *Art and Culture* twenty-two years after its first printing in *Partisan Review* (fall 1939). Greenberg was perpetually dissatisfied with this essay, as he later told Saul Ostrow in an interview in *Arts Magazine* (December 1989): 57.

14. Herbert Marcuse, *The Aesthetic Dimension: Toward a Critique of Marxist Aesthetics* (Boston: Beacon Press, 1978), 66.

15. It is no coincidence that the subtitle of Marcuse's book is *Toward a Critique of Marxist Aesthetics* and that it was also published by Beacon Press. Ideologically, his critique shares the need to pull art away from its illustrational subservience to theory, which is essentially what Greenberg began in the 1950s. Marcuse, of course, handles his argument in a much different way.

16. One could speculate on several reasons for this phenomenon. Clearly the sale of Jackson Pollock's *Blue Poles* (1952) for $3 million and Jasper Johns's *Three Flags* (1958) for $1 million incited marketing interest in the mid-1970s. By 1986, Johns's *False Start* (1959) sold for nearly $17 million, setting a new market standard for a work by a living artist. There was little question that the incentives from these and other sales spurred an investment interest in art and quickly transformed contemporary art into a commodity.

17. Trish Evans and Charles Harrison, "A Conversation with Clement Greenberg in Three Parts." An interesting exchange on the marketing of art occurs between Greenberg and Harrison in the second part of this series.

18. Clement Greenberg, "States of Criticism."

19. Ibid.

20. Ibid.

21. Clement Greenberg, "Counter-Avant-Garde."

22. Many of the new theorists associated with postmodern theory were graduate students of Professor Krauss's at the Graduate Center of the City University of New York in the 1980s.

23. Many of the essays included in this volume are aesthetic essays. A previous volume published posthumously, *Homemade Esthetics: Observations on Art and Taste* (New York: Oxford University Press, 1999), also focuses on the more philosophical issues initially delivered in lectures at Bennington College in 1971. These essays were later published in various art periodicals and were collectively known as the "Seminars"; two have been reprinted here (see "Can Taste Be Objective?" [Seminar 3] and "Seminar 6").

24. This assertion agrees with the statement in O'Brian's introduction to volume 3 of *The Collected Essays and Criticism* that "the art that most opposed Greenberg's teleology was Pop and Minimalism. Pop art and Minimal art represented practices that dissented from the narrative Greenberg had latterly fashioned for modernism."

25. Greenberg, "Counter-Avant-Garde."

26. Ibid.

27. Clement Greenberg, "Influences of Matisse," in *Henri Matisse* (New York: Acquavella Galleries, 1973), unpaginated; also published in *Art International* 16 (November 1973): 28–31.

28. Clement Greenberg, "Necessity of 'Formalism.'"

29. Greenberg, "Influences of Matisse."

30. Ibid.

31. Evans and Harrison, "A Conversation with Clement Greenberg in Three Parts."

32. Clement Greenberg, "Can Taste Be Objective?" (Seminar 3).

33. Marcel Duchamp, "The Creative Act," in Gregory Battcock (ed.), *The New Art* (New York: Dutton, 1971).

34. Clement Greenberg, "Picasso."

35. Ibid.

36. Clement Greenberg, "Towards a Newer Laocoön," in O'Brian, *The Collected Essays and Criticism*, 1: 26–27.

37. Ibid., 32.

38. John Dewey, *Art as Experience* (New York: Capricorn Books, 1931).

39. Clement Greenberg, "Clyfford Still."

40. Clement Greenberg, "Abstract, Representational, and So Forth."

41. Evans and Harrison, "A Conversation with Clement Greenberg in Three Parts."

Clement Greenberg
L A T E W R I T I N G S

I

· ·

THE AVANT-GARDE

AND MODERNISM

· ·

• •

COUNTER-AVANT-GARDE

• •

Das Gemeine lockt jeden: siehst du in
Kürze von vielen
Etwas geschehen, sogleich denke nur:
dies ist gemein.

—Goethe, *Venetian Epigrams*

The case of what passes nowadays for advanced-advanced art has its fasci-
nation. This isn't owed to the quality of the art; rather it has to do with its
very lack of quality. The fascination is more historical, cultural, theoretical
than it is aesthetic. Not that no advanced art of superior quality is being
produced at this time. It is, in the usual relatively small quantities. But it's
not that kind of art that I call advanced-advanced art. Nor does superior
art, in any case, have the kind of fascination I'm speaking of, which offers
far more challenge to understanding than to taste. Here, understanding
requires going to origins.

As we know, the production of art in the West divided itself over a
century ago into advanced or avant-garde on one side and academic,
conservative, or official on the other. All along there had been the few
artists who innovated and the many who didn't. And all along the highest

5

qualities of art had depended in crucial part on the factor of newness or originality. But never before the 1860s in France had the difference between decided newness and everything else shown itself so strikingly in high art. Nor had innovation ever before been resisted so stubbornly by the cultivated art public.

That was when the present notion of the avant-garde was born. But for a while this notion did not correspond to a readily identifiable or definable entity. You might paint in imitation of the impressionists or write verse like a symbolist, but this did not mean necessarily that you have joined something called the avant-garde. It wasn't there definitely enough to join. You could join bohemia, but bohemia antedated the avant-garde and meant a way of life, not a way of art. The avant-garde was something constituted from moment to moment by artists—a relative few in each moment—going toward what seemed the improbable. It was only after the avant-garde, as we now recognize it, had been under way for some fifty years that the notion of it seemed to begin to correspond to a fixed entity with stable attributes. It was then that the avant-garde came into focus as something that could be joined. That was also when it first began to look like something really worth joining; by then enough people had awakened to the fact that every major painter since Manet, and every major poet since Baudelaire (at least in France), entered the maturity of his art as a "member" of the avant-garde. At this point, too, innovation and advancedness began to look more and more like given, categorical means to artistic significance apart from the question of aesthetic quality.

The Italian futurists may not have been the very first individuals to see the avant-garde and advancedness in this light, but they were the first to make the avant-garde, as seen in this light, a viable, ongoing notion and classification. They were the first to think in terms of avant-garde*ness,* and to envisage newness in art as an end in itself; and they were the first group to adopt a program, posture, attitude, stance that was consciously "avant-garde."

It was no accident (to talk as Marxists used to) that futurism became the first manifestation connected with the avant-garde to win public attention more or less immediately, and that "futuristic" became the popular adjective for modernist art. The futurists announced, spelled out, and illustrated their intention of pursuing the new as no intention associated with avant-garde art had ever been before. (The sensation made at the New York Armory show in 1913 by Marcel Duchamp's *Nude Descend-*

ing a Staircase, which resembles futurist versions of analytical cubism, is a case in point: this work gave people enough cues to permit them to watch themselves being startled by the "new"—as they could not do with Picasso's, Braque's, Léger's, or even Matisse's newnesses in that same exhibition.)

The futurists discovered avant-gardeness, but it was left to Duchamp to create what I call avant-gard*ism.* In a few short years after 1912 he laid down the precedents for everything that advanced-advanced art has done in the fifty-odd years since. Avant-gardism owes a lot to the futurist vision, but it was Duchamp alone who worked out, as it now looks, every implication of that vision and locked advanced-advanced art into what has amounted to hardly more than elaborations, variations on, and recapitulations of his original ideas.

With avant-gardism, the shocking, scandalizing, startling, the mystifying and confounding, became embraced as ends in themselves and no longer regretted as initial side effects of artistic newness that would wear off with familiarity. Now these side effects were to be built in. The first bewildered reaction to innovative art was to be the sole and appropriate one; the avant-gardist work—or act or gesture—was to hold nothing latent, but deliver itself immediately. And the impact, more often than not, was to be on cultural habits and expectations, social ones too, rather than on taste. At the same time newness, innovation, originality itself was to be standardized as a category into which work, an act, a gesture, or an attitude could insert itself by displaying readily recognizable and generally identifiable characteristics or stimuli. And while the conception of the new in art was narrowed on one side to what was obviously, ordinarily, or only ostensibly startling, it was expanded on the other to include the startling in general, the startling as sheer phenomenon or sheer occurrence.

All along the avant-garde had been accused of seeking originality for its own sake. And all along this had been a meaningless charge. As if genuine originality in art could be envisaged in advance, and could ever be attained by mere dint of willing. As if originality had not always surprised the original artist himself by exceeding his conscious intentions. It's as though Duchamp and avant-gardism set out, however, deliberately to confirm this accusation. Conscious volition, deliberateness, plays a principal part in avant-gardist art: that is, resorting to ingenuity instead of inspiration, contrivance instead of creation, "fancy" instead of "imagination"; in effect, to the known rather than the unknown. The "new" as known

beforehand—the general look of the "new" as made recognizable by the avant-garde past—is what is aimed at, and because known and recognizable, it can be willed. Opposites, as we know, have a way of meeting. By being converted into the idea and notion of itself, and established as a fixed category, the avant-garde is turned into its own negation. The exceptional enterprise of artistic innovation, by being converted into an affair of standardized categories, of a set of "looks," is put within reach of uninspired calculation.

Avant-gardism was not all there was to futurism, dada, or Duchamp—even to the post-1912 Duchamp. It's far from being all there was to surrealism either, though surrealism did more than futurism to popularize avant-gardism. But it's doubtful whether even in surrealism's heyday, in the latter 1920s and in the 1930s, avant-gardism took hold in artistic practice as thoroughly as it had among the few adventurous or would-be adventurous artists at the time of dada. For all the designed "aberrations" of surrealist art, there was hardly a surrealist artist of consequence who sacrificed his *taste* to the sole effect of the innovative.

In the latter 1940s and in the 1950s, when abstract expression and *art informel* were in the ascendant, avant-gardism receded even further from actual artistic practice. The worst of the artists caught up in these tendencies (and they were legion), as well as the best (they were a handful), were genuinely avant-garde, not avant-gardist, in aspiration, whether they knew it or not. They wanted their works to function as art in the "traditional" sense that avant-gardism often professed to repudiate.

This may sound surprising to some people. If so, it's because they haven't looked closely enough at abstract expressionist or *informel* painting and/or because they've taken on faith too much of what's been written and said about them. (The very term, *art informel,* expressed and forces a misunderstanding, not to mention "action painting.")

Almost all new manifestations of art get misunderstood in the first attempts to explain them, and usually they stay misunderstood for a good while after. This was so long before the avant-garde appeared, but it has become ever so much more so since then. With avant-gardism, however, there has come *forced* misunderstanding—aggressive, inflated, pretentious misunderstanding. Avant-gardism, even today, is planted deeper and more broadly in the talk and writing about art than in its practice. And it planted itself in the talk and the writing earlier, appearing in Apollinaire's art

criticism before it ever did in the futurist practice of attitudinizing. What Apollinaire wrote on behalf of cubism foretold in many respects what was later written on behalf of dada, surrealism—and abstract expressionism. The palaver of the 1950s about absolute spontaneity, about the liberation from all formal constraints, and about breaking with the whole past of art—all this wasn't just part of the ordinary muddlement that has affected talk about art ever since people first tried to account for it. It emerged, as *applause*, only with avant-gardist rhetoric. Maybe the most constant topic of avant-gardist rhetoric is the claim made with each new phase of avant-garde, or seemingly avant-garde, art that the past is now being finally closed out and a radical mutation in the nature of art is taking place after which art will no longer behave as it has heretofore. As it happens, this was already said more or less about impressionism in its time, but it was also said about every next step of modernist art—but it was said then only in condemnation and opposition. Not till around 1910 did the same thing begin to be said in praise and welcome. Again—as with the business of pursuing originality for its own sake—it was as though avant-gardism were trying deliberately to confirm a standard charge against the avant-garde.

A key figure in the abstract expressionist situation was Jackson Pollock. I mean a key figure—aside from the value of his art—as looked back at in the light of what has most conspicuously happened in art since abstract expressionism. Pollock's allover "drip" paintings of 1947–50 were in their time taken for arbitrary effusions by his fellow abstract expressionists as well as by almost everybody else. These fellow artists may have basked in avant-gardist rhetoric about total "liberation," and they may have indulged in that kind of rhetoric themselves, but, as I've said, at bottom they still believed in, and acted on, painting as a discipline oriented to aesthetic values. Because they could discern little or nothing of these in Pollock, they did not consider him to be a "real" painter, a painter who *knew* how to paint, like a de Kooning, a Kline, or a Rothko; they saw him, rather, as a freakish apparition that might signify something in terms of cultural drama but hardly anything in those of art proper. The younger artists who in the 1960s displaced the abstract expressionists on what's called the "scene" likewise saw Pollock's middle-period painting as freakish and inartistic, but instead of deploring that, they hailed it. They could no more "read" Pollock than their predecessors could, but they admired him all the more

precisely because of that. And as the 1960s wore along and art went further and further out, Pollock's reputation became more and more a hallowed one, second only to Duchamp's in the pantheon of avant-gardism.

The conclusions avant-gardist artists of the 1960s drew from their inability to grasp the art in Pollock got acted on in much the same way as those which Duchamp had drawn almost fifty years earlier from his inability to recognize the whole of the art in cubism. He would seem to have attributed the impact of cubism—and particularly of Picasso's first collage constructions—to what he saw as its startling difficulty; and it's as though the bicycle wheel mounted upside down on a stool and the store-bought bottle rack he produced in 1913 were designed to go Picasso one better in this direction. Young artists in the 1960s, reasoning in a similar way from their misconception of Pollock's art, likewise concluded that the main thing was to look difficult, and that the startlingly difficult was sure to look new, and that by looking newer and newer you were sure to make art history. To repeat: it wasn't abstract expressionist art as such that helped bring on the great resurgence of avant-gardism in the 1960s, but the misconceptions of it propagated by avant-gardist rhetoric and welcomed and maintained by younger artists of retarded, academic taste.

"Academic" is an unhelpful term unless constantly redefined and relocated. One of the notable things done by Charles W. Millard, in an article called "Dada, Surrealism, and the Academy of the Avant-Garde" that appeared in the *Hudson Review* of spring 1969, was to define and locate academicism as an aggressive tendency inside the precincts of the avant-garde, and not just a matter of imitativeness or belatedness. Mr. Millard specifies dada and surrealism as being in part an effort to "modify modernism, to make it 'easier,' and to reintroduce literary content." I would add that dada and surrealism, insofar as they were avant-gardist (Mr. Millard doesn't use this label), constituted a first attempt not just to modify but to capture the avant-garde—from within as it were—in order to turn it against itself.

Academic qualms are omnipresent, like mold spores in the air. They arise from the need for security, which artists feel as much as other human beings do. Until recently any kind of art in which this need predominated declared itself more or less openly as academic. There were, of course, degrees and degrees; and it never was, and never will be, easy to distinguish among them. Yet when we look back it seems that it used to be easier to do so than it is now, when so many sheep have taken to wearing wolf's clothing. In the 1950s, old-time, self-evident academic art began to be

pushed from the current foreground of the larger art public's attention by abstract expressionism and *art informel*. It was left to pop art, however, to finish the job, in the early 1960s, and pop art was able to finish it because it was more essentially, and viably, academic than abstract expressionism had ever been, even in its last and worst days. The current foreground was the natural habitat of academic art, and it was a habitat, moreover, that wouldn't tolerate any other kind of art. Having been thrust from that habitat in all its old guises, academic art rushed back in new ones. This marked the beginning of the present revival of avant-gardism. In the meantime, the public attracted by whatever could be considered advanced art had grown enormously, so that by the early 1960s it had come to coincide to all intents and purposes with the public for contemporary art in general. But this public, while it had a great appetite for the look of the advanced, turned out to have no more real stomach for the substance of it than any previous art public had.

Like assemblage and op, pop art remained too tamely artistic, too obviously tasteful, to maintain for long the advanced-advanced look that avant-gardist art needed in order to be plausible. If academic sensibility were to continue to disguise itself effectively it would have to wear a much more physically, phenomenally new look, a more opaque and "difficult" one. Innovation was not supposed to be all that easy on taste. Again Duchamp was consulted, this time less for his "pop" irony than for his vision of the all-out far-out—art beyond art, beyond antiart and nonart. This was what the past triumphs of the classic avant-garde, from Manet to Barnett Newman, had now—with help from avant-gardist rhetoric— prepared a new middlebrow consciousness for.

Academic sensibility has taken to cavorting in ways that seem to defy and deny all past notions of the academic. Doesn't the academic depend, always, on the tried and proven, and isn't every sort of untried and unproven thing being adventured with here? Well, just as there's almost nothing that can't (under sufficient pressure of both taste and inspiration) be turned into high and original art, so there's almost nothing that can't be turned immediately into academic (or less than academic) art: nothing that can't be conventionalized on the spot, including unconventionality itself. It's one of avant-gardism's great theoretical services to have demonstrated that the look, at least, of the unconventional, the adventurous, the advanced, can be standardized enough to be made available to the tritest sensibility.

But you can still wonder exactly why it is that all the phenomenal, configurational, and physical newness that abounds in art today should evince so little genuinely artistic or aesthetic newness—why most of it comes out so banal, so empty, so unchallenging to taste. In the past phenomenal newness used almost always to coincide with authentic artistic newness—in Giotto's or Donatello's case, really, as much as in Brancusi's or Pollock's. Why does the equation between phenomenal and aesthetic newness no longer seem to hold today?

In some part this question resolves itself into one of context. All art depends in one way or another on context, but there's a great difference between an aesthetic and a nonaesthetic context. The latter can range from the generally cultural through the social and political to the merely sexual. From the start avant-gardist art resorted extensively to effects depending on an extraaesthetic context. Duchamp's first readymades, his bicycle wheel, his bottle rack, and later on his urinal, were not new at all in configuration; they startled when first seen only because they were presented in a fine-art context, which is a purely cultural and social, not an aesthetic or artistic context. (It doesn't matter in this connection that the "influence" of cubism can be detected in the choice of the bicycle wheel and the bottle rack.) But of "context" art, more a little later.

There are, however, other varieties of avant-gardist art that do not rely on extrinsic context, and which do aim at intrinsic visual or situational originality: minimal art (which is not altogether avant-gardist), technological, "funky," earth, "process," "systems," etc., etc. These kinds of art more emphatically pose the question of why phenomenal novelty, and especially spectacular phenomenal novelty, seems to work nowadays so differently from the way it used to.

Among the many things that highly original art has always done is convert into art what seems to be nonart. Avant-garde art called attention to this supposed conversion in more obvious and striking ways than any art before it had—at least any urban art. It was as though the line between art and supposed nonart receded faster for the avant-garde, and that at the same time the latter had to push harder and harder against that line. As I've already said: to most people at the time, the first full-blown impressionist paintings seemed to break with everything previously considered pictorial art and to remain "nonart" objects; this, the "nonart" reaction, was provoked by every subsequent move of modernist art and, like other

such standard reactions to it, was finally adopted by avant-gardism as something to be welcomed.

But Duchamp's readymades already showed that the difference between art and nonart was a conventionalized, not a securely experienced, difference. (As they also showed that the condition of being art was not necessarily an honorific one.) Since then it has become clearer, too, that anything that can be experienced at all can be experienced aesthetically; and that anything that can be experienced aesthetically can also be experienced as *art*. In short, art and the aesthetic don't just overlap, they coincide (as Croce suspected, but didn't conclude). The notion of art, put to the strictest test of experience, proves to mean not skillful making (as the ancients defined it), but an act of mental distancing—an act that can be performed even without the help of sense perception. Any and everything can be subjected to such distancing, and thereby converted into something that takes effect as art. There turns out, accordingly, to be such a thing as art at large, art that is realized or realizable everywhere, even if for the most part inadvertently, momentarily, and solipsistically: art that is private, "raw," and unformalized (which doesn't mean "formless," of which there is no such thing). And because this art can and does feed on anything within the realm of conceivability, it is virtually omnipresent among human beings.

This "raw," ubiquitous art doesn't as a rule move anybody more than minimally on the aesthetic level, however much it might do so on the level of consolation or therapy or even of the "sublime." It's literally and truly minimal art. And it's able to remain that because in its usual privacy it is sheltered from the pressure of expectations and demands. Art starts from expectation and satisfaction, but only under the pressure of heightened expectation—expectation as schooled and heightened by sufficient aesthetic experience—does art lift itself out of its "raw" state, make itself communicable, and become what society considers to be art proper, public art.

Duchamp's "theoretical" feat was to show that "raw" art could be formalized, made public, simply by setting it in a formalized art situation, and without trying to satisfy expectations—at least not in principle. Since Duchamp this formalizing of "raw" art by fiat has become a stereotype of avant-gardist practice, with the claim being made, always, that new areas of nonart are being won for art thereby. All this has actually amounted

to, however, is that public attention is called to something that was art to begin with, and banal as that, and which is made no more intrinsically interesting by being put into a recognized art context. New areas are thereby won, not for art, but only for bad formalized art. The aesthetic expectations to which art by fiat is directed are usually rudimentary. Surprise, which is an essential factor in the satisfaction of more than minimal aesthetic expectations, is here conceived of in relation mainly to nonaesthetic ones, and derives only from the act of offering something as formalized art that's otherwise taken to be, and expected to be, anything but art—like a bicycle wheel or a urinal, a littered floor, or the temperature multiplied by the barometric pressure in a hundred different places at the same time or at a thousand different times. (Or else the surprise comes from reproducing or representing objects in incongruous materials or sizes, or from affixing incongruous objects to pictures, or from offering reproductions of photographs as paintings, and so on, with the stress being always put on incongruity in the "material mode." And though there's nothing that says that *stressed* incongruity can't be an integral aesthetic factor, it has hardly ever managed to be that so far except in literature.)

The issue for art is not merely to extend the limits of what's considered art, but to increase the store of what's experienced as "good and better" art. This is what extending the "limits" of art meant for the classic avant-garde. The issue remains quality: that is, to endow art with greater capacity to move you. Formalization by itself—putting a thing in a public art context—does not do this, or does it only exceptionally. Nor does surprise for the sake of surprise do this. Art, as I've said, depends on expectation and its satisfaction. It moves and satisfies you in a heightened way by surprising expectation; but it does not do so by surprising expectation *in general;* it does what it does best by surprising expectations that are of a certain order. By conforming to these even as it jars them, artistic surprise not only enhances aesthetic satisfaction but also becomes a self-renewing and more or less permanent surprise—as all superior art shows.

Superior art comes, almost always, out of a tradition—even the superior art that comes early—and a tradition is created by the interplay of expectation and satisfaction through surprise as this interplay operates not only within individual works of art, but between them. Taste develops *as* a context of expectations based on experience of previously surprised expectations. The fuller the experience of this kind, the higher, the more

truly sophisticated the taste. At any given moment the most sophisticated, the best taste with regard to the new art of that moment is the taste which implicitly asks for new surprises, and is ready to have its expectations revised and expanded by the enhanced satisfactions which these may bring. Only the superior artist responds to this kind of challenge, and major art proceeds as one frame of expectations evolves out of, and includes, another. (Need I remind anyone that this evolution, for all its cumulativeness, does not necessarily mean "progress"—any more than the word *evolution* itself does?)

The superior artist acquires his ambition from, among other things, the experience of his taste, his own taste. No artist is known—at least not where the evidence is clear enough—to have arrived at important art without having effectively assimilated the best new art of the moment, or moments, just before his own. Only as he grasps the expanded expectations created by this best new art does he become able to surprise and challenge them in his own turn. But his new surprises—his innovations—can never be totally, utterly disconcerting; if they were, the expectations of taste would receive no satisfaction at all. To repeat in different words what I've already said: surprise demands a context. According to the record, new and surprising ways of satisfying in art have always been connected closely with immediately previous ways, no matter how much in opposition to these ways they may look or actually have been. (This holds for Cavallini and Giotto as well as for David and Manet, and for the Pisanos as well as for Picasso as constructor and sculptor.) There have been no great vaults "forward," no innovations out of the blue, no ruptures of continuity in the high art of the past—nor have any such been witnessed in our day. Ups and downs of quality, yes, but no gaps in *stylistic* evolution or nonevolution. (Continuity seems to belong to the human case in general, not just to the artistic one.)

The academic artist tends, in the less frequent case, to be one who grasps the expanded expectations of his time, but complies with these too patly. Far more often, however, he is one who is puzzled by them, and who therefore orients his art to expectations formed by an earlier phase of art. The unique historical interest of Duchamp's case lies in his refusal, as an academic artist of the second kind, to follow this second way, and in his deciding, instead, to wreak his frustration on artistic expectations in general. As well as by scrambling literary and cultural with visual contexts he tried to disconcert expectation by dodging back and forth between

pictorial and sculptural ones (as he must have thought Picasso was doing in his collage constructions).[1]

Again, there's nothing necessarily wrong or qualitatively compromising in the juggling of expectations between one medium and another. The classic avant-garde's emphasis on "purity" of medium is a time-bound one and no more binding on art than any other time-bound emphasis. What's been wrong in the avant-gardist juggling of expectations is that the appeal from one frame of expectations to another has usually been away from the most sophisticated expectations working in one medium to less sophisticated ones operating in some other. It's a lesser pressure of literary taste that the pop artist appeals to as against a higher pressure of pictorial or sculptural taste; it's a lower pressure of pictorial taste that the minimalist artist appeals to as against a higher pressure of sculptural taste. The invoking of the literally three-dimensional in a two-dimensional context (as in the shaped canvas), and of the two-dimensional in a three-dimensional context (though there are strong exceptions here), has meant, in general, the attempt to evade the highest-going pressures of taste and at the same time to disguise this. Which is maybe the most succinct way of all of describing avant-gardism in any of the arts—those of literature and music and architecture as well as of painting and sculpture.

For good reasons, the drift of avant-gardist medium scrambling in visual art has been more and more toward the nonpictorial and three-dimensional. Now that utter abstractness is taken for granted, it has become more difficult to approach the "limits" of art in a pictorial context; now everything and anything two-dimensional states itself automatically as pictorial—a stretch of mud (in bas-relief) as well as a blank wall or blank canvas—and thus exposes itself immediately and nakedly to pictorial taste. (Some awareness of this lies behind the recent cry that painting is "finished.") On the other hand, taste, even the best taste, appears to function far more uncertainly nowadays in the area of the three-dimensional than in that of the two-dimensional. The difference between abstract sculpture (or "object" making) and "nonart" still seems relatively tenuous. Experience of sculpture has not yet produced an order of expectations that would help the eye firmly separate abstract sculpture not only from architecture and utilitarian design but even from three-dimensional appearances at large. (This may help account for the repeated disappointments of abstract sculpture so far.) Something like a break in the continuity of sculptural taste has appeared: something that looks even like a vacuum of taste. This ostensible

vacuum has come in opportunely for academic sensibility that wants to mask itself. Here is the chance to escape, not just from strict taste, but from taste as such. And it's in this vacuum that avant-gardist art has produced, and performed, its most daring and spectacular novelties. But this vacuum also explains, finally, why they all come out so unnew, why phenomenal and configurational innovation doesn't coincide the way it used to with the genuinely artistic kind.

Art that realizes—and formalizes—itself in disregard of artistic expectations of any kind, or in response only to rudimentary ones, sinks to the level of that unformalized and infinitely realizable, subacademic, sub-*kitschig* art—that subart which is yet art—whose ubiquitousness I called attention to earlier. This kind of art barely makes itself felt, barely differentiates itself, as art because it has so little capacity to move and elate you. Nor can any amount of phenomenal or configurational novelty increase this capacity in the absence of the control of informed expectations. Ironically enough, this very incapacity to move, or even interest, you—except as a momentary apparition—has become the most prized, the most definitive feature of up-to-date art in the eyes of many art followers. Some recent art that happens not at all to be avant-gardist in spirit gets admired precisely when it fails to move you and because of what makes it fail to do so.

But to adapt that saying of Horace's again: you may throw taste out by the most modern devices, but it will still come right back in. Tastefulness—abject good taste, academic taste, "good design"—leaks back constantly into the furthest-out as well as furthest-in reaches of the vacuum of taste. The break in continuity gets steadily repaired. Finally it turns out that there has not really been a break, only the illusion of one. In the showdown, abstract sculpture does get *seen,* and does get judged. The vacuum of taste collapses.

The inexorability with which taste pursues is what avant-gardist art in its very latest phase is reacting to. It's as though conceptualist art in all its varieties were making a last desperate attempt to escape from the jurisdiction of taste by plumbing remoter and remoter depths of subart—as though taste might not be able to follow that far down. And also as though boredom did not constitute an aesthetic judgment.

(1971)

NOTE

1. In all fairness to Duchamp as an artist I should point out that he did several things (the "straight" painting *Network of Stoppages* of 1914 and *Glasses* of a slightly later date) that achieve genuinely large, even major quality and that are also prophetic in the way that they make a virtue out of their opposition to synthetic cubism. In those years, Duchamp could fall into inspiration.

Looking for the Avant-Garde

• •

TO START BY REPEATING WHAT'S WELL KNOWN: high art, high culture rest on the comfortable leisure of a minority. This minority—usually a very small one—goes with urban society, civilization. The distinction between high and less than high culture doesn't apply apparently in preurban societies (though some of these have or had privileged minorities too).

As good as preurban art can be, it doesn't measure up with any consistency to high urban art—high urban art almost anywhere. (This is what the best taste says, and it's no use arguing that taste is relative, that what I call the best taste is that only of an elite. The "best" science and the "best" learning likewise belong to an elite, the same elite.)

It's unjust, of course, that high art and high culture should be the preserve of an advantaged minority. But urban society has always been unjust. Civilization has flowered because a few people have been able to devote themselves comfortably to "idle" things by living off the labor to which most other people are condemned. (Bowing to this fact doesn't mean approving of it. Marx pointed it out as no one before him had, and he bowed to it as a fact that only industrialism could and would make avoidable.)

What the French started to call official art in the nineteenth century

(which English-speakers now call Establishment or even, in many cases, middlebrow) was and is high art of sorts, and still is an affair of the privileged and exploitative (if you please) minority. And no matter how much that minority has gotten swollen over the past decades by a swollen middle class, it remains an elite still (if only because it still isn't as used up by work or harrowed by need as the majority is).

The avant-garde emerged a hundred-odd years ago as a minority within a minority: a minority culture within the larger minority culture that was official. If the latter, according to current jargon, has to be considered elitist, then the avant-garde was hyperelitist. The avant-garde has probably been the most elitist manifestation of culture there ever was. This not only because of the small number, until recently, of those whose tastes and attitudes have constituted the fact of the avant-garde, but also because of the small effect their tastes and attitudes have had in their own time on society at large. This was something new as far as high culture was concerned, and still is new. High culture, the culture of the privileged and ruling and exploiting minority, had always laid down what was to be taught in school, and official culture still does. It is, or rather used to be, a defining characteristic of avant-garde culture that education, along with everything else institutionalized, more or less excluded it.

Now it's true that official culture has assimilated the avant-garde all along, but only after waiting until a given phase of the avant-garde had receded far enough into the past. Such delay seems only to have reinforced the isolation of the avant-garde in its following phase or phases. Insofar as the avant-garde has belonged to the present, insofar as it's continued to produce and to excel, official culture has kept it at a distance. For official culture it's been as though the avant-garde came to an end with each phase of it that got assimilated. The rhythm of this assimilation hasn't by any means been a regular one. Rather it's gone by fits and starts (especially outside France). In the English-speaking world the epochal fit and start came between the late 1930s and the 1950s. It was a telescoping process: Mondrian became respectable along with van Gogh, Joyce and Eliot along with Gerard Manley Hopkins; Mallarmé and Rimbaud entered French literature courses in American colleges at the same time that Proust and Valéry and Apollinaire did. Something similar went on in music (but the case of avant-garde music seems to me a special one, and I'm not equipped to deal with it even in a cursory way).

Of course it's as though I were setting up a fixed model for the avant-

garde's location and trajectory in cultural history. Worse yet, I've been talking as though the avant-garde has remained the same in nature and configuration throughout. Well, I need a kind of fixed model in order to make my point, which is that a great difference has opened up between the situation of the avant-garde as it used to be and what looks like the situation of the avant-garde over the past fifteen or twenty years. Official, established, polite culture seems no longer to have to wait for avant-garde activity to retreat into the past before assimilating it. Official culture now appears to keep up. The time lag hasn't just diminished, it seems to have vanished. Nothing has become too "advanced" or "experimental" or outrageous for official culture to embrace on the spot. By museums and libraries and classrooms, by the mass-circulation press, by foundations, by collectors, by governments. (The Centre National d'Art et de Culture Georges Pompidou in Rue Beaubourg in Paris has come along—and at just the right time, I would say—to monumentalize this revolutionary state of affairs.)

How to account for this turn, this momentous-seeming turn, in our official culture? All I can do is throw out suggestions: the great expansion of the middle classes that I've already mentioned, and with it the expansion of what's called functional literacy; the discrediting, and not just among the functionally literate, of nineteenth-century attitudes and of what used to be authoritative attitudes in general. I'm not telling you anything new here. Nor maybe am I telling you something so new when I point to the spreading realization among the larger minority on whom official culture depends that the most important artistic and cultural achievements of the past hundred years and more have belonged to the avant-garde or at least to dissenters from official culture; from which has followed *la grande peur*, the great fear of missing the boat again the way it was missed all through those hundred years by most art lovers (Henry James, who looked at painting and sculpture even if he didn't—apparently—read poetry or listen to music, could be a typical enough example). With the *grande peur* has come the categorical resolve to welcome anything that looks new enough, to accept the ostensibly or sheerly shocking and startling precisely because it is that (a resolve which reaches to the extent of tolerating boredom of a magnitude that may be new in human experience—the sheerly shocking and startling being so sheerly boring in its essence). There must be, however, other, deeper factors involved here that remain for time and a searching enough sociologist of culture to discover.

That, as seems, the contemporary avant-garde should no longer be isolated from or within official culture, that it should become part of it let alone compatible with it: this would mean that the avant-garde has lost one of its main identifying features, namely, its isolation and apartness. If this was an essential feature of the avant-garde, then it would have to be concluded that the avant-garde no longer carries on as itself, that it's become something else, or even that it's finished (just in the way that official culture had expected it to be every time it caught up with a past phase of the avant-garde).

But isolation is not the essentially identifying, constitutive feature of the avant-garde as the time- and place-bound phenomenon that it's been. What created the avant-garde and defines and constitutes it essentially, crucially, is something else, of which its isolation has been a concomitant. That something else lies in the insistence on aesthetic quality, aesthetic value, in the demand laid on art as art for the highest possible or experienceable such value. This insistence amounts to the avant-garde's only raison d'être, its only real justification. It's an insistence that used to be matter of course, implicit, in high or—if you want—official culture before the last century. The mission that brought the avant-garde into being appeared when official culture gave up on this insistence, with an implicitness like that with which it had once maintained it. It was left to the avant-garde alone to persevere in this insistence, and in order to do so it had to declare the insistence more explicitly and uncompromisingly than it had been declared before. That's the long and the short of it; everything else that's validly connected with the avant-garde derives in one way or another from that declaration. When it stops harping on quality, the avant-garde becomes something other than itself.

Well, in view of its assimilation to official culture and art, can it be taken that the contemporary avant-garde—or what passes for it—persists in the uncompromising demand for artistic excellence? That it remains true to that which constitutes and essentially defines what's been known hitherto as the avant-garde? It's possible, it can't be ruled out. If the evidence of our eyes says so, then it has to be so. There's nothing that says that official culture can't, after an interval of a hundred-odd years, return to the asserting and maintaining of the highest artistic standards in the here and now, and no longer just retroactively and retrospectively. But if this should be so, then it would follow that the avant-garde has been relieved of its justification as well as its isolation and, along with that,

of its identity and distinctiveness; that it's really turned into something else. Which would be all right. There's nothing intrinsically precious in the avant-garde's identity beyond its insistence on aesthetic value. If some other agency takes up or resumes that insistence, nothing is lost—and maybe something's gained.

Well, has official culture actually taken up that insistence in all its uncompromisingness? When the press, the museums, the governments, and the collectors embrace the likes of Beuys and Christo and Rauschenberg and, for that matter, even Francis Bacon, are the highest aesthetic standards being upheld? Is the classic avant-garde's mission being perpetuated? My own eyes, my own taste, say hardly. They say that official culture finds the ostensible avant-garde art of the last fifteen years and more so readily acceptable because, among other things, official art and culture remain what they've been since the second quarter of the ninteenth century. My own eyes tell me that in point of value or quality the ostensible avant-garde art of this time is only ostensibly avant-garde; that the insistence on value, if it's being maintained at all, is being maintained elsewhere. That it remains of the essence of official culture since it began to be called official to compromise in the matter of art and the aesthetic in the here and now. (I don't say that it need be this way, only that it has been and still is this way.)

The supreme paradox (and most paradoxes tend to be supreme lately) is that official art has, in its own terms, lost rather than gained by its new readiness to welcome the ostensible avant-garde. Gérôme, Alma-Tadema, Meissonier, Landseer, Watts, even Maxfield Parrish, in their good small moments, have more than Lichtenstein at his best. Old-time official art at its worst never offered anything as boring, sheerly boring, as Beuys; it never lingered over anything as vacuous as Christo. It's as though official art, by embracing the ostensible avant-garde, had set out to discredit itself in a final, incontrovertible way.

Meanwhile, does an authentic as against an ostensible avant-garde persist? Does art anywhere still pursue excellence in the classic avant-garde way? My taste tells me yes, that the genuine avant-garde is still with us and still maintaining its traditional level. It may no longer live in the same kind of obscurity that it used to, but it's still kept in the background more or less. And it still bides or is made to bide its time. And the best new art is more malicious than ever, more even than it was in 1863 or 1904 or 1950. Its malice is redoubled now, as if precisely to confound all those

pledged not to repeat the mistakes of the past, for those who have to keep up, all those afflicted with the *grande peur.* Now the old mistakes are not only repeated but compounded.

And official art, as though having acquired a malice of its own, cooperates by serving up a Rauschenberg instead of a Carrière, an Andre instead of a Manship. To complicate the case, and to the further confounding of the followers of the new, official art at the same time furnishes a Wyeth. All those—an elite still, for all their numbers—who relish Wyeth do more to maintain the level of official art than does that avant-gardized elite which prefers Rauschenberg; they do more to maintain the level of art in general. Irony abounds as it may never have before, and not only in the visual arts. The Beatles are more musical than John Cage; along with Bob Dylan, they may be more poetic than John Ashbery—and so on.

(1977)

Modern and Postmodern

• •

"POSTMODERN" IS A RATHER NEW TERM. It's a catchy one and has been coming up more and more often in talk and writing about the arts, and not only about the arts. I'm not clear as to just what it points to except in the case of architecture. There we know more or less definitely what "modern" means, so we're better able to tell what "post" means when prefixed to "modern." Modern architecture means—to put it roughly— functional, geometric rigor and the eschewing of decoration or ornament. Buildings have been put up or projected lately that break with these canons of style, and therefore have gotten called postmodern. Everybody concerned knows what's meant, including the architects themselves.

Can postmodern be identified in an equally agreed upon way in any of the other arts? I haven't yet seen or heard the term applied in earnest to anything in recent literature. It's come up in connection with music, but haphazardly and with no agreement about what it means there. And from what I can tell it comes up hardly at all in talk about the dance or the movies. Away from architecture, it's in the area of painting and sculpture that I've mostly heard and seen postmodern used—but only by critics and journalists, not by artists themselves.

There are reasons and reasons here. One possible reason is the return to

the foreground of figurative or representational pictorial art. But there's been enough precedent, since De Chirico and surrealism and neoromanticism, for including figurative art in the modern. There have to be other, less obvious, and at the same time more general reasons for the currency of postmodern in talk about recent painting and sculpture. All the more because no critic or journalist I'm aware of who makes free with postmodern points to any specific body of work he or she feels really confident in calling that.

Now the post in postmodern can be taken in a temporal chronological sense. Anything that comes after something else is "post" that something else. But this isn't quite the way in which postmodern is used. It's supposed, rather, to mean or imply art that supersedes, replaces, succeeds the modern in terms of stylistic evolution, the way that the baroque succeeded mannerism and the rococo succeeded the baroque. The corollary is that the modern is over and done with, just as mannerism was over and done with when superseded by the baroque. But the problem for those who claim this becomes to specify what they mean, not by post, but by modern. Anything in its own time can be called modern. However, what we usually mean by modern is something considered up-to-date, abreast of the times, and going beyond the past in more than a temporally or chronologically literal sense.

Well, how are you to decide what is and what isn't modern in present-day art in a sense that goes beyond the literal one? There's no rule, no principle, no method. It comes down to a question of tastes, or else a terminological quibble. Different stylistic definitions of the modern have been proposed in every generation since the word first came into circulation as applicable to painting and sculpture in more than a merely temporal sense, and none of them have held. Nor have any of those offered by the proponents of the postmodern, whether stylistic or not.

I want to take the risk of offering my own definition of the modern, but it will be more in the nature of an explanation and description than a definition. First of all, I want to change the term in question from modern to Modernist—Modernist with a capital M—and then to talk about Modernism instead of the modern. Modernism has the great advantage of being a more historically placeable term, one that designates a historically—not just chronologically—definable phenomenon: something that began at a certain time, and may or may not still be with us.

What can be safely called Modernism emerged in the middle of the last century. And rather locally, in France, with Baudelaire in literature and

Manet in painting, and maybe with Flaubert too, in prose fiction. (It was a while later, and not so locally, that Modernism appeared in music and architecture, but it was in France again that it appeared first in sculpture. Outside France later still, it entered the dance.) The "avant-garde" was what Modernism was called at first, but this term has become a good deal compromised by now as well as remaining misleading. Contrary to the common notion, Modernism or the avant-garde didn't make its entrance by breaking with the past. Far from it. Nor did it have such a thing as a program, nor has it really ever had one—again, contrary to the common notion. Nor was it an affair of ideas or theories or ideology. It's been in the nature, rather, of an attitude and an orientation: an attitude and orientation to standards and levels: standards and levels of aesthetic quality in the first and also the last place. And where did the Modernists get their standards and levels from? From the past, that is, the best of the past. But not so much from particular models in the past—though from these too—as from a generalized feeling and apprehending, a kind of distilling and extracting of aesthetic quality as shown by the best of the past. And it wasn't a question of imitating but one of emulating—just as it had been for the Renaissance with respect to antiquity. It's true that Baudelaire and Manet talked much more about having to be modern, about reflecting life in their time, than about matching the best of the past. But the need and the ambition to do so show through in what they actually did, and in enough of what they were recorded as saying. Being modern was a means of living up to the past.

But didn't artists and writers before these two look to the past for standards of quality? Of course. But it was a question of how one looked, and with how much urgency.

Modernism appeared in answer to a crisis. The surface aspect of that crisis was a certain confusion of standards brought on by romanticism. The romantics had already looked back into the past, the pre-eighteenth-century past, but had made the mistake in the end of trying to reinstall it. Architecture was where this attempt became most conspicuous, in the form of revivalism. Romantic architecture wasn't all that slavish, it wasn't the dead loss it's supposed to be, but still it didn't suffice; it may have maintained a look of the past, but not its standards. It wasn't revised enough by later experience, or revised in the right way: as Baudelaire and Manet might have put it, it wasn't modern enough. There ensued finally an academicization of the arts everywhere except in music and

prose fiction. Academicization isn't a matter of academies—there were academies long before academicization and before the nineteenth century. Academicism consists in the tendency to take the medium of an art too much for granted. It results in blurring: words become imprecise, color gets muffled, the physical sources of sound become too much dissembled. (The piano, which dissembles its being a stringed instrument, was the romantic instrument par excellence; but it is as if precisely because it made a point of dissembling that it produced the wonderful music it did in romantic times, turning imprecision into a new kind of precision.)

Modernism's reaction against romanticism consisted in part in a new investigating and questioning of the medium in poetry and painting, and in an emphasis on preciseness, on the concrete. But above all Modernism declared itself by insisting on a renovation of standards, and it effected this by a more critical and less pious approach to the past in order to make it more genuinely relevant, more "modern." It reaffirmed the past in a new way and in a variety of new ways. And it belonged to this reaffirming that the balance was tipped toward emulation as against imitation more radically than ever before—but only out of necessity, the necessity imposed by the reaffirmed and renovated standards.

Innovation, newness have gotten themselves taken as the hallmark of Modernism, newness as something desired and pursued. And yet all the great and lasting Modernist creators were reluctant innovators at bottom, innovators only because they had to be—for the sake of quality, and for the sake of self-expression if you will. It's not only that some measure of innovation has always been essential to aesthetic quality above a certain level; it's also that Modernist innovation has been compelled to be, or look, more radical and abrupt than innovation used to be or look: compelled by an ongoing crisis in standards. Why this should be so, I can't try to account for here; it would take me too far afield and involve too much speculation. Let it suffice for the moment to notice one thing: how with only a relatively small lapse of time the innovations of Modernism begin to look less and less radical, and how they almost all settle into place eventually as part of the continuum of high Western art, along with Shakespeare's verse and Rembrandt's drawings.

That rebellion and revolt, as well as radical innovation, have been associated with Modernism has its good as well as bad reasons. But the latter far outnumber the former. If rebellion and revolt have *truly* belonged to Modernism, it's been only when felt to be necessary in the interests of aesthetic value, not for political ends. That some Modernists have been

unconventional in their way of life is beside the point. (Modernism, or the avant-garde, isn't to be identified with bohemia, which was there before Modernism, there in London's Grub Street in the eighteenth century, there in Paris by the 1830s, if not before. Some Modernists have been bohemians more or less; many more others haven't been at all. Think of the impressionist painters, of Mallarmé, of Schoenberg, of the sedate lives led by a Matisse, a T. S. Eliot. Not that I attach a particular value to a sedate as against a bohemian life; I'm just stating a fact.)

By way of illustration I'd like to go into a little detail about how modernism came about in painting. There the proto-Modernists were, of all people, the Pre-Raphaelites (and even before them, as proto-proto-Modernists, the German Nazarenes). The Pre-Raphaelites actually foretold Manet (with whom Modernist painting most definitely begins). They acted on a dissatisfaction with painting as practiced in their time, holding that its realism wasn't truthful enough. It seemed to belong to this want of truth that color wasn't allowed to speak out clearly and frankly, that it was being swathed more and more in neutral shading and shadows. This last they didn't say in so many words, but their art itself says it, with its brighter, higher-keyed color, which marks off Pre-Raphaelite painting in its day even more than its detailed realism (to which clearer color was necessary in any case). And it was the forthright, quasi-naive color, as well as the quasi-innocent realism of fifteenth-century Italian art that they looked back to in calling themselves Pre-Raphaelite. They weren't at all the first artists to go back over time to a remoter past than the recent one. In the later eighteenth century, David, in France, had done that when he invoked antiquity against the rococo of his immediate predecessors, and the Renaissance had done that in appealing to antiquity against the Gothic. But it was the urgency with which the Pre-Raphaelites invoked a remoter past that was new. And it was a kind of urgency that carried over into Modernism proper and remained with it.

How much Manet knew of Pre-Raphaelism, I can't tell. But he too, ten years or so later than they, when he was starting out, became profoundly dissatisfied with the kind of painting he saw being done around him. That was toward the end of the 1850s. But he put his finger on what dissatisfied him more "physically" than the Pre-Raphaelites had, and therefore, as I think, to more lasting effect. (From the seventeenth century on the English anticipated ever so much, in culture and the arts as well as in politics and social life, but usually left it to others to follow through on what they'd started.) Seeing a "Velázquez" in the Louvre (a picture now thought

to be by Velázquez's son-in-law Mazo), he said how "clean" its color was compared to the "stews and gravies" of contemporary painting. Which "stews and gravies" were owed to that same color-muffling, graying and browning shading and shadowing that the Pre-Raphaelites had reacted against. Manet, in his own reaction, reached back to a nearer past than they had in order to "disencumber" his art of those "halftones" responsible for the "stews and gravies." He went only as far back as Velázquez to start with, and then even less far back, to another Spanish painter, Goya.

The impressionists, in Manet's wake, looked back to the Venetians insofar as they looked back, and so did Cézanne, that half-impressionist. Again, the looking back had to do with color, with warmer as well as franker color. Like the Pre-Raphaelites, like so many others in their time, the impressionists invoked truth to nature, and nature on bright days was luminous with warm color. But underneath all the invocations, the explanations, and the rationalizations, there was the "simple" aspiration to quality, to aesthetic value and excellence for its own sake, as end in itself. Art for art's sake. Modernism settled in in painting with impressionism, and with that, art for art's sake. For which same sake the successors in Modernism of the impressionists were forced to forget about truth to nature. They were forced to look even more outrageously new: Cézanne, Gauguin, Seurat, van Gogh, and all the Modernist painters after them—for the sake of aesthetic value, aesthetic quality, nothing else.

I haven't finished with my exposition and definition of Modernism. The most essential part of it comes, finally, now. Modernism has to be understood as a holding operation, a continuing endeavor to maintain aesthetic standards in the face of threats—not just as a reaction against romanticism. As the response, in effect, to an ongoing emergency. Artists in all times, despite some appearances to the contrary, have sought aesthetic excellence. What singles Modernism out and gives it its place and identity more than anything else is its response to a heightened sense of threats to aesthetic value: threats from the social and material ambience, from the temper of the times, all conveyed through the demands of a new and open cultural market, middlebrow demands. Modernism dates from the time, in the mid-nineteenth century, when that market became not only established—it had been there long before—but entrenched and dominant, without significant competition.

So I come at last to what I offer as an embracing and perdurable definition of Modernism: that it consists in the continuing endeavor to stem

the decline of aesthetic standards threatened by the relative democratization of culture under industrialism; that the overriding and innermost logic of Modernism is to maintain the levels of the past in the face of an opposition that hadn't been present in the past. Thus the whole enterprise of Modernism, for all its outward aspects, can be seen as backward-looking. That seems paradoxical, but reality is shot through with paradox, is practically constituted by it.

It also belongs to my definition of Modernism that the continuing effort to maintain standards and levels has brought about the widening recognition that art, that aesthetic experience no longer needs to be justified in other terms than its own, that art is an end in itself and that the aesthetic is an autonomous value. It could now be acknowledged that art doesn't have to teach, doesn't have to celebrate or glorify anybody or anything, doesn't have to advance causes; that it has become free to distance itself from religion, politics, and even morality. All it has to do is be good as art. This recognition stays. It doesn't matter that it's still not generally—or rather consciously—accepted, that art for art's sake still isn't a respectable notion. It's acted on, and in fact it's always been acted on. It's been the underlying reality of the practice of art all along, but it took Modernism to bring this out into the open.

But to return to postmodern. A friend and colleague had been to a symposium about postmodern last spring. I asked him how the term had gotten defined at that symposium. As art, he answered, that was no longer self-critical. I felt a pang. I myself had written twenty years ago that self-criticism was a distinguishing trait of Modernist art. My friend's answer made me realize as I hadn't before how inadequate that was as a conveying definition of Modernism or the modern. (That I hadn't the presence of mind to ask my friend just how self-critical art could be told from art that wasn't self-critical was only incidental. We both understood, in any case, that it hadn't to do with the difference between abstract and figurative, just as we also understood that the modern wasn't confined to particular styles, modes, or directions of art.)

If the definition of Modernism or the modern that I now offer has any validity, then the crucial word in "postmodernism" becomes "post." The real, the only real, question becomes what it is that's come after and superseded the modern; again, not in a temporal sense, but in a style-historical one. But it's no use, as I said in the beginning, asking the critics and journalists who talk "postmodern" (which includes my friend); they

disagree too much among themselves and resort too much to cloudy generalizations. And anyhow there's nobody among them whose eye I trust.

In the end I find myself having to presume to tell all these people what I think they mean by their talk about the postmodern. That is, I find myself attributing motives to them, and the attributing of motives is offensive. All the same, I feel forced to do so, by the nature of the case.

As I said, Modernism was called into being by the new and formidable threats to aesthetic standards that emerged, or finished emerging, toward the middle of the nineteenth century. The romantic crisis, as I call it, was, as it now seems, an expression of the new situation, and in some ways an expression of the threats themselves insofar as they worked to bring about a confusion of standards and levels. Without these threats, which came mostly from a new middle-class public, there would have been no such thing as Modernism. Again as I said earlier, Modernism is a holding operation, a coping with an ongoing emergency. The threats persist; they are as much there as they ever were. And right now they may have become even more formidable because more disguised, more deceptive. It used to be the easily identifiable philistines who did the threatening. They are still here but hardly matter. Now the threats to aesthetic standards, to quality, come from closer to home, from within it were, from friends of advanced art. The "advanced" used to be coterminous with Modernism, but these friends hold that Modernism is no longer advanced enough; that it has to be hurried on, hurried into "postmodernism." That it will fall behind the times if it continues to be concerned with such things as standards and quality. I'm not manipulating the evidence here in order to make a rhetorical point; just take a look at what these "postmodern" people like and at what they don't like in current art. They happen, I think, to be a more dangerous threat to high art than old-time philistines ever were. They bring philistine taste up-to-date by disguising it as its opposite, wrapping it in high-flown art jargon. Notice how that jargon proliferates nowadays, in New York and Paris and London, if not in Sydney. Realize, too, how compromised words like "advanced," as well as "avant-garde," have become of late. Underneath it all lies the defective eye of the people concerned; their bad taste in visual art.

The making of superior art is arduous, usually. But under Modernism the appreciation, even more than the making, of it has become more taxing, the satisfaction and exhilaration to be gotten from the best new art more hard-won. Over the past hundred and thirty years and more the best new painting and sculpture (and the best new poetry) have in their time

proven a challenge and a trial to the art lover—a challenge and a trial as they hadn't used to be. Yet the urge to relax is there, as it's always been. It threatens and keeps on threatening standards of quality. (It was different, apparently, before the mid-nineteenth century.) That the urge to relax expresses itself in changing ways does but testify to its persistence. The "postmodern" business is one more expression of that urge. And it's a way, above all, to justify oneself in preferring less demanding art without being called reactionary or retarded (which is the greatest fear of the newfangled philistines of advancedness).

The yearning for relaxation became outspoken in presumedly avant-garde circles for the first time with Duchamp and dada, and then in certain aspects of surrealism. But it was with pop art that it became a fully confident expression. And that confidence has stayed in all the different fashions and trends of professedly and supposedly advanced art since then. What I notice is that the succession of these trends has involved, from the first, a retreat from major to minor quality; and a cause for concern about the state of contemporary art is just that: the retreat from the major to the minor, the hailing of the minor as major, or else the claim that the difference between the two isn't important. Not that I look down on minor art, not at all. But without the perpetuation of major art, minor art falls off too. When the highest levels of quality are no longer upheld in practice or taste or appreciation, then the lower levels sink lower. That's the way it's always been, and I don't see that way changing now.

The notion of the postmodern has sprouted and spread in that same relaxing climate of taste and opinion in which pop art and its successors thrive. It represents wishful thinking for the most part; those who talk about the postmodern are too ready to greet it. Yes, if the modern, if Modernism, is over and done with, then there'll be surcease, relief. At the same time art history will have been kept going, and we critics and journalists will have kept abreast of it. But I happen to think that Modernism isn't finished, certainly not in painting or sculpture. Art is still being made that challenges the longing for relaxation and relief and makes high demands on taste (demands that are more taxing because deceptive: the best new art of latter years innovates in a less spectacular way than the best new art used to under Modernism). Modernism, insofar as it consists in the upholding of the highest standards, survives—survives in the face of this new rationalization for the lowering of standards.

(1980)

Beginnings of Modernism

THE TERM "MODERNISM" POINTS TO A HISTORICAL FACT, episode, in Western culture, just as classicism and romanticism do. But there are extrahistorical ways of applying the adjectives "classical" and "romantic"; they can be used to characterize phenomena of any time or place. "Modernist" can't be used with the same freedom; it remains time-bound, more historically specific.

But for all its historical specificity, it's not easy to say when modernism actually began. It used to be viewed as a prolongation of romanticism, of its temper and mood if not of the romantic period as such. This may be partly true, only not true enough to be useful. But I don't propose to try here to extricate the beginnings of modernism from the afterlife of romanticism. That can't be done any more conclusively than extricating the beginnings of romanticism itself from eighteenth-century classicism, let alone neoclassicism (where it's more a matter of differentiation than of extrication).

My subject gets me into a question of classification, which makes me uncomfortable. But how am I to talk about beginnings without distinguishing between what was there in the first place and what came after, and how am I to do this without classification? And then, how is clas-

sification possible without definition? Yet the last thing I want to do is attempt a definition of modernism. I proceed as with art. Art hasn't and probably never will be defined acceptably, yet this doesn't prevent us from telling the difference by and large between art and everything else. We do that by intuition, and I'll say it's the same, at least for the time being, with modernism. We identify modernism too without help of a definition, by intuition. How else settle an argument about whether or not Puvis de Chavannes, say, or Thomas Hardy was a modernist?

Like romanticism, like almost any other broad tendency, modernism emerged at different times in the different arts—but not for the most part in different places. Except in architecture and dance, where modernism came latest, it appeared first in France, and as a driving impulse was exported from France, like Gothic architecture and the *roman courtois* and so much else. (Even in the case of music, where modernism came relatively late, it was still with Debussy, a Frenchman. It came even later—curiously enough—in sculpture: if not with Rodin or even Degas, then with Maillol and Despiau; if not quite with them, then most definitely with Brancusi and Picasso, who, though foreigners, couldn't have done what they did at the time they did without being in and of Paris.)

The notion of modernism comes up first in French literature, "historically" if not conclusively. Gustave Lanson in his monumental and wonderful history of French literature, writes, "It's on Gautier somehow that our literature pivots in order to turn from romanticism toward naturalism." In his equally absorbing history of French literature after 1789, Albert Thibaudet writes that "the term modernism [was] introduced by the Goncourts to convey a form of literary art." At first glance I don't see Gautier as tending toward naturalism any more than the Goncourts as tending toward what I would recognize as modernism. But then I realize that my focus is too narrow. Widening it, I see that naturalism, a more detached, more impassive realism, did lie somehow at the origins of modernism in French fiction. Flaubert is there to tell me that: the first modernist in whatever art or medium. Flaubert the key: as much the first art-for-art's-sakeist as Gautier, and far more the first naturalist, Lanson's pivot or hinge.

A contradiction seems to be on its way here, but it gets resolved even as it gets started. Art for art's sake and naturalism did not have to be in opposition, and turned out not to be, most readily in painting. (Henri Zerner and Charles Rosen, in the *New York Review of Books*, 4 March

1982, are enlightening here, up to a point.) If any poet, moreover, was a "naturalist" it was Baudelaire, who was at the same time an art-for-art's-sakeist before he was anything else, along with Flaubert. But I mustn't be unjust to Gautier: both other writers felt him as *the* initiator of their early support, which does back up Lanson, if not quite in the way he meant.

Flaubert, Baudelaire, maybe Gautier, maybe other French writers were there first. But as an unmistakable, full-fledged fact, as a phenomenon that declared itself as radically new, modernism arrived only in Manet's paintings of the early 1860s. Nowhere before did it announce itself so definitely as in Manet's sheer handling of his *medium*. This, without proclamation, without program (but then modernism never knew a program, not when it was the real thing; all it knew was an ideal: "pure" art, illusory in itself, but immensely useful, as it proved, insofar as it served as something like a beacon). So modernism proclaimed itself most clearly at first in terms of technique, technique in the most immediate, concrete sense. That's how Manet breaks with recent precedent more momentously than any contemporary in his or any other of the arts. (Not that he broke continuity of tradition. Harking back to a more than recent past in Spanish painting, he found himself compelled to leap into the future. Something similar has happened in every important phase of modernist art since then—and, as Berenson has pointed out, it had happened often enough before then; it's not peculiar to modernist art.)

To be sure, Baudelaire and Flaubert innovated in terms of medium handling, but not by far so radically or momentously. If innovation is measured by shock, it was their explicitness about sex that alone created shock. They weren't hard to read, whereas Manet was, for a time, hard to *see*. Now it's true that his innovativeness wasn't confined to technique and that he, too, provoked scandal by the "indecency" with which he treated his subjects (though only in two paintings). But the lasting shock had to do with his handling of the medium, nothing else (and it was all that Fromentin, in the 1870s, complained about in Manet). And with the impressionists, in Manet's wake, the shock or scandal was from the start caused by nothing other than the way they used paint.

It's what happened to the medium, in every art: that's what I consider most decisive in fixing the beginnings of modernism. It's the renovation of the medium, of the immediate phenomenal substance, that had largely made modernism the renovation of aesthetic quality by which it justifies itself. Away from such renovation modernism evaporates: what happens

becomes something else—not necessarily something less, by no means, but still no longer or not yet modernism.

Since the mid-nineteenth century some arts have pressed for the more or less radical renovation of their mediums more than others. Notice how comparatively little the medium of prose fiction has needed innovation-cum-renovation in order to maintain quality. Despite Joyce, there's D. H. Lawrence, there's Thomas Mann, there's finally Proust. But here the distinction between what belongs to the medium as such and what doesn't is too fine, and maybe any notion of the medium as such can be too narrow. Whether the same distinction can be made out to be greater or lesser when it comes to poetry would ask for too much space to be discussed in less than a separate talk. And maybe the distinction between what's medium and what isn't in literature is anyhow too Scholastic, too Alexandrian, too far away from the actual experience of literature, to take trouble over. In literature, "content" and "form," technique, or medium swallow one another more immediately than in any other art—though they do the same ultimately in all the other arts too.

It remains, nonetheless, that in music and in visual art the medium declares itself as medium conspicuously enough—up to a point. On the surface music is all medium, all form, all technique, but by the same token all content too. This couldn't be said so immediately of painting or sculpture as long as they remained figurative, representational; nor can it be said of architecture that serves a function. The relative ease—even if factitious under scrutiny—with which the medium in painting could be isolated seems to me a main reason why painting was the first to dive deep into its medium in all its concreteness, so to become the first unmistakably modernist art, and to remain the exemplary one. (See how the painter supplanted the poet as typical bohemian figure, this as the nineteenth century wore along. Not, however, that modernism is to be identified with the bohemia that had emerged long before, in London's eighteenth-century Grub Street, before it did in Paris.)

That sculpture, by contrast, was slow to enter modernism, slower maybe than music, was due above all to its being the least alive of the high arts in the nineteenth century, as it had been in the eighteenth. I find it as simple as that. Well, sculpture was reinvigorated under modernism, finally. (Its case was, curiously, the opposite of music's, which entered modernism so late because it was, with painting and prose fiction, the liveliest of the high arts in the nineteenth century and precisely for that reason, like prose

fiction but unlike painting, needed reinvigoration least. Why painting "needed" it is a question all by itself. My own speculative answer is that painting's great future as "photographic," literal realism was blighted by photography itself. Evidence for that future can be found everywhere in painting, even in Delacroix, all through the middle of the nineteenth century—in Germany, in Italy, in the Lowlands, in Russia, in America, and still other places.) By now sculpture has caught up with painting in point of "advancedness," of modernism, and shares with painting the sphere in which some of the crucial issues of modernism seem being decided. Music now shares that sphere too, and I want to suspect that music, when we look back in time to come, is where those issues will have been most brought out into the open, if not decided. (Modernist music's very lack of a sufficient public seems to me to make its case the exemplary, maybe even the most significant one.)

But to return and to repeat: Manet's compulsion to innovate, like Flaubert's and Baudelaire's, if more urgent, had behind it the same need to be "modern." And along with that went art for art's sake as a product of modernity's heightened, rationalizing awareness of the relation between means and ends: like well-being, like happiness, like the soul's salvation, art finally became recognized as an end in itself. Modernness meant at bottom the means to better art. And better art—not life for the sake of art—is all that art for art's sake meant to begin with (Flaubert to Baudelaire in 1857: "what I like most of all about your book is that art comes first").

The question is why modernity, together with art for art's sake, should have compelled innovation in such a way as it had never, apparently, been compelled before: disturbingly, shockingly, provocatively. There had always been innovation in the arts insofar as they maintained quality. But before modernism innovation had never been so startling (not only in Western but in any other tradition). Yes, originality, the incision of the individual (even when more than one) had always been of the essence to the vitality of art, its quality, its effectiveness. But only with modernism did artistic innovation begin to innovate so disruptively to taste, with such shock, with such disorienting effect. Why? The case has been with us for a hundred-odd years, but still hardly any real attention has been paid to the question it raises.

Every successive move of modernism delivered a shock at first to cultivated, "elite" taste, not just to that of philistines. True, after a generation or so it became assimilated, accepted in each case. Modernist art in almost

every medium turned out to be art as art, at bottom, had been before. This despite all talk about "breaks," revolutions, and so forth. Continuity persisted. And yes, innovation in the arts had been resisted before modernism, not always but often enough. But still, not in the same way, not with an equal shock, not with such outrage. The resistance modernism met at each step was newer than its innovations themselves. Never before, as far as we can tell, had there been such a blocking off of aesthetic reaction, such an initial blindness, deafness, or incomprehension.

The urgency of modernist innovation and the resistance to it were questions that involve one another, as do their answers. Modernism has meant, among other things, the devolution of a tradition. The continued production of superior aesthetic value after the mid-nineteenth century began, turn by turn in most of the arts, to require the devolution, the unraveling—not so much the dismantling—of the Renaissance tradition of commonsense rationality, conformity to ostensible nature (even tonality in music was held to be nature-derived), and conformity, too, to the way things in general seemed to happen. Modernist architecture, which began late, may be an exception: it turned against the Renaissance and historicist revivals precisely because of their "irrationality." And modernist architecture did not so much devolve a tradition as start, suddenly, a new one. The same might be said about modernist dance. But these exceptions don't make it any the less true that devolution is the general rule in modernism, not revolution.

The very fact of devolution might seem to account for the resistance to modernist innovation. Taste, habits, have been disoriented, just as disturbingly as if there had been revolution instead of devolution. And maybe devolution can be more disturbing and disorienting than outright revolution. And maybe devolution can also generate a greater momentum of innovation, a greater urgency. I find it easy to envisage that.

But accounting for the resistance to modernist innovation by the fact of devolution alone doesn't answer the question adequately. If only because the past offers one very clear precedent for creative devolution, at least in the visual arts, that didn't meet resistance. Between the fourth and sixth centuries of our era, Greco-Roman pictorial art underwent a creative devolution that turned it into Byzantine art. Then, too, painting flattened itself out as under modernism. (Greco-Roman pictorial art had been the first and only kind before the Western European to create sculptural, three-dimensional illusion by means of shading-modeling.) Then,

too, what had hitherto been the subordinately decorative infiltrated and finally identified itself with the autonomously pictorial. Sculpture in the round declined and finally disappeared (being prohibited anyway by the Eastern church because it was reminiscent of pagan idols). But sculpture did persist as bas-relief, usually small in scale and shallow-cut, and it did so under the guidance of the pictorial—just as Western sculpture got its new lease on life in this century from bas-relief constructions that emerged from cubist painting at the hands of Picasso. But the parallels between the two creative devolutions stop with their respective receptions.

The late Greco-Roman and then Byzantine devolution was accepted from the first, its products installed straightaway in churches, palaces, other official places. Within architecture, which likewise underwent a creative devolution, it was the same. I'd like to think that this acceptance came about because the devolution was so gradual. Also because it so soon became an evolution, one of a largely new tradition of visual art and architecture. In contrast, the Western devolution had gone very fast: instead of two or three centuries or more, it took place in effect within a matter of years between the 1850s and the 1910s (not that it's finished yet). Never has innovation in the arts gone anywhere nearly so fast. This explains in part the resistance to modernism—but only in part, I think.

The Byzantine devolution-evolution expressed a general and radical change in sensibility, and not only among the upper classes, so it seems. Has modernism expressed a similar change in the West? Yes and no. The change may not have been so general, maybe still isn't: we're too close in time to be able to tell. And whether the modernist devolution means the start of the evolution of a new tradition as the Byzantine devolution did, at least in visual art, remains moot, despite modernist architecture and maybe dance.

Another thing that makes a sharp difference between the two devolutions is that Byzantine art had no competitor or alternative. The production and practice of anything that looked like classical Hellenic or Greco-Roman art had fallen off and finally become extinct, for whatever reasons. Renaissance-adherent art continued, and still continues, in the presence of modernism: I mean "faithfully" representational art, which still produces work of at least minor significance. There is an analogous situation in literature, and maybe in music. And I feel that the existence of Renaissance-adherent art as a living, productive, even creative alterna-

tive has had much to do with the resistance to modernism—although I wouldn't maintain that it's been crucial.

The question stays open. Such attempts to answer it as I've made don't satisfy me enough. The case is too historically unique. There's been *creative* devolution in all the arts under modernism, as there wasn't in Byzantium; there Hellenic literacy tradition did not only devolve, it declined and failed for the most part. The parallels with Western modernism are evident in visual art and architecture alone. The adequate explanation of the resistance to modernism, as well as of the urgency and dynamism of modernist innovation, has still to be sought.

That over the last two decades the art-interested public, along with officialdom, has turned around and now embraces the *idea* of modernist innovation—but without being aware of its point, the maintaining of aesthetic value—hardly affects the matter. This turnaround has become a problem all by itself, but only within the larger one I've been wrestling with.

(1983)

II

. .

STATES OF CRITICISM

. .

Necessity of "Formalism"

• •

THERE IS THE COMMON NOTION OF MODERNISM as something hectic, heated. Thus Irving Howe lists among the "formal or literary attributes of modernism" the fact that "Perversity—Which Is to Say: Surprise, Excitement, Shock, Terror, Affront—Becomes a Dominant Motif" (subhead in his introduction to a collection of essays by various hands called *The Idea of the Modern in Literature and the Arts* [New York, 1967]). A related notion is that modernism can be understood as an extreme version of romanticism. But a long look at modernism doesn't bear out either notion as a covering one.

Modernism is as specific a historical phenomenon as romanticism was, but it doesn't represent nearly so specific an attitude, position, or outlook. Modernism may continue certain aspects of romanticism, but it also reacts against romanticism in general—just as in reviving certain aspects of classicism it reacts classicism in general. In the context of what is signified by terms like romanticism and classicism when they are used *unhistorically,* modernism as a whole distinguishes itself by its inclusiveness, its openness, and also its indeterminateness. It embraces the conventional polarities of literary and art history; or rather it abandons them (and in doing so exposes their limited usefulness). Modernism defines itself in the long

run not as a "movement," much less a program, but rather as a kind of bias or tropism: toward aesthetic value, aesthetic value as such and as an ultimate. The specificity of modernism lies in its being so heightened a tropism in this regard.

This more conscious, this almost exacerbated concern with aesthetic value emerges in the mid-nineteenth century in response to an emergency. The emergency is perceived in a growing relaxation of aesthetic standards at the top of Western society, and in the threat this offers to the serious practice of art and literature. The modernist response to this emergency becomes effective because it takes place in actual production rather than in discourse; in fact, it is more conscious in the practice of art than it is in discourse or criticism. This response begins to break with many well-tried conventions and habits, ostensibly a radical break. But for the most part it remains only ostensibly a break and only ostensibly radical. Actually, it's a "dialectical" turn that works to maintain or restore continuity: a most essential continuity, continuity with the highest aesthetic standards of the past. It's not particular past styles, manners, or modes that are to be maintained or restored, but standards, levels of quality. And these levels are to be preserved in the same way in which they were achieved in the first place: by constant renewal and innovation.

The emergency has proved to be a lasting one, and modernism a lasting response to it. And so far it has been a more or less successful response. The higher standards of the past have been maintained in production, which does not have to mean that the best of the past has been matched in quality in a point-for-point way; it suffices that the best of modernist production attains a similar qualitative level.

The modernist preoccupation with aesthetic value or quality as an ultimate is not new in itself. What makes it new is its explicitness, its self-consciousness, and its intensity. This self-consciousness and intensity (together with the nineteenth century's increasing rationality in fitting means to ends) could not but lead to a much closer and larger concern with the nature of the medium in each art, and hence with "technique." This was also a questioning concern, and because it got acted on in practice by artists, poets, novelists, and composers, not by pedants, it could not but become an "artisanal" concern too (which does not mean the same thing as a "mechanical" concern—or at least the best of modernism has shown that it does not mean the same thing). And it's this, the artisanal concern and emphasis of modernism, that has proved to be

its covering emphasis, its enduring and also its saving one—the one that again and again brings modernism back to itself.

Its artisanal emphasis is what more than anything else makes for the hard-headed, sober, "cold" side of modernism. It's also part of what makes it react against romanticism. An eventual tendency of romanticism was to take medium and artisanry too much for granted and to consider them as more or less transparent or routine. I won't say that this was a decisive factor in the deterioration of standards, but it was a symptom of that deterioration. It was not just the soft-headedness of romanticism popularized and in decline that provoked the hardheaded reaction of the first modernists; it was also a certain unprofessionalism.

I don't for a moment contend that modernism is exclusively an affair of hardheadedness and artisanal sobriety. I started out by saying that it distinguishes itself by its openness and inclusiveness of temper and attitude. And I set out to correct, not demolish, what I feel is too one-sided a view. Yet this view almost invites demolition when it comes to modernist painting and sculpture (and maybe to modernist music too). For these exhibit modernism as almost crucially a concern in the *first* place with medium and exploratory technique, and a very workmanlike concern. Manet and the impressionists were paragons of hardheaded professionalism; so was Cézanne in his way, and so were Seurat and Bonnard and Vuillard; so were the fauves—if ever there was a cool practitioner, it was Matisse. Cubism was overwhelmingly artisanal in its emphasis. And this emphasis remains a dominant one, under all the journalistic rhetoric, in abstract expressionism and *art informel.* Of course, Apollonian temperaments may produce Dionysian works, and Dionysian temperaments Apollonian works. Nor does artisanal hardheadedness exclude passion; it may even invite and provoke it. And of course, there were notable modernist artists like Gauguin and van Gogh and Soutine who were anything but soberly artisanal in outlook; but even they occupied themselves with questions of "technique" to an extent and with a consciousness that were uniquely modernist.

Artisanal concerns force themselves more evidently on a painter or sculptor than on a writer, and it would be hard to make my point about the artisanal, the "formalist" emphasis of modernism nearly so plausible in the case of literature. For reasons not to be gone into here, the medium of words demands to be taken more for granted than any other in which art is practiced. This holds even in verse, which may help explain why

what is modernist and what is not cannot be discriminated as easily in the poetry of the last hundred years as in the painting.

It remains that modernism in art, if not in literature, has stood or fallen so far by its "formalism." Not that modernist art is coterminous with formalism. And not that formalism hasn't lent itself to a lot of empty, bad art. But so far every attack on the "formalist" aspect of modernist painting and sculpture has worked out as an attack on modernism itself because every such attack developed into an attack at the same time on superior artistic standards. The recent past of modernist art demonstrates this ever so clearly. Duchamp's and dada's was the first outright assault on "formalism" that came from within the avant-garde, or what was nominally the avant-garde, and it stated itself immediately in a lowering of aspirations. The evidence is there in the only place where artistic evidence can be *there:* in the actual productions of Duchamp and most of the dadaists. The same evidence continues to be there in the neo-dadaism of the last ten years, in its works, in the inferior quality of these works. From which it has to be concluded that if modernism remains a necessary condition of the best art of our time, as it has been of the best art of the hundred years previous, then formalism, apparently, remains a necessary condition too, which is the sole and sufficient justification of either modernism or formalism.

And if formalism derives from the hardheaded, "cold" side of modernism, then this must be its essential, defining side, at least in the case of painting and sculpture. That's the way it looks right now—and looks more than ever right now. The question is whether it will keep on looking that way in the future: that is, whether modernism will continue to stand or fall by its cold side and by its formalism. Modernism has been a failing thing in literature these past twenty years and more; it's not yet a failing thing in painting or sculpture, but I can imagine its turning into that in another decade (even in sculpture, which seems to have a brighter future before it than painting does). If so, this may come about in the same way that it has come about, it seems to me, in literature: through the porousness of modernism's "hot" side, the enthusiastic and hectic side, which is the one that middlebrows have found it easier all along to infiltrate.

There have, of course, to be deeper, larger factors in all this than the ambiguous difference between modernism's hot and cold sides. If modernism's hot side has become a liability in these past years, this is a symptom,

not a cause; the cause, or causes, have to be sought outside modernism and outside art or literature.

Postscriptum

Art is, art gets experienced, for its own sake, which is what modernism recognized in identifying aesthetic value as an ultimate value. But this doesn't mean that art or the aesthetic is a *supreme* value or end of life. The neglect of this distinction by the original art-for-art's-sakers—most of whom were not modernists anyhow—compromised a valid perception.

Post-Postscriptum

My harping on the artisanal and "formalist" emphasis of modernism opens the way to all kinds of misunderstanding, as I know from tiresome experience. Quality, aesthetic value originates in inspiration, vision, "content," not in "form." This is an unsatisfactory way of putting it, but for the time being there seems to be no better one available. Yet form not only opens the way to inspiration, it can also act as means to it; and technical preoccupations, when searching enough and compelled enough, can generate or discover content. When a work of art or literature succeeds, when it moves us enough, it does so ipso facto by the content which it conveys; yet that content cannot be separated from its form—no more in Dante's than Mallarmé's case, no more in Goya's than in Mondrian's, no more in Verdi's than in Schoenberg's. It embarrasses me to have to repeat this, but I feel I can count here on the illiteracy of enough of my readers in the matter of what can and what can't be legitimately put in words about works of art.

(1971)

Can Taste Be Objective?

• •

THE WORD "TASTE" (*gusto* in both Italian and Spanish) entered the discussion of art in the seventeenth century. In the eighteenth it became the hard-and-fast word for the faculty of aesthetic judgment. It's as though this term, in isolating this faculty, also isolated and brought into focus most of the problems connected with that faculty: problems that were, as far as the understanding was concerned, the crucial ones involved in the experiencing of art.

I've used the word "problem" in the plural; maybe I should use it in the singular. For the crucial problems involved in the experiencing of art are problems of taste, and the problems of taste boil down to one: namely, whether the verdicts of taste are subjective or objective. This is the problem that haunted Kant in his *Critique of Aesthetic Judgment*, and he stated it better than anyone I know of has since. He acknowledges its importance, returns to it again and again, and in exhibiting the difficulties of the problem faces up to them.

He doesn't solve the problem satisfactorily. He posits a solution without proving it, without adducing evidence for it. He deduces his solution from the principles of his "transcendental psychology," and it's a wonderful deduction but it doesn't really advance the argument that the verdicts

of taste can be, and should be, objective. Kant believed in the objectivity of taste as a principle or potential, and he postulated his belief on what he called a *sensus communis,* a sense or faculty that all human beings exercised similarly in aesthetic experience. What he failed to show was how this universal faculty could be invoked to settle disagreements of taste. And it's these disagreements that make it so difficult to assert the potential or principled objectivity of taste.

Kant's failure in this direction may have had a good deal to do with what looks like the general abandonment of the problem of taste or aesthetic judgment on the part of philosophers of art after his time. The last two hundred of the six hundred pages of Gilbert and Kuhn's meritorious *History of Esthetics* (Indiana University Press, 1953) contain only three fleeting mentions of the word "taste," and none at all of "esthetic judgment." But I think that the romantic exaltation of art may have had even more to do with this. That art could be and was subjected to judgment and evaluation came to be felt as unseemly; or at least the open acknowledging of this came to be felt as that. The word taste itself acquired prosaic connotations and was increasingly compromised by association with manners, clothes, furniture. It became too mundane a notion to be connected with anything so spiritual and exalted as the romantic conception of art.

Not that taste didn't, and doesn't, remain as essential in the appreciation, and in the creation, too, of art as it ever was. Not that questions of taste didn't, and don't, enter, even more than in the past, into informal talk about art and the arts; or that assertions deriving from operations of taste, however indirectly, didn't, and don't, come up everywhere in the formal talk and in the writing about art. And not that very much of that talk and writing would, in fact, be possible without presupposing verdicts of taste. All the same, the reluctance to bring the question of taste out into the open again, the coyness about dealing with it, persists.

As I've said, the romantic change in attitude toward art is at the bottom of much of this. But I come back to Kant. After his time the question of the objectivity of taste, of aesthetic judgment, came to seem more insoluble than ever, with or without romantic attitudes to art. There seemed to be less than ever a way of settling disagreements of judgment or appreciation. None of the philosophers who addressed themselves to aesthetics after Kant was quite ready to admit that taste was a subjective matter, but none of them was ready, either, to try to show that it wasn't. As far as I know, they avoided the question or else only pretended to tackle it. Some

had the courage to dismiss it explicitly. Grant Allen, a not unknown in-
quirer into aesthetics of the later nineteenth century, held that it was an
advantage from the scientific point of view to be without strong prefer-
ences in art (he may not have been wrong in some of the reasons he gave).
But even Croce—the philosopher of aesthetics I've found more in than
anyone since Kant—escaped into what I make out as double-talk when
it came to the objectivity of taste. Santayana simply evaded the question,
and Suzanne Langer only grazes it, if she even does that. Harold Osborne
doesn't evade or graze, but somehow still fails to meet it head-on.

The question continues to be suppressed, evaded, or merely grazed. I
wouldn't claim that the failure to deal conclusively with the issue of taste and
its objectivity is alone or even mainly responsible for some of the startling
features of recent art and of recent discussion of art. But I think it is partly
responsible—at a distance as it were; the shunting away of the whole ques-
tion does make certain things more permitted than they would otherwise
be. There are artists now who confidently dismiss taste as irrelevant. And
art critics who say out loud that judgments of value are beneath them,
being the affair of "reviewers," not of critics proper. It certainly has been
taken for granted for a while now that art critics—and literary critics, too,
for that matter—can maintain themselves more than respectably without
having to tell, or being able to tell, the difference between good and bad.
At the same time words like "connoisseur" and "connoisseurship" have
come to sound old-fashioned and even pejorative. Add to this the busi-
ness about "elitism," which is in effect the argument that taste should no
longer be decisive because the art it elevates has so little to do with life as
lived by the common man. It used to be that only philistines said this sort
of thing, but now it's said by people, including artists, who don't other-
wise talk or act like philistines.

And yet taste continues to be decisive and maybe more obviously so
than ever before (at least in the West)—that is, if you look at what actually
happens to, with, and in art, and pay less attention to what's proclaimed
about it by up-to-date persons in up-to-date situations. Art that used to
be valued for all sorts of nonaesthetic reasons (religious, political, na-
tional, moral) has lost its hold on the cultivated public almost entirely, or
else its nonaesthetic significance has been more and more discounted in
favor of its purely aesthetic value, whatever that might be. (It could be Fra
Angelico's or it could be Maxfield Parrish's.) And as this happens differ-
ences of taste fade into one another; the agreements become more impor-

tant and conspicuous than the disagreements. Actually, this is what has been happening all along, in one way or another. As far back as we can see into the past, agreement has been overcoming disagreement. The solution of the question of the objectivity of taste stares you in the face. It's there in the record, as well as in all the implicit assumptions on which the making and the experiencing of art have proceeded since time immemorial.

In effect—to good and solid effect—the objectivity of taste is probatively demonstrated in and through the presence of a consensus *over time*. That consensus makes itself evident in judgments of aesthetic value that stand up under the ever-renewed testing of experience. Certain works are singled out in their time or later as excelling, and these works continue to excel; that is, they continue to compel those of us who in time after look, listen, or read hard enough. And there's no explaining this durability— the durability which creates a consensus—except by the fact that taste is ultimately objective. The best taste, that is; that taste which makes itself known by the durability of its verdicts; and in this durability lies the proof of its objectivity. (My reasoning here is no more circular than experience itself.) It remains that the people who look, listen, or read hard enough come to agree largely about art over the course of time—and not only within a given cultural tradition but also across differences of cultural tradition (as the experience of the last hundred years teaches us).

The consensus of taste confirms and reconfirms itself in the durable reputations of Homer and Dante, Balzac and Tolstoy, Shakespeare and Goethe, Leonardo and Titian, Rembrandt and Cézanne, Donatello and Maillol, Palestrina and Bach, Mozart and Beethoven and Schubert. Each succeeding generation finds that previous ones were right in exalting certain creators—finds them right on the basis of its own experience, its own exercise of taste. We in the West also find that the ancient Egyptians were right about Old Kingdom sculpture, and the Chinese about T'ang art, and the Indians about Chola bronzes, and the Japanese about Heian sculpture. About these bodies of art, *practiced* taste—the taste of those who pay enough attention, of those who immerse themselves enough, of those who try hardest with art—speaks as if with one voice. How else account for the unanimity, if not by the ultimate objectivity, of taste?

It's the record, the history of taste that confirms its objectivity, and it's this objectivity that in turn explains its history. The latter includes mistakes, distortions, lapses, omissions, but it also includes the correcting and repairing of these. Taste goes on making mistakes, and it also goes on

correcting them, now as before—now maybe even more than before. Amid it all, a core consensus persists, forming and re-forming itself—and growing. The disagreements show mainly on the margins and fringes of the consensus and have to do usually with contemporary or recent art. Time irons these disagreements out, progressively. Within the core, certain disagreements will continue, but only about ranking: Is Titian or Michelangelo the better painter? Is Mozart or Beethoven the better composer?

Disagreements of this kind assume fundamental agreement about the names concerned: that they are among the supreme ones. The implicitness of this fundamental agreement is borne out at every turn. You may find Raphael too uneven or Velázquez too cold, but if you can't see how utterly good they are when they are good you disqualify yourself as a judge of painting. In other words, there are objective tests of taste, but they are utterly empirical and can't be applied with the help of rules or principles.

It's the best taste that, as I've already indicated, forms the consensus of taste. The best taste develops under the pressure of the best art and is the taste most subject to that pressure. And the best art, in turn, emerges under the pressure of the best taste. The best taste and the best art are indissoluble. Well, how do you in your own time identify the bearers of the best taste? It's not all that necessary. In time past the best taste could have been diffused through a whole social class, or a whole tribe. In later times it may or may not have been the possession of a coterie—like the cognoscenti in and around the Vatican in the early 1500s, or the circles in which Baudelaire mixed in the mid-nineteenth century. But it would be wrong on the whole to try to pin the best taste of a given period to specific individuals. I would say it works more like an atmosphere, circulating and making itself felt in the subtle, untraceable ways that belong to an atmosphere. At least that's the way it seems, in the absence of closer investigation. The most that is safely known is that the best taste, cultivated taste, is not something within the reach of the ordinary poor or of people without a certain minimum of comfortable leisure. (Which happens to be true of the highest fruits in general of civilization, and it doesn't change the nature of those fruits, however much the human cost of them may be deplored, or however clearly it is recognized that art and culture are not supreme values.)

Anyhow, we know the best taste well enough by its effects, whether or

not we can identify those who exercise it. And through these effects the consensus of taste makes itself a fact, and makes the objectivity of taste a fact—an enduring fact. The presence of this fact is what's primary, not so much the names of the particular individuals who, as exponents of the best taste, continue to create the fact.

The philosophers of art must have been aware from the first of something like a consensus of taste, however dimly. What I wonder about is why they didn't become more definitely aware of it and take it more into account, with its implications. Had they done so they would, I think, have had no choice but to exclude once and for all the possibility that taste is ultimately subjective. (As if Homer's standing, or Titian's or Bach's, could have been the outcome of the accidental convergence of a multitude of strictly private, solipsistic experiences.)

It's Kant's case, I believe, that may offer the best clue as to why the consensus of taste hasn't been taken seriously enough: it was solely a matter of record, too simply a historical product. To found the objectivity of taste on such a product would be proceeding too empirically, and therefore too unphilosophically. Philosophical conclusions were supposed to catch hold in advance of all experience; they were supposed to be arrived at through insulated reasoning, to be deduced from premises given a priori. This isn't my own view of philosophy, nor is it the view of many philosophers themselves, including Hume, Kant's predecessor. But, as it seems to me, it's a view that has infected the investigation of aesthetics even among empirical philosophers. They, too, have tended to start from the inside of the mind and try to establish aesthetics on the basis of first mental or psychological principles. It was well and good for Kant to postulate a *sensus communis* on the basis of experience—empirically, that is. (And who knows but that experimental psychology may not bear his postulate out in some scientific detail in some unforeseeable future?) But his deductions from the postulate didn't advance his case much; what they showed mostly is that we *want* to agree in our aesthetic judgments and may be justified in so wanting. He could have clinched his case for the time being—and for some time to come too—by remaining content to point to the record, the empirical record, with the consensus of taste that it showed. And he could also have pointed to how that consensus of taste showed that most important disputes of taste did get settled in the shorter or longer run. But he would have had to recognize then, I think, that they

got settled through experience *alone*—as far as anybody could tell. And with the recognition that experience alone demonstrates and vouches for the objectivity of taste, he would have had to leave the question.

I realize that I take my life in my hands when I dare to say that I've seen something better than Kant did—Kant, who, among so many other things he did, came closer to describing what went on in the mind when experiencing art than anyone before or anyone after him. I can plead in justification of my brashness only that close to two hundred years of art since his time have expanded and clarified.

Closer to our own time, psychologists have been trying by experimental methods to discover constants in aesthetic appreciation that would enable them, presumably, to predict, if not describe, the operations of taste. Some habits of aesthetic perception or reflex have been ascertained. It has been discovered that most people, across most cultural divisions, prefer blue to other colors; and that certain relations of sound tend, at least in the West, to be preferred by most people—and so on. But nothing has been ascertained so far that bears usefully on the way in which practiced taste works or that says anything really useful about the objectivity of taste.

In the meantime I keep wondering, again, why the consensus of taste, with all it says for the objectivity of taste, goes so unmentioned in the recorded controversies about aesthetic questions that have been carried on *outside* formal philosophy. All the reputations that have come down to us form a kind of pantheon. There the masters are, and they are there by virtue of what has to be a consensus of taste, and nothing else. The fact of that consensus should loom in the awareness of anyone seriously interested in art or music or literature or dance or architecture. Yet somehow it remains unregistered at the same time that it remains implicit and necessary. It's not referred to all the while that it's proceeded upon; all the while that the activity of art and around art, as we know it, would be unthinkable without the presence of the consensus. When I say "unregistered" I mean without being brought to clear consciousness and without being invoked as a given on which an argument can be built. And so the common, objective validity of aesthetic judgments continues to be disputed—and not just as a demonstrable fact, but even as a possibility.

Art can do without taste: I hear voices from as far back as 1913 saying this. What they mean, without knowing it, is that art can do without art; that is, art can do without offering the satisfactions it alone can offer.

That's what art doing without taste really means. Well, if the satisfactions exclusive to art are dispensable, why bother with art at all? We can go on to something else. (And there are, after all, things more valuable than art, as I myself would always insist.) But meanwhile we're talking about art.

(1972)

Abstract, Representational,

and So Forth

· ·

THE TENDENCY IS TO ASSUME that the representational as such is superior to the nonrepresentational as such; that all other things being equal, a work of painting or sculpture that exhibits a recognizable image is always preferable to one that does not. Abstract art is considered to be a symptom of cultural, and even more, decay, while the hope for a "return to nature" gets as taken for granted by those who do the hoping as the hope for a return to health. Even some of the apologists for abstract art, by defending it on the plea that an age of disintegration must produce an art of disintegration, more or less concede the inherent inferiority of the nonrepresentational. And those other apologists who claim, rightly or wrongly, that abstract art is never entirely abstract, are really conceding the same. One fallacy usually gets answered by another; and so there are fanatics of abstract art who turn the argument around and claim for the nonrepresentational that same absolute, inherent, and superior virtue which is otherwise attributed to the representational.

Art is a matter strictly of experience, not of principles, and what counts first and last in art is quality; all other things are secondary. No one has yet been able to demonstrate that the representational as such either adds or takes away from the merit of a picture or statue. The pres-

ence or absence of a recognizable image has no more to do with value in painting or sculpture than the presence or absence of a libretto has to do with value in music. Taken by itself, no single one of its parts or aspects decides the quality of a work of art as a whole. In painting and sculpture this holds just as true for the aspect of representation as it does for those of scale, color, paint quality, design, etc., etc.

It is granted that a recognizable image will add conceptual meaning to a picture, but the fusion of conceptual with aesthetic meaning does not affect quality. That a picture gives us things to identify, as well as a complex of shapes and colors to behold, does not mean necessarily that it gives us more as *art*. More and less in art do not depend on how many varieties of significance are present, but on the intensity and depth of such significances, be they few or many, as are present. And we cannot tell, before the event—before the experience of it—whether the addition or subtraction of conceptual meaning, or of any other given factor, will increase or diminish the aesthetic meaning of a work of art. That *The Divine Comedy* has an allegorical and anagogic meaning, as well as a literal one, does not necessarily make it a more effective work of literature than *The Iliad,* in which we really discern no more than a literal meaning. The explicit comment on a historical event offered in Picasso's *Guernica* does not make it necessarily a better or richer work than an utterly "nonobjective" painting by Mondrian.

To hold that one kind of art must invariably be superior or inferior to another kind means to judge before experiencing; and the whole history of art is there to demonstrate the futility of rules of preference laid down beforehand: the impossibility, that is, of anticipating the outcome of aesthetic experience. The critic doubting whether abstract art can ever transcend decoration is on ground as unsure as Sir Joshua Reynolds was when he rejected the likelihood of the pure landscape's ever occasioning works as noble as those of Raphael.

Ambitious, major painting and sculpture continue in our time, as they always did in the past, by breaking with fixed notions about what is possible in art and what is not. If certain works of Picasso as well as Mondrian deserve to be considered *pictures,* and certain works of Gonzalez as well as Pevsner deserve to be considered *sculpture,* it is because actual experience has told us so. And we have no more reason to doubt the validity of our experience than the contemporaries of Titian had to doubt theirs.

At this point I feel free, however, to turn around and say things perilously like those which I have just denied anyone the right to say. But I will say what I have to say only about the abstract art I already know, not about abstract art in principle.

Freestanding pictorial and sculptural art, as distinct from decoration, was until a short while ago identified wholly with the representational, the figurative, the descriptive. Now it can be properly asked whether, in view of what painting and sculpture have achieved in the past, they do not risk a certain impoverishment by eliminating the representational, the figurative, the descriptive. As I have said, the nonrepresentational is not necessarily inferior to the representational, but is it not too little provided for, nevertheless, by the inherited, habitual, automatic expectations with which we approach an object that our society agrees to call a picture or statue? For this reason, may not even the best of abstract painting still leave us a little dissatisfied?

Experience, and experience alone, tells me that representational painting and sculpture have rarely achieved more than minor quality in recent years, and that major quality gravitates more and more toward the non-representational. Not that most of recent abstract art is major; on the contrary, most of it is bad, but this still does not prevent the very best of it from being the best art of our time. And if the abstract is indeed impoverishing, then such impoverishment has now become necessary to important art.

But may it not be, on the other hand, that our dissatisfaction with abstract art—if it is a dissatisfaction—has its source not so much in our nostalgia for the representational, as in the relatively simple fact that we are unable to match the past no matter how we paint or sculpt? May it not be that art in general is in decline? But if this is so, the dogmatic opponents of abstract art would be right only by accident, and on empirical, not principled or theoretical grounds; they would be right, not because the abstract in art is invariably a symptom of decline, but simply because it happens to accompany decline at this moment in the history of art, and they would be right only for this moment.

The answer may be even simpler, however, and at the same time more complicated. It may be that we cannot yet see far enough around the art of our own day; that the real and fundamental source of the dissatisfaction we may feel with abstract painting lies in the not uncommon problems offered by a new "language."

From Giotto to Courbet, the painter's first task had been to hollow out an illusion of three-dimensional space on a flat surface. One looked through this surface as through a proscenium onto a stage. Modernism has rendered this stage shallower and shallower until now its backdrop has become the same as its curtain, which has now become all that the painter has left to work on. No matter how richly and variously he inscribes and folds this curtain, and even though he still outlines recognizable images upon it, we may feel a certain sense of loss. It is not so much the distortion or even the absence of images that we may mind in this curtain-painting, but rather the abrogation of those spatial rights which images used to enjoy back when the painter was obliged to create an illusion of the same kind of space as that in which our bodies move. This spatial illusion, or rather the sense of it, is what we may miss even more than we do the images that used to fill it.

The picture has now become an entity belonging to the same order of space as our bodies; it is no longer the vehicle of an imagined equivalent of that order. Pictorial space has lost its "inside" and become all "outside." The spectator can no longer escape into it from the space in which he himself stands. If it deceives his eye at all, it is by optical rather than pictorial means: by relations of color and shape largely divorced from descriptive connotations, and often by manipulations in which top and bottom, as well as foreground and background, become interchangeable. Not only does the abstract picture seem to offer a narrower, more physical, and less imaginative kind of experience than the illusionist picture, but it also appears to do without the nouns and transitive verbs, as it were, of the language of painting. The eye has trouble locating central emphases and is more directly compelled to treat the whole of the surface as a single undifferentiated field of interest, and this in turn compels us to feel and judge the picture more immediately in terms of its overall unity. The representational picture, seemingly (though only seemingly), does not require us to squeeze our reactions within such a narrow compass.

If, as I believe, abstract sculpture meets less resistance than abstract painting, it is because it has not had to change its language so radically. Whether abstract or representational, its language remains three-dimensional—literal. Constructivist or quasi-constructivist sculpture, with its open, linear forms and denial of volume and mass, may puzzle eyes attuned to the monolith, but it does not require them to be refocused.

Shall we continue to regret the three-dimensional illusion in painting?

Perhaps not. Connoisseurs of the future may prefer the more literal kind of pictorial space. They may even find the Old Masters wanting in physical presence, in corporeality. There have been such reversals of taste before. The connoisseurs of the future may be more sensitive than we to the imaginative dimensions and overtones of the literal, and find in the concreteness of color and shape relations more "human interest" than in the extrapictorial references of old-time illusionist art. They may also interpret the latter in ways quite different from ours. They may consider the illusion of depth and volume to have been aesthetically valuable *primarily* because it enabled and encouraged the artist to organize such infinite subtleties of light and dark, of translucence and transparence, into effectively pictorial entities. They may say that nature was worth imitating because it offered, above all, a wealth of colors and shapes, and of intricacies of color and shape, such as no painter, in isolation with his art, could ever have invented. At the same time, these connoisseurs of the future may be able, in their discourse, to distinguish and name more aspects of quality in the Old Masters, as well as in abstract art, than we can. And in doing these things they may find much more common ground between the Old Masters and abstract art than we ourselves can yet recognize.

I do not wish to be understood as saying that a more enlightened connoisseurship will hold that *what*, as distinct from *how*, Rembrandt painted is an indifferent matter. That it was on the noses and foreheads of his portrait subjects, and not on their ears, that he piled the juiciest paint of his last manner has very much to do with the aesthetic results he obtained. But we still cannot say why or how. Actually, my own hope is that a less qualified acceptance of the importance of sheerly abstract or formal factors in pictorial art will open the way to a clearer understanding of the value of illustration as such—a value which I, too, am convinced is indisputable. Only it is not a value that is realized by, or as, *accretion.*

(1974)

Detached Observations

Picture Making

PICTURE MAKING, ONE ART NEVER AT HOME ON COUNTRYSIDE; never a folk, peasant, or tribal art. Whenever and wherever pictures have been made on countryside, it's been under urban influence.

Paintings and engravings of hunters, from Paleolithic on, not pictures proper, but two-dimensional images: self-contained in a way more sculptural then pictorial. When two or more such images are related on the same surface it's in an ideographic rather than pictorial way. This even in Mesolithic and Neolithic "compositions" that show hunting, fighting, or ceremonial "scenes"; there, flat and schematic images hang apart in space that's somewhere between the two- and three-dimensional. Pictorial space joins and contains, and by containing makes everything it shows discontain itself and surrender itself to a unity, which in turn contains itself.

Picture making, not just picturing or depicting. More a question of delimiting and unifying a surface. As abstract art has shown, any kind of mark, any kind of inflection on any kind of surface, can serve to make a picture.

I'm not hypostatizing a notion of picture or the pictorial (though I am

wrenching the word "picture" from its etymological roots). Matter of sheer experience: experience of the pictorial is of its own specific and recognizable kind. Not that there's a hard-and-fast line between pictorial and nonpictorial; within the medium of the two-dimensional, categories and classifications overlap and merge, just as they do everywhere else in art, or in any given medium of art. Experience only guide here, not definitions or descriptions or anything else in nature of a concept. There's no *essence* of the pictorial either, only limiting or necessary and enabling or sufficient conditions—as registered by experience.

(Don't want to be understood as implying that pictorial, because it's an exceptional category of aesthetic experience in that it depends on urbanness, is therefore an inherently superior category in point of aesthetic value. Nothing of the sort. As Croce emphasized once and for all, no category, form, class, or medium of art is inherently, or apodictically, superior in aesthetic value to any other.)

Rub in my argument—if it is an argument—comes from the fact that anything on a surface can now be experienced as picture. Eye alone, without the hand, without the intervention of anything more material than eyesight, can provide the limiting and enabling conditions of the pictorial. Habits, "training," previous experience of the beholder make all the difference (in all the arts). All the difference, that is, in the creating of categories of aesthetic experience, but not in the creating of aesthetic value or quality. You can decide to see anything as a picture—just as the camera can make anything visible into a picture—but you can't decide to see it as a good or as a bad picture. That is, you can control and direct your attention, but you can't control the actual experience you have as a result of the controlling and directing of your attention. (Nor is attention itself always amenable to control; it does get *caught,* aesthetically as well as otherwise, and when it gets caught aesthetically it gets caught by aesthetic experience in such a way that there's no distinguishing between the act of attention and the experience had as a result of this act. But this is getting off into deep water.)

Did the making of pictures proper have to wait for the advent of writing, which is another practice that began only in town or city? Did the way in which writing gets organized physically, in lines and then in self-enclosed rectangles, make two-dimensional picturing (and bas-relief) follow suit? What seems likely is that, just as writing was made more readily intelligible by being made orderly in spatial respects, so the con-

nections among images were. It became no longer enough to establish two-dimensional or relieved images in isolation more or less, with the meant relations between them being implied. Now these relations had to be made more explicit, had to declare themselves in a more contained, more specifically limited physical context and frame. Thus one reason the picture replaced the two-dimensional image would be because it communicated more efficiently. There had to be other reasons or factors, but these too can only be speculated about.

If Christianity is the most urban in origin of all major religions, then it seems appropriate that it should be the one to cultivate the pictorial most. As it certainly has. Pictures—portable pictures and mural pictures—have gone wherever Christianity has as with no other big religion (or even culture). Not even with Tantric Buddhism. Christianity, and Christianity alone, brought wall pictures into Ethiopia. Spasms of iconoclasm have made no difference. Even the strictest of Puritans seem to have construed Old Testament iconoclasm as applying only to three-dimensional likenesses.

SHADING-MODELING

Used only in Greco-Roman and Western pictorial art in a thoroughgoing and integral way. I mean sculptural shading, shading-modeling that goes from light to dark to create an illusion of third-dimensionality, of volume and unevenness of surface. Far Easterners knew how to shade in this way, but did so only gingerly (never applying it to depictions of human beings or animals). That Indian painters during the high Buddhist period (Ajanta) shaded somewhat more freely could be attributed, I suppose, to Greco-Roman influence, as remote as it was by that time. I sense that the Persian miniaturists knew how to shade sculpturally too, though I might be hard put to show real evidence of that.

Paleolithic artists in southwestern Europe and "Bushmen" artists in Africa did use a quasi-impressionist kind of shading, by differences of hue more than by gradations of light and dark. This kept the image or depiction "light"—the way, for that matter, almost all picturing outside Europe has tended to be. Only the Greco-Romans and Westerners seem to have been willing to let a depiction or a picture get "heavy" with the relief effects achieved by thoroughgoing sculptural shading: the stereoptical bulging and receding.

Photography shades with gradations of light and dark, even color photography, where the shading will brown, gray, or blacken local color

in much the same way it does in postmedieval Western European paint-
ing. But photography stays "light" all the same. Not just because of the
smallness of the usual photographic print but more importantly, I think,
because of how the shading sticks to the surface, lets itself be flattened
by the surface, get embedded and become one with the surface, instead
of resting on and coating it, which is what oil and even tempera do, and
fresco, in Western hands, has usually been made to do (though nothing
can match oil for real "heaviness"). Curious and yet not so curious: early
photography, for technical reasons, met the then current taste in the West
for "heaviness"; since then it has met the more modern taste for "light-
ness," again for technical reasons.

But what about Western watercolors and prints? Don't they stay "light"
and yet bulge and give with shading the way oil painting does? Yes and no.
But maybe the "no" doesn't matter. Vision, ways of looking and feeling,
can overcome almost any circumstances of a medium. Though not neces-
sarily in the interests of aesthetic value. But in this case, yes. I'll say that it's
the combination of "heaviness" with lambency that makes for the supreme
distinction of Western watercolors, prints, and drawings. Rembrandt, who
did a lot in his late drawings and etchings that he couldn't quite match in
most of his late figure compositions.

Greco-Roman and Western "heavy" painting sees more three-
dimensionality, more relief, in nature than the eye does. The eye sees
more relief, as well as more in the way of depth, than the camera does
(given that the latter can't focus with the same freedom and that what it
sees it has to see on a flat surface). But it seems to me that the eye still sees
more like the camera than like "heavy" painting. "Heavy" painting digs
in for the third dimension as the eye doesn't—because it doesn't need to;
"heavy" painting has to make an emphatic point of the third dimension;
it can't just indicate it; the eye knows it's there and makes do with hints.
(The impressionists realized this, I feel, without saying it aloud.) "Heavy"
pictorial art, even in drawings and watercolors, model-shades beyond the
point of necessity as it were (and darkens cast shadows too beyond the
point of necessity; for that matter it's only "heavy" art, along with photog-
raphy, that sees cast shadows).

It's arguable that geometric perspective was devised not primarily to ex-
pand spatial illusion but to accommodate sculptural illusion; that sculptur-
al, plastic illusion demanded and forced the systematizing of perspective. It
may be that the Chinese didn't formalize their perspective geometrically

because such sculptural shading as they did use (as in the depicting of tree trunks and rocks) didn't need to be accommodated and organized by it.

The only possible instance of "heavy" pictorial art I know of which isn't full-bodiedly illusionist is Byzantine (and Russian icon painting in its wake). And what a curious instance it is. The scheme of Greco-Roman sculptural shading is stood on its head and made to serve effects that largely deny illusion. The gradations of light and dark are rendered as successions of flat strips or bands that do more to affirm the impenetrability of the surface than to ease it. The "heaviness" here, if it is heaviness, seems due mostly to "decorative" loading and a forceful backdrop that remains a backdrop. Byzantine wall art bulges by virtue of radiance, not plasticity, and I'm not sure it really can be accounted as "heavy": light does, after all, stay light. This may not be true of the frescoes (of which I've seen very few) as against the mosaics; in the frescoes the color itself is "heavy," and all the heavier because on a large scale. All the same, I would have to say that the "heaviness" of Western and Greco-Roman pictorial art still seems something quite different, by virtue of the integral presence of sculptural shading, which is what really puts meaning into the word "heavy" as I've used it here.

One more word about photographic illusion. The television tube, especially when confined to black and white, can body forth a remarkably vivid illusion of relief if not of space. It outdoes the printed photograph in this respect. And so does the movie screen. The reasons are obvious: a transparent or reflecting support lends itself better to illusion than an opaque and nonreflecting one. I don't mean to imply that the superior illusionism of TV and movies confers greater artistic value. Once again: mediums or categories of art have nothing inherently superior or inferior about them as far as quality is concerned. This doesn't keep me from saying that there's a sheer aesthetic pleasure to be gotten from sheer illusion that can't be gainsaid. I've gotten such pleasure from old stereopticon views, and I got it from the plastic "renderings" of the human body I saw, watching wrestling matches on black-and-white TV twenty years ago; these "renderings" rivaled anything I've known of in the way of two-dimensional plastic definition; not only did they "keep the plane," sometimes even the framing of the TV tube worked beautifully. Whether color television can do as well, I can't say—not yet, though I've seen some remarkable pictures in that medium too, but remarkable in a different way, one that has less to do with sculptural illusion and for which I can find only a scant precedent

in the mannerism of Rosso Fiorentino and Pontormo. This isn't to suggest a comparison in point of aesthetic value. But I will say that hardly anything in the new wave of photographically realistic painting—except certain pictures by Richard Estes—does compare in point of quality with some of the momentary pictures I've seen on color TV.

Also: abstract art has come out better, so far, in moving pictures than in still and printed photography. I don't think there's a necessary reason for this: working in an abstract vein on light-sensitive surfaces in the one case shouldn't meet more difficulties, aesthetically, than in the other. The only explanation I can offer is that most of those few artists (I can think of Len Lye, Judson Belson, Norman MacLaren) who've tried their hands at abstract movies have been better *painters* than the many who've attempted abstract still photography. You have to be a good painter to make good abstract art, in whatever medium; it's not enough to be a good photographer. Not that a good photographer can't make as good art as a good painter, but two really different submediums are involved, though they both eventuate in pictures. Good photography has meant, so far, good *straight* photography, photography that deals with nature transparently more or less, exploiting capacities unique to the camera. A different gift and a different kind of inspiration are required from those of the painter. It's not enough here, conversely, to be a good painter. Good painters have been mediocre photographers, and good photographers have been mediocre painters or not painters at all. It remains, anyhow, that the best printed photographs I've seen are straight photographs, and that some of the artists who made them, when they attempted anything like abstraction, failed lamentably (Stieglitz with his cloudscapes, Moholy-Nagy, Man Ray, to name only names).

DECORATION

Case could be made for the Persians as best of all decorators. Because consistently better colorists: Achaemenid brick-tile reliefs (the example in the Louvre), ceramics of the first Islamic centuries, miniature paintings (which aren't decoration), sixteenth- to eighteenth-century rugs (which become less and less decorative and more and more pictorial as our eyes get widened by modern art). Persian color can generate sufficient rightness of design and shape. Though it has to be allowed that the pottery shapes of the Persians don't always compete, purely as shapes, with those of the Chinese and Japanese. Nor do the Persians seem equally interested

in ceramic textures. But it remains, for me, that there's nothing to match Persian color.

Theodor Hetzer (a great German art historian-critic whose writings were introduced to me by Kenworth Moffett) said that decoration *(Ornament)* "died only in the nineteenth century." But maybe it really fell dead only in the twentieth. Lincoln Center inside and sometimes outside; the interiors of the recent public and quasi-public buildings in which decoration has been attempted. Art nouveau and art deco were better, but still not good enough to hang on, nor were the tours de force of Louis Sullivan or Frank Lloyd Wright, as good as they were.

So why can we in the West no longer decorate—that is, cover unfree surfaces—pleasingly? Why does even good jewelry design nowadays have the character of a tour de force when it's not borrowing some historical style?

It's easier to begin to understand why *Ornament* has died by now in all the other urban cultures, those of the Far and other Easts; almost all their traditional visual arts have died too: died, that is, in point of quality. (Of natural causes as it were; most certainly not because of the intrusion of the West.) But all the other traditional visual arts in the West have not died, not yet. Indeed, I think that a good part of the reason for the death of decoration lies precisely in the continuing vitality of Western painting, sculpture, and architecture (for all that's become "problematical" in them).

The vitality seems connected with Western rationalizing: that insistence on making means accountable to their ends which has come to mark our civilization as it has no other. Things are to be fined down, ideally, to their ultimate uses (whatever these uses may be). The ultimate use of art is construed as being to provide the experience of aesthetic value; therefore art is to be stripped down toward this end. Hence modernist "functionalism," "essentialism" it could be called, the urge to "purify" the medium, any medium. "Purity" being construed as the most efficacious, efficient, economical employment of the medium for the purposes of aesthetic value.

"Purity" of and in art—any art, including music and dance—is an illusory notion, of course. It may be remotely conceivable or imaginable, but it can't be realized because it can't be recognized any more than a "pure" human being or a "pure" (or, for that matter, gratuitous) act can be. All the same, for Western art in its modernist phase "purity" has been a useful idea and ideal, with a kind of logic to it that has worked, and still works,

to generate aesthetic value and maintain aesthetic standards as nothing else in our specializing culture has over the last hundred-odd years.

But this logic has also worked to exclude the decorative—the decorative insofar as it functions solely as decoration. It's as though aesthetic value, quality, could be preserved only by concentrating on "absolute" or "autonomous" art: thus on visual art—including even architecture—that held and moved and stirred the beholder as sheer decoration could not. Decoration is asked to be "merely" pleasing, "merely" embellishing, and the "functional" logic of modernism leaves no room, apparently, for such "mereness." This is part of the pity of modernism, one of the sacrifices it enjoins.

What also helps explain the death of *Ornament* is the fading of that *horror vacui* which used to belong to Western sensibility in what seems a special way, a way that has to do with that "heavy" pictorial art of the West which I've already mentioned. (The Greeks might have been somewhat less affected by *horror vacui*, but not the Romans, who appear to have felt it in a decided way too.) Modernist visual art has tended on the whole toward lightness and openness. It tolerates increasingly, nay it demands increasingly, empty spaces and blank surfaces. That's been its long-term if not consistent tendency. Economy: "less is more." Orientalization? Not exactly. Islam, India, China have their own kinds of *horror vacui*, even if these haven't been as unrelenting as those in the West and the Greco-Romans. The Japanese have, on the evidence, "suffered" from *horror vacui* least (and their culture is the only one that can match the West's when it comes to rationalizing); it's thus no accident—as Bolshevik Marxists used to say—that Japanese art once had such an encouraging influence on modernist painting, architecture, and poetry: more than that of any other exotic tradition.

But as I've indicated, modernism hasn't been consistent in its overcoming of *horror vacui*. Many of its heroes went on feeling it and acting on it: Picasso, Proust, Joyce, Pollock, Stravinsky; others felt it but resisted it, or resisted it off and on: Valéry, David Smith, Bonnard, Mallarmé, Stefan George. But I don't want to make too much of *horror vacui;* it's too hard to say where it begins and where it ends.

Decoration and the decorative are, into the bargain, no longer free to be themselves. That's another factor in the decline of *Ornament*. What used to belong exclusively to visual decoration—the patterned and the repetitive and the blank flatness which relieved them—has been taken over

by painting and even sculpture. By intruding and appropriating the means of decoration, painting and sculpture have excluded decoration itself.

Picture making now exploits devices of *Ornament* as it did not before. Decoration can break the plane without abrupt contrasts of light and dark and then restore it simply by repeating these contrasts at regular enough intervals. This used to be the antithesis of the pictorial; now it's part and parcel of it. Easel painting began to assimilate the "mechanical" repetitiveness of the decorative with the analytical cubism of Braque and Picasso and the 1911–14 cubism of Léger. These masters did far more than Matisse to take over the "essentially" decorative for pictorial art. (Matisse was held to be decorative only because he was flat and incorporated decoration as such in his pictures, but pictorial art in places outside the West, and in the West before the Renaissance, was as flat by and large as Matisse usually was, and abounded in *representations* of decorated objects.) It was left, however, to Tobey and Pollock to make the assimilation of the decorative complete: their alloverness. Now alloverness has become academic and too often is allowed to become a *patterned* alloverness, which it never was in Tobey's or Pollock's hands. Nor in David Smith's; in certain works of the 1940s he embraced the mechanically repetitive in a way that was triumphant because it was matter-of-fact—which was the same way in which he embraced the look of the two-dimensional. Since Smith, abstract sculpture has often made too much of a point of alloverness and repetition, as if the mere assertion of these were enough, the mere presentation.

Are there equivalents in the other arts of this absorption of the decorative? That is, are there equivalents of the decorative in literature, music, and dance, and have these too been wrenched away from their function? Is there decoration or decorativeness in *The Aeneid* or in Lyly's *Euphues* or in a cadenza? What an invitation here to the worst kind of interpretive ingenuity. And who's to say when elaboration or incrustation or flourishes or figures of speech become decorative instead of substantive in any of these nonvisual arts?

QUALITY

Hetzer again, writing about Goya: "The spread between good and bad in art was never so great as it became in the nineteenth century." That spread may have become even greater since the advent of abstract art. The badness of abstract painting and sculpture—I mean the badness they can attain, not the badness inherent to abstraction, far from it—doesn't seem to

have any precedent, not even in unschooled art, not even in nineteenth-century Salon art (uniquely abysmal as some of that was, in part precisely because it was schooled or half-schooled).

But the badness of most of the far-out or "novelty" art that has come up since the 1950s, in the wake of abstract expressionism, is even more extreme. This is the real novelty in "novelty" art. The spread between good and bad in seriously taken art is so much greater than Hetzer, thirty or forty years ago, could have imagined.

It's not that art in general has gone to hell. If that were so the spread between good and bad wouldn't be so newly enormous: an Andre wouldn't look quite so bad, for the moment, without the presence of a Caro, a Brice Marden quite so feeble without the proximity of an Olitski. But good Lord, what am I talking about? Andre and Marden, in their turn, make the likes of a Samaras, a Richard Tuttle, a Nauman, a Beuys, and a Buren look as bad as they ever will. There's a spread below the spread between good and bad. Yet this ultimate spread between the best and the so much less than good remains. Good, superior, excelling art continues to be made in this time, art that measures itself against the best of the past.

Art, like the rest of reality, has a way of upsetting, turning on expectations. So now the best new art comes in unclamorously, conservatively as it were, precisely because it's expected to come in otherwise. But it still comes in unacceptedly and relatively unnoticed, as it has ever since the mid-nineteenth century and maybe before. No, Western art isn't decadent yet. It's only that its public—the current public for current art—is. That public started to be "decadent" decades before anyone noticed. It's possible to say that the bourgeoisie have offered the worst public for art ever, once they became—as they did in Western Europe after the 1830s—a public and the public. (The poor bourgeoisie: I'm tired of the name and the abuse it receives.)

RESURRECTIONS

Reappreciation of Gérôme, Meissonier, Alma-Tadema, Landseer, Bierstadt, Bouguereau, et al., as revisions of taste? Of course not. Only journalists view it that way. Years ago enough people say that when these artists were good—which was almost always in small, informal pictures or else in early ones (Bouguereau)—they were really good. But it's no use pretending that even at their very best they were on the same *level* as a Monet, Pissarro, Sisley, Renoir. And anyhow there were several dozen lesser-known

contemporaries who were better day in and day out: Bonvin, Ribot, Leibl, Trübner, Stobbaerts, Lépine, Menzel, Rayski, and others in the Lowlands, Germany, France, Britain, Austria, Russia, Eastern Europe. Painting reached a high general level of "culture" in the nineteenth century.

But to repeat—and not repeat: it still took Manet and the impressionists to save Western painting, to keep it going on *the* high level, the level higher than, say, that of Hokusai and Hiroshige in Japan, which was the last level of any height that I'm aware of in exotic art.

(1976)

Seminar 6

EXPERIENCE SAYS THAT FORMALIZED ART, the kind most people agree to call art, offers greater satisfactions by and large than any other kind of aesthetic experience. Formalizing art means making aesthetic experience communicable: objectifying it, making it public, instead of keeping it private or solipsistic as happens with most aesthetic experience.[1] For aesthetic experience to be communicated it has to be submitted to conventions—or "forms" if you like—just as a language does if it's to be understood by more than one person.

Conventions put resistances, obstacles, controls in the way of communication at the same time that they make it possible and guide it. The particular satisfactions we get from formalized art are due, in some essential part, to the sense gotten of resistances coped with by dint of choices or decisions (*intuited* decisions or what I call *judgment decisions*). Quality, the very success or goodness, of formal art derives, formally, from these decisions, from their intensity or density.[2]

The density or intensity of decision that goes into the making of communicable art has nothing to do with quantity or multiplicity. But it's impossible not to resort to quantitative terms in discussing the matter: thus as when I affirm that as "much" density of decision can, in principle,

go into the shaping of a box as into the carving or modeling of a representation of the human figure. The size, proportions, material, and color of a box can bear as great a weight of intuited decision as the sculpture that fills a pediment. The fact that this has proved unlikely so far (despite some of the achievements of one or two minimal artists) doesn't make it any the less possible.

To say it again: under a certain aspect, and a very real one, quality in art appears to be directly proportionate to the density or weight of decision that's gone into its making. And a good part of that density is generated under the pressure of the resistance offered by the conventions of a medium of communication. This pressure can also act to guide and evoke and inspire; it can be an enabling as well as resistant pressure; and it guides and enables and evokes and inspires precisely by virtue of its resistance. Measure in verse and music, patterns in ballet, ordered necessities of progression in drama, prose or verse, fiction, and movies: these have empowered creation at the same time as they have constrained it—and because they have constrained it.

The conventions of art, of any art, are not immutable, of course. They get born and they die; they fade and then change out of all recognition; they get turned inside out. And there are the different historical and geographic traditions of convention. But wherever formalized art exists, conventions as such don't disappear, however much they get transformed or replaced. This goes for "low" art and for folk art and for tribal, preurban art as much as it does for high urban art.

Most of what I've just said is not new. But the emphasis I've put on decision or choice may be. If so, that would be thanks to what's happened in art itself in recent years. It's the boringness, the vacuousness of so much of the purportedly advanced art of the past decade and more that has brought home—at least to me—how essential the awareness of decision is to satisfying experience of formal art. For the vacuousness of "advanced" art in this time is more like that of "raw," unformalized art or aesthetic experience, which vacuousness derives precisely from the absence of enough conventions and the want of decisions made or received under the pressure of conventions.

"Convention," "conventional" became pejorative words during the last century. But another of the theoretical services done by recent "advanced" art is to begin to rehabilitate them, to make us more careful in using them, just as we've also become more careful in using "academic" in a pejorative

way. Now when we object to an art that's found to be too imitative or tame or routine, we have to say "*too* conventional" or "*too* academic" and not academic or conventional *tout court*. Now when we say academic we begin to feel that we have to specify *which* academy and allow at the same time that not all academies were bad. (This, however, isn't just because of the lessons learned from the latest bad art; it has also to do with the irrefragable fact that taste keeps becoming more catholic, in which respect—and it's the only respect—progress is being made in art or in the context of art.)

Bad, inferior art is not necessarily boring or vacuous. What is relatively new about the badness of recent "advanced" art—new that is, in the context of formal art—is that it *is* so boring and vacuous. This, because of the large absence of decisions that can be felt as "meant," as intuited and pressured, and not just taken by default. That's just it: that so many of the decisions that go into the supposedly newest art go by default, become automatic, and by the same token arbitrary, decisions. It used to be that the tutored artists failed through wrong or incomplete decisions; but the wrongness or the incompleteness came under the pressure of conventions, which made them "meant" decisions. Which is why even the failed results could be interesting, at least up to a point. You could get intrigued by what went wrong, receive intellectual if not aesthetic pleasures from seeing how it went wrong (even though the possibility of your getting that kind of intellectual pleasure depended upon having enough *taste* to see that something went wrong). The real newness of "advanced" art in this time consists mostly in the uninterestingness of its failures, their desolateness.

I flatter myself with thinking that I can put myself into the state of mind of the "far-out" artist. I think that I can do this because the idea of innovation, of newness in art, has been so epidemic since the mid-1960s, and the mind-set that goes with it has consequently become so familiar. Don't we all, in the art world, know now what it feels like to decide to innovate? to go far out? So you start by discarding every, or almost every, convention you can recognize as a convention. You leave easel painting and "sculptural" sculpture behind; that is, you "free" yourself from the conventions that these arts have, as you supposed, been controlled and guided by. You next alight on an "idea," "conception," or category: serialization, objecthood, literariness, process, "conditions of perception," or simply far-fetched and startling. This becomes the decisive moment of creation;

all following decisions are left to the care of this moment. You don't intuit your way any further; you don't, if you can help it, make any further decisions or choices: in principle, you let that first moment carry you, logically or mechanically, all the way through execution.

No one can say that superior art can't possibly come about this way. Superior art can come about in any way, conceivable or inconceivable; there's no legislating or prescribing, or proscribing either, when it comes to art. There are only, at a given time, greater and lesser probabilities—neither of which are to be *believed* in. But I'm talking here about art that has already come about in the way just outlined. (Art which is already there is the only art that can be talked about.) That art happens to be almost entirely what I've said it was: uninterestingly bad. And I presume to think I can account for this badness, at least in scheme. This art has been made too largely in freedom from pertinent aesthetic pressures (if not from physical, economic, or social ones). The decisions that have gone into it have been too largely tangential in the aesthetic context, however much governed by other terms (such as those, say, of serial repetition, or mathematical permutation, or those of the physical or mental environment, etc., etc.).

Aesthetic pressure can come from only two directions. There is the pressure of what the artist has to say, make, express. Facing that is the pressure of the conventions of his medium, which is also the pressure of taste—for in the end it's taste and nothing else that empowers or disempowers convention. (But of that more later.) Convention isn't "form"; rather it's a limiting and enforcing condition that functions in the interests of the communication of aesthetic experience. This alone: whether it acts as measure in music; or perspective, shading, design, the "integrity" of the picture plane in painting; or the notion of compactness or else that of light and shade in sculpture, or else that of a circumscribed ground plane; or as meter in verse; or as the obligation to go from beginning through middle to end in fiction. There are many, many less evident, less specifiable artistic conventions than the like of these "old-fashioned" ones I've just listed. We have to go along with the notion of convention, for the most part, as with the notion of art: as something recognizable but not adequately definable. That belongs to what makes art what it essentially is, just as it makes intuitive experience in general what it essentially is.

I've already said: the conventions of art are neither permanent nor immutable. But no matter how feeble they may become, they don't—as the

record shows—get finished off by fiat, by wishing and willing. At least not fruitfully, profitably, effectively, not in the interests of good art. Conventions will fade and they will die out, but not because anybody has simply resolved to have it that way. And how conventions have decayed and lapsed with the decline and extinction of a whole artistic tradition, say the Greco-Roman, is one thing; and how they have done so within a tradition that stays alive and moves beyond them is another. But in either case it happened because the conventions in question prevented certain artists from saying new things that they had to say—or else prevented them even from finding out that they had new things to say.

A tradition of art keeps itself alive by more or less constant innovation. We all know that. What we may have to know better is that some element of innovation or originality goes into all good, not to say superior, art. All good art innovates, however modestly or furtively. It innovates because any maker of better art has, aside from his competence, something to say that no one else has said or could say. Each time certain conventions or aspects of convention have to be altered in order to accommodate the better artist's uniqueness, no matter how small that may be. This truism holds for Luini as it does for Leonardo, for Lépine as it does for Corot, for Samain as it does for Baudelaire. It holds for all the many relatively obscure artists who, in every tradition, inserted enough of their own particular selves or own particular inspiration in what they sometimes did to make it worth looking at, listening to, or reading. Innovation can't be separated from any dimension of real success in art, allowance made for the fact that by far the most innovation is not striking enough to make itself known as that.

It used to be better recognized, even if only implicitly, that in order to break with a convention you had to possess it or, if not that, at least see its point and appreciate that point. Blake, and Whitman too, had enough metric verse in them to be able to go over more or less effectively, or at least interestingly, into "free" verse. Joyce had to own the literary past in order to do what he did do to so many hallowed conventions of narration. Schoenberg had to have classic tonality in his bones before he could depart from it as he did. Manet knew from inside out the centuries-old convention of modeling-shading that he so radically dismantled. Pollock was practiced well enough in all the precedents of composition and handling that he violated. Picasso was fully conversant with the Western tra-

dition of monolithic sculpture when he broke away from it as he did in his collage constructions.

I don't mean to insist that all signal innovators were, or had to be, learned in the full sense, the accepted sense. (And anyhow, artistic learning, the learning that an artist needs, is not a matter so much of knowledge as of taste, of consciousness developed in a certain direction. Shakespeare didn't have, apparently, as much book learning as Ben Jonson, but he was more artistically learned; i.e., his taste was wider and deeper.) All I mean is that the record shows no case of significant innovation where the innovating artist didn't possess and grasp the convention or conventions that he changed or abandoned. Which is to say that he subjected his art to the pressure of these conventions in the course of changing or shredding them. Nor did he have to cast around for new conventions to replace those he had shed; his new conventions would emerge from the old ones simply by dint of his struggle with the old ones. And these old ones, no matter how abruptly discarded, would somehow keep being there, like ghosts, and give ghostly guidance. The monolith haunts Picasso's first collage constructions (the most radical and "revolutionary" of all twentieth-century innovations in art), as it does his later direct-metal sculpture, to give them their compass bearing as it were.

Even a rather cursory review of the past of art (of any art and of any tradition of any art) shows that artistic conventions have hardly ever—and maybe never—been overturned or revised *easily*, not by even the greatest of innovative geniuses. A more than cursory review of the past of art, at least of the recent past, shows, however, that conventions have been, and can be, tampered with or abandoned prematurely. Premature innovation afflicts some of the best art of the nineteenth century and some of the just less than best of the twentieth. The frequent ungainliness of Blake's and Whitman's free verse is due to a certain thinness of decision that's due in turn to a departure from measured verse that isn't *lingering* enough. Seurat is usually better, in oil, when he stays closest to impressionism (as in his beachscapes) than when outrightly pointillist. Both Gauguin and van Gogh are at their best, too, when closest to "conservative" impressionism. That the importance for the future of painting of all three of these artists stems from their least impressionist works doesn't change the case as far as sheer quality is concerned (which is part of what could be called the "problematics" of art in general after 1860). The impressionists

themselves were more consistently successful when they were, as in the late 1860s and earlier 1870s, less than completely impressionist, when they still hadn't worked themselves free of light-and-dark painting. It was because Cézanne never stopped regretting the light and dark of illusionist tradition, because he kept on trying to rescue the conventions that his impressionist vision compelled him to undermine—it was in some very important part because of this, the back-drag of the quality of the past, that Cézanne's art steadied itself as it did, for all its ups and downs, on an extraordinarily high level. It was with great reluctance that he "sacrificed" anything of his art to innovation. And yet, and almost precisely because of this greater reluctance, Cézanne's innovations turned out to be more lasting and also more radical than those of the other postimpressionists. Matisse and Picasso and Braque and Léger and even Mondrian and certainly Klee were likewise reluctant innovators, cherishing the very conventions they felt themselves forced to go against—and by their time it had become a little harder to do that kind of cherishing. It was still harder for Pollock, who from first to last kept yearning for the sculptural shading-modeling that his taste, involved with his own art in its own time and oriented by the best art of the time just before, would not let him return to.

How reluctant such artists as Kandinsky, Kupka, and Malevich were as innovators is hard to tell, but all three of them were premature innovators on the evidence of their art—and erratic because of their prematureness. This at the cost of quality. While shedding certain conventions all three stayed stuck in certain others whose revision was more fundamental to what they were trying to bring about. (That it takes hindsight to see this doesn't matter.) Something similar happened with Gauguin and with Walt Whitman (who stayed with certain conventions of rhetoric and diction that often deprived his poetry of a needed tautness). Kandinsky's is almost the exemplary case. His first abstractness, in the pictures he did from 1910 to 1918, fails to assimilate to itself, that is, modify enough, the traditional and conventional illusion of the third dimension, so that in too many of these pictures the abstract configurations get lost in the space that contains them: they wobble and float and sink (though it can't be denied that in certain rare moments this is just what brings a painting off: such being the wonderful inconsistency of quality in art). But it's Kandinsky's outrightly flat pictures, which come afterward, that offer the more obvious case of premature innovation. Here Kandinsky renounces stereometric illusion

in toto, but the resulting flatness still doesn't stay flat enough because the configurations that he introduces, and still more the placing of these configurations, disrupt that flatness (violate the integrity, rather, of the picture plane, of which the flatness is just an agent; in the showdown there's more integral "flatness" in a good Ruisdael than in this kind of Kandinsky). The point is that Kandinsky went over into his all too literal flatness by a leap, so to speak, without having coped with, worked his way out of, the conventions of spatial illusion that he was so abruptly discarding.

Duchamp after 1912 is a different kind of example of premature innovation. But in the paintings he made before 1913 his case was as a case, much like Kandinsky's in scheme. That these paintings are quasi-futurist and pseudo-cubist doesn't necessarily hurt them; that is, they put on a look of newness while retaining a conventional enough "infrastructure." But they don't really dispose of the conventions they seem to be shedding (they depend on a traditional illusion of depth more than Kandinsky's first abstract works do, which helps make them a little thin, even a little papery). They also tell us that Duchamp had hardly grasped what real cubism was about. The first "recovered objects" that he mounted, the *Bicycle Wheel* and the *Bottle Rack* of 1913, tell us that he didn't know either, what Picasso's first collage constructions were about. It was one thing to have your fun with long-settled-in conventions (though even that was not so easy when it came to the essential conventions of illusion); it was another thing to "play" with more recently established ones, like the shuffled planes of cubism. That new a convention could be coped with only by a truly penetrating taste. Duchamp doesn't seem to have had that. He seems to have thought that cubism was too much a "physical" way of art, and at the same time that it was theoretical enough to have required, as he said late in life, to be "detheorized"!

I can't help thinking, and imputing, that it was out of frustration that Duchamp became so "revolutionary" after 1912; and that it was out of despair of being new and advanced in his own art that he came to set himself against formal art in general. That he wasn't consistent in this direction; that he kept on making some things that took a proper place as formal art, even rather good formal art (the painting *Network of Stoppages,* the *Glasses,* large and small, and still other works)—this doesn't affect my argument. Duchamp was like most other human beings in not being able to control and program himself beyond a certain point. And formalization, and inspiration with it, can insinuate themselves without

being summoned. Also some artists make superior art only when they give up trying to make it, when they give up conscious awareness and self-awareness. Besides which, I think that Duchamp's unconscious absorbed more of cubism, and of other excelling art in his time, than his rather mechanical conscious mind let him notice.)

All the same, Duchamp did by intention set himself against formal and formalized art. He did, in effect, try to make free-floating "raw" aesthetic experience—which is inferior aesthetic experience by and large—institutionally viable (showable in art galleries and museums, discussable in print and by art-interested people). His "raw" art turned out, however, to be less than raw insofar as it had its own orientation to conventions; only these weren't aesthetic ones but the largely unaesthetic conventions of social propriety, decorum. The point became to violate these. So a urinal was shown in an art gallery; the spread and unclothed lower limbs and the hairless vulva of the effigy of a recumbent young female were put on view through a peephole in a rather staid museum. The point was made. But there was a still further point: to defy and deny aesthetic judgment, taste, the satisfactions of art as art. This remained the main point for Duchamp (even though he couldn't always adhere to it: the painted background of his Philadelphia Museum peep show is beautiful in a small way). And it remains the main point for the subtradition that he founded. With the necessity or inevitability of aesthetic judgment pushed aside, the making of art and of aesthetic decisions, whether by artist or beholder, was freed of real pressure. You could create, act, move, gesticulate, talk in a kind of vacuum—the vacuum itself being more "interesting," or at least counting for more, than anything that happened inside it. The gist of consorting with art was to be intrigued, taken aback, given something to talk about, and so forth.

Yet Duchamp and his subtradition have demonstrated, as nothing did before, how omnipresent art can be, all the things it can be without ceasing to be art. And what an unexceptional, unhonorific status art as such—that is, aesthetic experience—really has. For this demonstration we can be grateful. But that doesn't make the demonstration in itself any the less boring. That's the way it is with demonstrations: once they've demonstrated what they had to demonstrate, they become repetitious, like showing all over again how two plus two equals four. That's not the way it is with more substantial art, good and bad: that kind of art you have to experience over and over again in order to keep on *knowing it.*

To come back to conventions, and then to decisions. Grasping a convention, digesting and assimilating it—certainly doing so enough to be able to change, expand, shrink, or discard it in the interests of art—that means appreciating those works in which the convention is enabling and disappreciating those in which it's disabling. That requires taste, that penetrating taste I've already referred to. A convention is disabling when the artist or beholder lets himself be controlled in the wrong places by that convention. It takes taste, as well as inspiration, to get that convention out of the way; inspiration alone (of which the beholder has his need too) won't usually do it.

One of the ironies that haunt ostensibly avant-garde art in this time lies in the persistence of "older" conventions that taste fails to notice—I mean the taste of the practitioners of ostensibly avant-garde art. The persistence of these older conventions, *older* because they persist unrevised, betrays itself in conventionality of sensibility. No amount of "far-outness," no degree of "literalness," no quantity of lucubration about what art is and how it relates to language or society and so forth, has been able to hide this conventionality. It shows through all the many gaps in the apparatus of innovation. Undetected, therefore uncoped with conventions remain the controlling ones. They control artist and viewer alike by permitting and inducing routine aesthetic decisions. This is the kind that artists who are called academic in the pejorative sense have always made. (And Duchamp's subtradition has only contributed to all the expectability. What's unexpected in a social or abstractly cultural context, no matter how titillating or shocking, usually turns out to have been long rehearsed in an aesthetic context. Duchamp's *tableau "mort"* in the Philadelphia Museum is a perfect case in point.)

But what artists in the pejoratively academic sense rarely did before was try to escape in their decisions from the pressure, as such, of convention. This has been the notion of all too many would-be innovative artists in this time. And as I've suggested, the usual outcome has been that, while shedding the obvious conventions, they get trapped in the unobvious ones. Or else, having succeeded in placing themselves in a situation that seems to shut out every conceivable convention, they fall into "raw," unformalized, usually random art. Here, where it should be beside the point if ever, sensibility manages all the same to sneak back in—and it's invariably, or has been so far, conventional sensibility despite all appearances to the contrary. All that's happened is that aesthetic decisions become

unbelievably weightless and aesthetic results unprecedentedly empty—at least within the context of formalized art. And conventions hang on, paltry ones like those that guide the decisions that go into scattering flower petals over water in a basin.

And yet once again: something has been demonstrated that was worth demonstrating. Art like Duchamp's has shown, as nothing before has, how wide open the category of even formalized aesthetic experience can be. This has been true all along, but it had to be demonstrated in order to be known as true. The discipline of aesthetics has received new light. In this respect it doesn't matter that the body of art which has thrown this new light is possibly the worst and certainly the most boring formalized art known to be recorded experience. Art as such has lost the honorific status it never deserved as such; and aesthetics will never be again what it used to be.

In the meantime, genuinely innovative art, major art—the relatively small amount of it there is—goes on in this time much as before. Only now it proceeds underground so to speak, working away at the unapparent conventions and parameters of convention: coping, that is, with what hamstrings and defeats the "far-out" multitude.

(1976)

NOTES

1. See this writer's "Seminar One" in *Arts* magazine, November 1973, and his "Seminar Five" in *Studio International,* May–June 1975.

2. Because we sense these decisions as coming from human beings alone, they somehow speak for all of us, for the whole species. True, we are given these decisions as results, but that's how the art maker himself experiences them in the showdown: the intuitive decisions that go into the final version of a work of art are simultaneously results. But what about those young chimpanzees and gorillas who painted plausible and sometimes even agreeable abstract pictures? Did they speak for our species? Well, yes. All the plausible or agreeable pictures were done on sheets of paper, and they betray the fact that the young apes who painted them respected the quadrilateral limits of the paper support and were even guided by these. Other young apes botched their pictures because they didn't distinguish between the paper surface and the surface of the table or board on which the paper lay; they painted on both indiscriminately: that is, they didn't submit to the convention, the human convention, that had been presented to them. The apes that did do so joined

the human species for the time being, for the nonce, insofar as by recognizing or accepting or discovering that a pictorial surface had to be delimited, they intuited an aesthetic decision in a particularly human way, that is, a formal way. (Whether we who found their pictures plausible or even agreeable did, by that fact, join a simian species for the nonce is another question.)

• •

STATES OF CRITICISM

• •

VALUE JUDGMENTS CONSTITUTE THE SUBSTANCE of aesthetic experience. I don't want to argue this assertion. I point to it as fact, the fact that identifies the presence, the reality, in experience of the aesthetic. I don't want to argue, either, about the nature of aesthetic value judgments. They are acts of intuition, and intuition remains unanalyzable.

The fact of aesthetic intuition, as distinguished from other kinds of intuition, has, for lack of a better word, to be called taste. This word has acquired unfortunate connotations since the nineteenth century, for what are really irrelevant reasons. That great literary critic F. R. Leavis, while insisting on the primacy of value judgment, avoided the word for—it seems to me—fear of these connotations. Instead, he resorted to "sensibility" or circumlocutions like "feeling for value" or "sense of value." (I may not be quoting with exactness, but I'm not misrepresenting.) I want to try to rehabilitate the word; taste is the handiest term for what's meant, and somehow the bluntest—in part precisely because of the disrepute into which it has fallen. The word drives home the fact that art is first of all, and most of all, a question of liking and not liking—just so. Liking and not liking have to do with value, and nothing else.

It's as though the shying away from the use of the word taste had been

a portent of the present general tendency to shy away from what it, or its synonyms, means. There is a reluctance nowadays to express value judgments in criticism—at least in criticism of painting and sculpture, and maybe of some of the other arts too.[1] I mean outspoken value judgments, judgments that can be discussed. Implied judgments abound, and they have to: they decide usually (though by no means always) what items, or occasions, art critics give their attention to. But implied judgments don't get discussed enough, they don't get put on the table. Art will get explained, analyzed, interpreted, historically situated, sociologically or politically accounted for, but the responses that bring art into experience as art, and not something else—these will go unmentioned.

Need they be mentioned? Only insofar as it's art as art, and not anything else, that's to be talked about. Sure, art can be talked about as something else: as document, as symptom, as sheer phenomenon. And it does get talked about that way more and more, and by critics no less than by art historians and by philosophers and psychologists. There's nothing necessarily wrong in this. Only it's not criticism. Criticism proper means dealing in the first place with art as art, which means dealing with value judgments. Otherwise criticism becomes something else. Not that it is to be so narrowly defined as to have to exclude interpretation, description, analysis, etc.; only that it must, if it's to be criticism, include evaluation, and evaluation in the first place—for the sake of art, for the sake of everything art is that isn't information or exhortation, for the sake of what's in art's gift alone.

To experience art as art is—again—to evaluate, to make, or rather receive, value judgments, consciously and unconsciously. (A value judgment doesn't mean a formulation or statement, a putting of something into thoughts and words; a value judgment takes place; the thoughts and words come afterward.) The critic happens to be under the obligation to report his value judgments. These will be the truth, for him, of the art he discusses. It will also, most often, make for the greatest relevance, and greatest interest, of what he says or writes. Though I grant that the issue of what's interesting here may be a moot point for a lot of people.

I realize that I'm simplifying. But I'm not oversimplifying. I'm stating flatly what hasn't been stated flatly enough, or often enough with emphasis. But then the primacy of value judgment in art criticism used to be taken so much as a matter of course that it didn't have to be stated, much less stated emphatically. The last great art critics I'm aware of—Julius

Meier-Graefe and Roger Fry—simply assumed it, just as E. D. Hirsch's literary critics did. And it is still assumed, as far as I can see, in music and architectural criticism, and in literary reviewing as distinct from "serious" literary criticism, as it isn't in art criticism or even art reviewing. Which is why I don't feel I'm belaboring the obvious when I harp on the primacy of value judgment in the present context. Didn't the late Harold Rosenberg say that taste was an "obsolete concept"? Didn't another reputable art critic refer recently to the weighing of the quality of specific works of art as "art mysticism"?

To be sure, value judgments of a certain kind—more than enough of them—are to be met with in the current art press. But they are not aesthetic value judgments. The values invoked are those of sheerly phenomenal newness, or of "objectness," or "information," or "process," or of purported demonstrations of how the perceiving and knowing, or of acts and things by which our notion of what's possible as art is expanded. The critics who take these values or claims to value seriously ipso facto exclude any appeal to aesthetic value, whether they realize it or not. To judge from their rhetoric, more often they don't. I said earlier that implied value judgments abound, and I meant value judgments that were properly aesthetic, for better or for worse. I want to correct myself somewhat. Being for the new simply because it's new, or being for a certain kind of art simply because it's in vogue, doesn't entail an aesthetic value judgment. Nor does rejecting what seems old-fashioned simply because it seems that. (Categorical judgments are in any case never truly aesthetic ones.) What's involved here is something I'd call aesthetic incapacity: the incapacity lies in letting irrelevant factors like newness and oldness shut off aesthetic experience, inhibit the operations of taste. This amounts to, has amounted to, a kind of judgment *on* aesthetic experience itself. And it's this judgment, this disparaging judgment, that seems to control too much of what's offered as criticism of contemporary fine art.

Of course, there's more, and should be more, to art criticism than the expressing of value judgments. Description, analysis, and interpretation, even interpretation, have their place. But without value judgment these can become arid, or rather they stop being criticism. (A bad work of art can offer as much for description, analysis, and interpretation—yes, interpretation—as a good work of art. It's possible to go on as long about a failed Goya as about a successful one.) As Meier-Graefe and Fry show us, description and analysis can carry value judgments with them, im-

plicitly and otherwise. The literary criticism of F. R. Leavis shows that too, eminently. Donald Francis Tovey, in writing about music, shows it comparably. (It takes nothing away from Tovey to suggest that music, of all arts, seems most to compel the critic to evaluate as he describes or analyzes.)

But what about the extraaesthetic contexts of art: social, political, economic, philosophical, biographical, etc., etc.? The historical moment? Don't they have to be brought in? And how can aesthetic value be kept enough in sight in such contexts? It doesn't have to be. For when such contexts are brought to the fore it's no longer criticism that's being practiced. It's something else, something that can be valuable, something that can be necessary. But it's not criticism. And let those who occupy themselves with such contexts not think they're doing criticism; or that they're rendering criticism proper unnecessary.

I want now to enter a plea for the discipline of aesthetics. It's become routine lately to refer disparagingly to aesthetics, and there may be some justification. When you see the aesthetic lucubrations of a philosopher like Nelson Goodman treated with respect by others in the field you want to throw up your hands and conclude that anything can be gotten away with here, just as in art criticism. But that's not the whole story. Certainly artists don't need to be acquainted with aesthetics. However, it might be of help to those who teach art—acquaintance, that is, with the right kind of aesthetics, the kind that shows you what it's possible to say relevantly. Acquaintance with this kind of aesthetics would most certainly be of help to a critic. It might lead him to keep more firmly in mind that aesthetic value judgments can't be demonstrated in a way that would compel agreement; consequently, that in the last resort it's his reader's or listener's taste that he has to appeal to, not his reason or understanding. The critic might also be brought, with the help of aesthetics, to see more clearly what his own experience only too often doesn't bring him to see at all: namely, that content and form can never be adequately differentiated, since the term "form" is always somewhat indefinite in application, while the term "content" is of no definiteness at all. An awareness of this might head off a lot of vain controversy. (It might also keep someone like Joshua Taylor, in his recent *The Fine Arts in America,* from referring to the "intense concern for content, not method, that characterized" the "procedures" of the abstract expressionists. This is also what comes of taking artists at their word.)

Some critics would also do well to consult a dictionary oftener. They

might look up the word "gestural," for example, and discover what a solecism they commit when they talk of gestural painting. Is it conceivable for a painting to be made by means of gestures? Can a material object—or for that matter, a poem or a song—be created, fashioned, or altered by gestures?

It "signifies" that the appellation "art critic" has been narrowed down now to one who criticizes contemporary and recent art alone. When you deal with art further back in time you get to be called an art historian rather than an art critic. It was not always that way; it wasn't that way for Meier-Graefe, or Fry, or André Lhote, all three of whom wrote about past and present indiscriminately, and it was only ignorance that called any of them art historian. Now it's also become assumed that an art historian proper is not to engage in criticism, not to express value judgments, but keep to scholarship and interpretation. As a consequence, painting and sculpture of the more than recent past get less and less evaluated or re-evaluated, less and less criticized as *art*. There are exceptions, but that's just what they are: exceptions.

The case doesn't appear to be the same with music. There the productions of the past continue day in and day out to be evaluated and reevaluated along with those of the present, and to a great extent by the same people, whether musicologists or just plain music critics. Nor is the situation that much the same in literature either, despite all the truth there is in what E. D. Hirsch says. Literature of the past still does get discussed often enough in terms of aesthetic value. And while most literary scholars proper may not come near contemporary or very recent literature, literary critics still range between past and present with their value judgments, and do so as a matter of course, taking it for granted that without keeping an eye on the past it would be impossible to keep taste sharp enough for the present. Of course there are exceptions here, but these are mainly reviewers, not literary critics proper, and not taken seriously—as, alas, their counterparts in the field of art are.

The difference for current art writing stems, I feel, from what's become the entrenched assumption that modern, modernist painting and sculpture have broken with the past more radically and abruptly than any other modernism has. The assumption is wrong, just as the notion of a radical break as defining modernism itself is wrong. This doesn't make the assumption any the less prevalent, as it has been for a long time. I remember Paolo Milano—an Italian man of letters and as cultivated a person as

I've ever known—telling me back in the 1940s how surprised he was to gather from a review of mine in the *Nation* that I saw modernist art as not fundamentally or even phenomenally different in kind from art of the past; that was new to him. (His remark made me realize that originally I myself had made the same assumption to the contrary and had come to abandon it only unconsciously. In that *Nation* review I'd not at all made a point of indicating this change of view; I hadn't even known I was indicating it.) Anyhow, a large consequence of this assumption of a radical, epochal break between the visual art of modernism and that of the past is, finally, the further assumption that the former has made value judgment, made taste, irrelevant in dealing with painting and sculpture.

As I said in the beginning, even when it comes to current and recent art, criticism is ceasing to be criticism proper, ceasing to judge and assess. Look at the magazines devoted to contemporary visual art and see how more and more of the articles that fill them are scholarly or would-be scholarly, would-be highbrow in the academic way: explicative and descriptive, or historical, or interpretative, but hardly at all judicial, evaluative. Notice the proliferation of foot- and endnotes, and how they attest to recondite reading, most of which has nothing to do with art as art. Meanwhile the value judging is pocketed off in the spot reviews (where even so, there's always a certain coyness enforced by the art magazines' large dependence on art dealers' advertising—for which, things being as they are, the magazines can't be censured). On the other hand, there's now and then the laudatory or apologetic article about a given artist or artists that has to contain value judgments. Yet these are couched less and less in aesthetic terms. Aesthetic quality as such is no longer enough to warrant praise; other, extraaesthetic values have to be invoked: historical, political, social, ideological, moral, of course, and whatnot. But what's new about that?

What's new is something else. That the value in itself, the autonomous value, of the aesthetic wasn't asserted so often in the past, at least in the Western past, doesn't mean that we're permitted to keep on doing the same. We've eaten of the Tree of Knowledge. The more ruthless examination and cross-examination of inner experience, the more searching introspection, that have gone with the advance (if it can be called that) of rationality have shown well enough that the aesthetic is an intrinsic, ultimate, and autonomous value.[2] Art for art's sake has helped, and so have two hundred–odd years of aesthetics, both of them giving much and taking away enough. There's no excuse now for not realizing that when the

absolute value of the aesthetic is doubted, the reality itself of the aesthetic is doubted, the absoluteness being inseparable from the reality. Just as this reality is there and can't be thought away, so the status of that value is there and can't be thought away.

(1981)

Notes

1. E. D. Hirsch Jr. in the *New York Review of Books* (14 June 1979): "Ever since Plato, literary theory has concerned itself almost exclusively with the problem of value, e.g., 'Are the ancients better than the moderns?' 'Are standards of judgment universal?' You can read through virtually all the major works of the important literary critics before the twentieth century without finding an extended discussion of the problem of interpretation. In Britain, writers like Sidney, Pope, Hume, Johnson, Coleridge, and Arnold . . . asked of a piece of writing, 'Is it good?' or 'Why is it good?' rather than 'What does it mean?'

"By contrast, ever since the revolution begun by the New Critics during the 1940s, and the enormous increase in the numbers of academic interpreters over the past forty years, the question of value has fallen into the background."

2. This doesn't mean the same thing as *supreme* value. To claim this was the art-for-art's-sakers' unnecessary mistake. The great Charles Peirce did, however, argue that whatever is valued for its own sole sake, even when it's a supreme sake—like human life—has in the showdown to be understood as being valued aesthetically; in other words, anything valued as an end in itself, as something other than a means or instrument, is experienced in the aesthetic mode. Which isn't to say that absolute values have equal status. All the art that's ever been made isn't worth the life of a single human being.

Bearing this in mind can make the doing of art criticism—of any kind of aesthetic criticism—difficult. It means writing about art as art before anything else. And it does seem easier to write and talk about art as something else. I know it's easier for me. But it doesn't catch my interest much when I read or hear that kind of writing or talk. Almost, if not quite, I can do without it.

• •

Intermedia

• •

THE SCENE OF VISUAL ART HAS BEEN INVADED more and more, lately, by other mediums than those of painting or sculpture. By "scene" I mean galleries and museums and the art press. Now these welcome performance art, installation art, sound art, video, dance, and mime; also words, written and spoken; and sundry ways of making poetical, political, informational, quasi-philosophical, quasi-psychological, quasi-sociological points.

The printed page, the stage, the concert hall, the literary recital platform haven't been nearly so hospitable to the incursions of mediums not originally proper to themselves. It's true: drama, opera, and dance are by their nature "intermedia" or "multimedia." But words, sounds, movement, and mime are respectively primary in these art forms; in each case the overriding, all-embracing mediums, those on which taste-cum-attention is focused. This isn't true, or hardly so, with "intermedia" in galleries or museums. The "happenings" of years back already showed that. They "happened" in the context or setting of visual art, and most of the people taking part had to do mainly with visual art, yet they exhibited hardly anything that was actually visual art as such.

Hardly any of the creators or agents of "intermedia" started out as

actors, musicians, dancers, or writers, let alone as poets, philosophers, psychologists, sociologists, or political thinkers; not even as interior decorators, let alone architects. They almost all started out as painters or sculptors, or at least more in the neighborhood of these arts than any other. (The exceptions are only exceptions.)

There's nothing necessarily wrong in all this. Good art, great art can come from anywhere. Means don't matter, only results. The question of value or quality doesn't concern me here and now. What does is the *why:* why the scene, area, field of attention of the visual arts (excepting architecture, for good reason) should now be so open, so much more hospitable to extraneous mediums than any of the other scenes of art.

A good part of the explanation has to do, I feel, with the special and large place that painting (not sculpture or architecture) takes up in the whole spectrum of modernism. It was painting that was first compelled, in the mid-nineteenth century, to innovate and "experiment" in technical, material, utterly "formal" ways. It was painting that had earliest in the course of modernism to dig into its "mechanisms." That was in the beginning of the 1860s, with Manet (and him alone). None of the other arts on their way to modernism had that early to dig into their own entrails. Certainly not sculpture, not music, not dance, not even literature. Whitman's free verse, Gerard Manley Hopkins's new metrics are discussable here. So are Mallarmé's liberties with word order and syntax, and maybe grammar too. But none of these affected the medium of verse as radically as Manet and then the impressionists affected the medium of pictorial art. Flaubert and Baudelaire don't pertain in this respect: it was their matter, not their *form,* that scandalized. (The same might be said of Mallarmé, almost, whose versification stayed so traditional at bottom.) In music Debussy broke with the melodic and harmonic conventions of the eighteenth and nineteenth centuries nearly thirty years after Manet had done the equivalent in painting. Dance had to wait till a decade into this century before becoming "free." It was only in 1912, with Picasso's first bas-relief constructions, that sculpture "liberated" itself from the monolith; and only around the same time did Brancusi's insistence on the compact monolith "rid" sculpture of its obligation to lifelikeness.

So it was painting that in the beginning profiled itself as the modernist, the avant-garde art par excellence. (Gautier, that forerunner, glimpsed that.) In the latter nineteenth century painting was what startled most, and kept on startling most. (No value judgment here.) In the first decades

of our own century it continued to be the "cutting edge" of the new. See how poets and even composers in Paris invoked cubist painting for their own newnesses. And so at the same time, if more indirectly, did the initiators of modernist architecture.

By and large the situation hasn't changed since then. Sculpture of the "constructivist" kind that came out of Picasso's 1912–13 bas-reliefs may have become more "cutting edge" than painting (at the time it told Duchamp what direction to go in order to go "far out"), but this only enhanced the status of the visual as the area of the newest. (It should be noticed that the repudiation of the monolith, as, say, in Lipchitz's "transparencies," meant a more radical, more historical break with civilized, generally urban, not just Western traditions of sculpture than took place with regard to the equivalent in any other of the arts under modernism.) But painting was still to be heard from. After Pollock, and after Newman, the scene of visual art looked still more like the ambience of the newest in art. It began, too, as the 1960s wore along, to look like the place where anything went, where (to borrow the late Harold Rosenberg's expression) the "tradition of the new" licensed any- and everything—licensed it as it did nowhere else, not in music, certainly not in literature, not even in dance. (It was only later on that these other arts began to try to use similar license but without getting anywhere near the same amount of attention.)

This, the original and now longtime leadership of visual art in the matter of modernist newness, this is what I want to suggest as explanation of the present openness and hospitality of the visual art scene to "intermedia," "multimedia," and the rest of it. But I don't think it's the whole explanation. There has to be more to it than that.

Another part of what I surmise to be the explanation sounds relatively trivial, but I don't think it is, really. The stage, the concert hall, the literary recital, the printed page require more or less extended attention. Drama, music, dance, literature take place *over* time, not just in it. Visual art is instantaneous, or almost so, in its proper experiencing, which is of its unity above and before anything else. (That's the case with sculpture in the round as much at bottom as with a picture: you have to walk around sculpture in the round, but each step gives you all you need to see in an instant; when you linger you lose something. It's more or less the same with murals and scroll paintings: they deliver themselves from point to point, in instants; and as with round sculpture, the connecting of those instants—their flow into one another—is instantaneous too.) It belongs

to the essence of visual art that it dismisses the factor of time by crowd-ing so much, against all reason, into a point or points of time (like mak-ing innumerable angels dance on the tip of a pin). (And the pleasure to be gotten from the details in visual art? That's to be considered, but it's a subordinated pleasure or satisfaction, not to be compared with what's gotten from a visual whole, a unity.)

The virtual suppression of the time factor is another reason, I sug-gest, why items and events are put up with in art galleries, museums, and other places where visual art is the main thing as they wouldn't be put up with elsewhere. In any case, galleries and museums are to be sauntered through—you sit down only to rest. They can be escaped from as theaters and concert halls can't be. True. Performance art et al. ask for an attention span, time, but it's so much easier to walk out of a gallery or museum than a theater or concert hall without seeming rude. Considerations like these seem petty, yet they count; they belong to life as lived, in which boredom can turn into anguish. Anyhow, given the visual-art setting, per-formance art, body art, etc., don't—usually—ask for too much time, too much attention span.

In the *New Yorker* of 25 May 1981, Calvin Tomkins, writing about video art, put his finger on the time factor. He said that video art "asks for the kind of concentration we are expected to give to painting and sculpture, and it also asks us to give up our time." He means video as directed to "purely visual rather than dramatic, narrative, or documentary ends." That is, video as seen in galleries and museums, as what Mr. Tomkins as-sumes to be "art as such," "fine art." That I'd quarrel with his assumption, since I find that anything can be art "as such," even if dramatic, narrative, or documentary, is beside the point. (The whole of the Tomkins article is very much worth reading.) What is to the point is that only galleries, museums, and other visual-art venues (like colleges) put up with video as "purely" visual art. TV won't, nor will movie theaters. Commercial mo-tives stand in the way, of course. But these can have cogently aesthetic rea-sons. Mr. Tomkins finds most of video art that's presented as "purely visu-al," as "art as such," boring. I too. (And now a value judgment has slipped out. Well, the children of midcentury and after seem to have mutated into a tolerance, nay an appetite for boredom in the aesthetic realm that's unprecedented. It may be the newest of all things new we've seen yet.)

But in letting Mr. Tomkins take me into the problem of video I've wandered away a little from my subject. Video is just one among other

newcomers to art galleries and museums. And I feel that the two hypotheses I've offered to explain these newcomers still don't explain enough. Something more must be there, something more embracing than the early innovativeness of modernist painting on the one hand and the factor of time or attention span on the other; some shift, I'd say, in the appreciation of visual art by the nominally cultivated public (I mean the public that follows "advanced" art). I think it's a shift away from *taste* as such with respect to visual art as such (to echo Mr. Tomkins partly), a shift away from the demands of taste insofar as they have become, or seem to have become, more taxing with respect to visual art as such. This would account for the acceptance of still other phenomena than "intermedia": of pattern painting, of the "new aesthetic of bad taste," and more.

Yes, but how to account for the shift itself? The ordinary bad, untaxed taste obtaining since the 1850s or earlier is still with us. What's new (but no longer surprising) is that such a relatively large part of this taste in all its unsophistication should now focus on avant-garde or nominally avant-garde art. But this is a clue, not an explanation. The art boom of recent years is another clue. They both lead to the fact that great, great numbers of "new" people, people from rising, "new" social classes, new middle classes have entered the sphere of higher culture. And these people in their youthfulness identify higher culture with newness, advancedness, the "avant-garde." Why they do this now, as "new" people haven't before, is still another question. Suffice it that the authorities have come to recognize that the radically newest art since Manet has been by and large the best art, and they act on this recognition blindly as it were. And "new" people go by authority. But the situation is circular: those who staff authority nowadays are in effect "new" people themselves, new in the demoralization so to speak of their taste as brought about by the retrospected triumph of the avant-garde.

Anyhow, "new" people, when they come in great enough numbers and especially when the authorities are shaken, tend to bring standards down, at least for the time being. That, as I see it, is the main reason why nominally cultivated taste declined in the West from the 1840s on (though authority wasn't nearly as much shaken as now). Modernist, avant-garde art, literature, music arose in answer to that decline. (That's not the only reason; there were ones internal to the arts themselves; there was, as usually in human affairs, a coinciding.)

What's ominous is that the decline of taste now, for the first time,

threatens to overtake art *itself.* I see "intermedia" and the permissiveness that goes with it as symptoms of this. Not necessarily, but as it happens. Good art can come from anywhere, but it hasn't yet come from "intermedia" or anything like it.

(1981)

• •

To Cope with Decadence

• •

OUR WESTERN CULTURE HAS BEEN IN A SINGULAR POSITION
the past 150 years and maybe more. It's the only high urban culture—
civilization—that's still quite alive. I can think of only one precedent in
this respect: Sumer, five thousand years ago, which is said to have been
the first literate culture, and in being the first was the only high urban
culture extant for a while.

By a culture that's still alive, I mean one that's still developing, one in
which change fulfills potentialities. To be sure, a culture or civilization can
be developing in certain directions and not in others. But no matter what
particular direction or directions are taken as indices, all the non-Western
urban cultures seem now long decayed when not, as in most cases, al-
together dead and gone. (Japan may look like an exception, but the only
aspects under which its culture develops seem Westernized ones.)

What's not just singular but unique and altogether unprecedented in
Western culture's present position is that its reach is earthwide, that it's
become the first global urban culture, one that intrudes everywhere and
threatens to dominate everywhere, among tribal as well as urban peoples.
This is an utter historical novelty. It's not just because Western power,
with its industrial and preindustrial technology, has laid waste, and lays

waste, to all other cultures. All other urban cultures had run their course or were in a "late" stage before Western force or influence ever intruded upon them. (Yes, the West has overrun preurban cultures that may have still been thriving, but non-Western civilizations had been doing that long before, if not on the same scale.) Western "imperialism," for all its energy and aggressiveness from the sixteenth century on, was at the same time sucked into exotic urban spaces by a kind of vacuum that became one of culture as well as power (except in Japan). There was an excruciating coincidence in the fact that Western Europe had summoned up the energy, the force, and the technical means to intrude upon other urban cultures just when these had everywhere lost, or were on the point of losing, their vitality. And it was part of the coincidence that Western culture itself, qua culture, was at the height of its vitality. It hasn't been by force or enterprise alone that the West has invaded all those exotic spaces, which were spaces of mind as well as of place.

To begin with, Western art and ways of art did not march everywhere in step with imperialist power. Nor does it do so today, any more than Western ways of thinking or Western technology does. Western pictorial and sculptural illusionism penetrated, hundreds of years ago, where Europeans had hardly been, and proved as irresistible as Greco-Roman illusionism had two thousand years before in areas that Alexander's or Rome's armies never reached. Yet just as Indian artists converted Hellenistic lifelikeness into something integrally their own, so Far Eastern artists did two thousand years later with Western lifelikeness. Only, by the nineteenth century Indian and Chinese artistic tradition, and by the mid-nineteenth century Japanese too, had become too feeble, too worn, to assimilate anything to good effect anymore, whether from other traditions or from lived life.

In this century, and especially since, and despite, the retreat of Western imperialism after the last world war, the influence of Western culture, and of Western art, on other places of urban culture has increased to an extreme. Now it's no longer a question of the irresistibility of illusionism; now it's become the effect pure and simple of the continuing vitality of Western art (as of Western science, technology, and even scholarship). That vitality shows itself nowadays in modernism. Modernist art goes away from illusionism, yet in its modernist phase Western art has spread itself more "seriously" than it did before. What I could see for myself, visiting Japan and India in the 1960s, was that artists there weren't Westernizing simply as part of a general effort to Westernize or modernize in their coun-

tries. In much greater part it was because of the perception of how much better, how much more alive, recent art from the West was than anything being done in traditional ways at home. At the same time modernist art seemed to offer them a range of directions in which to be themselves as neither Western art before nor their home traditions any longer did.

Now there *is* such a thing as truly international art, visual art anyhow (including architecture). But it remains Western art, stays charged from and centered in the West. There, alas, the fate of high art over the only world we know is being decided, because there alone high art, high urban art, remains fully alive and fully rooted.

The spread of Western culture doesn't appear to affect its internal situation. Just as the course of Greco-Roman culture wasn't, seemingly, affected by its spreading beyond its homeland or, on the other hand, even by the incursions of barbarian outsiders. Western culture, with its art, seems to keep on evolving according to its own inner logic, its entelechy, uninfluenced at bottom by events at large. (I'm not going to argue about how that autonomy maintains itself [of course it's not absolute]. Nor would I assert it, necessarily, as a hard-and-fast fact, but it has been, and is, a very useful working hypothesis; it's hard to make sense of the history of culture or of art without entertaining the notion of autonomy.)

Yes, I've been talking in Spenglerian terms. Cultures and civilizations do run their "biological courses." The evidence says that, and the evidence forces me to accept Spengler's scheme in largest part. (This doesn't mean that I don't find the climate of his mind repellent. And he can be silly. And even I have caught him out in an error of fact. Nevertheless, certain of his insights are large, and they hold up.)

A feeling of "lateness" was already in the air in the West by the middle of the nineteenth century. My reading hasn't been wide enough to tell me how explicit it was made, but it was there implicitly among certain "aesthetes," especially in France: there as a mood more than anything else. Today a feeling of "lateness" abounds in many different ways, showing itself confusedly. Not that journalists and critics think that Western culture is in the late stage that Spengler said it had entered with the nineteenth century. When they talk of "postmodern," "postmodernist," and "postindustrial," they mean only that something has finished and something new is taking its place. They expect new beginnings. Their talk is superficial—as if there were anything in sight that was replacing industrialism, and as though modernism in the arts were just one episode among others. But what this

talk symptomatizes is not superficial. The sense of "lateness" goes deeper than the "post" vogue.

If Western lateness, which means Western decline, is an actual fact, then our culture is headed—in Spengler's scheme—toward the same fate that overtook all previous, all other high cultures. It will become lifeless in the same way. But this will mean, as it now looks, far more than it did in those previous cases. Because then there'll be no more living high urban culture anywhere. (Spengler saw Russia as coming to the rescue: that is, the Russian as the next new high urban culture. But the prospect is too remote to concern anybody, including Russians themselves, for the time being.)

It's as though the first full-fledged modernists in France, back in the 1850s (Baudelaire, Flaubert, Gautier, Manet, et al.), set out deliberately to upset Spengler's scheme of decadence and decline beforehand. Modernism in the arts emerged in answer to what was felt as a radical lowering of standards—aesthetic standards—and it remains an answer. Modernism, or the avant-garde if you please, is one more new and unique historical phenomenon, another way in which the West has produced or witnessed a historical novelty. (I seem to detect tentatives toward something like an avant-garde in the remoter past of Chinese and Japanese pictorial art, but all of them aborted.)

In the upshot it looks as though it remains to modernism alone to resist decline and maintain the vitality of the Western arts, and by doing that to maintain the vitality of high art in general, of high art anywhere—given that high art lives now only on Western terms. The vitality of art means the upholding of aesthetic standards. (When I say art I mean all the arts, including literature.) Aesthetic standards happen in this time to be far more precarious than those of science or scholarship or technology. Western science and technology don't seem to be threatened yet by decline. Spengler was as wrong in seeing this sixty-five years ago as in seeing in modernist art nothing but evidence of decadence. Nominally modernist, would-be modernist—or "postmodernist"—art is shot through with signs of impotence, but this still doesn't compromise authentic, genuine modernism, which can, and continues to, define itself by superior quality. By the same token it copes with "lateness" and decline.

(1982)

III
· ·

ART AND CULTURE

· ·

• •

OLD INDIA: HER MONUMENTS

• •

TWO MONTHS IN INDIA MADE ME AN ADDICT of her old sculpture. That includes her temples, which are sculpturally shaped in their construction as well as in their adorning. The old Indians were particularly, especially sculptors; they were obsessed by volume-enclosing surfaces.

An addiction does not necessarily mean a preference. Preferences in art depend, or should depend, on pure aesthetic judgment. My addiction to Indian sculpture does depend partly on that, but it also depends on a certain suspension or adulteration of aesthetic judgment. I'm fascinated by the very unevenness of Indian sculpture, by its failures as well as successes—or rather by the spectacle these make, the spectacle of this unevenness in all its profusion. It speaks for a unique vitality. No other tradition of sculpture can show its like. No other tradition shows an equal longevity, not even the old Egyptian or the Chinese: there, the lapses of quality amount to actual interruptions of quality; in India the lapses get swallowed up in a sustaining unevenness as it were, in a self-renewing unevenness. When they finally amount to an interruption, it's at the end only.

The constant self-renewal of Indian sculpture over the course of two millennia sets at naught such orderly notions of rise and decline as the history of artistic quality seems to impose elsewhere. In India different

schools or regional tendencies came and went, crossed and entwined, one rising while another was declining, and so on. What in any other artistic tradition might look like decadence could in India body forth in a culmination or climax. Who would believe, before seeing, that such flamboyant detail and elaboration as are found in Hoysala sculpture of the twelfth century could make for such contained perfection? Or that such perfection could come so late in a millennial tradition? Conversely, some of the far earlier Buddhist sculpture in the north manages to look decadent in all its vigorous clumsiness. It's as though the complicatedness of the history of quality in India echoed the complicatedness of detail in so many Indian works of art themselves. (Do I have to say that complicatedness is not the same thing as confusion?)

Under all this there must be—among other things—the centrifugal drive of the Indians, their urge to differentiation. It manifests itself in religion, politics, language, social distinctions, dress, diet, physical size, skin color—in almost everything except hair and eye pigmentation. But there is also an opposing tendency to blend or gradate differences—and this makes for still more complicatedness.

From the first, Indian art focused on the nude or nearly nude human figure. It was perhaps confirmed in this respect by the influence of Hellenic art, which came relatively early on during the Buddhist phase. But whereas the Greeks emphasized the masculine, Indian art feminizes. Often, especially in Hindu art, you have to look twice at a partially clothed figure to recognize it as male. Yet there's no suggestion of the homosexually tinged feminization of the male form that is seen so often in late Greek and in Roman sculpture. With the Indians it's more a question of reconciliation, of the softening of differences, than of femininity as such, even granted that their art paid more attention to the female nude than any other art, not excluding Western European, has. It could be said even that the Indian "will to art" is actually a very masculine one, and that it drives toward the feminine precisely because it is so masculine. (Just as it is my paradoxical impression that the Indians could so abundantly depict or describe sexual activity because sex was not really that much on their *minds*, in their *heads*.)

Indian temple architecture, in its urge to reconcile differences, wrestles with rectilinearity and rectangularity on behalf of the curved and rounded. But it never suppresses either of the former entirely, not even in the Buddhist stupa. Some of the extraordinary beauty of the "medieval"

Hindu temple arises from the way in which it resolves or contains this struggle: as in the swelling, tapering towers at Khajuraho, to name one example out of many. The Hindu temple can be stupendous, but it seldom inflates itself into the merely colossal; somehow it remains in human scale, or commensurable with human scale—which is not to say that the profusion of chiseled detail and the multiplicity of projecting and reentering angles, lateral and vertical, won't bewilder the eye on closer approach.

Here the obsession with three-dimensionality, with sculptured form, is partly responsible. Whatever else he did not suppress or exclude, the Indian architect and artist did suppress flat surfaces or planes. And it seems to follow from this obsession with three-dimensionality that the Indian painting that got started in the Buddhist period should be the only kind outside Greco-Roman and Western European to shade or model representations of the human form in a consistent way in order to achieve an illusion of relief and volume. The Greek influence cannot account for this altogether. Other peoples, exposed to that influence at much closer quarters, did not accept it; the Indians did, and the explanation lies with them, not with the Greeks or the Romans. Moreover, Buddhist painting came to full fruition in Ajanta, centuries after the influence or presence of Hellenic art was first felt in the subcontinent, which would indicate that it proceeded to that climax on its own momentum.

In Ajanta, too, there is the effort to blend differences. Relief (incorporating highlights as well as shading) and flatness are reconciled with a kind of explicitness whose like cannot be found in Western pictorial art. As Maurizio Taddei points out in his text, painting at Ajanta does not concern itself with an illusion of space within which volumes are contained. Rather it creates an illusion of volumes from within which space presses outward. Space, volume, mass are as though summoned from some inner center or source.

At this point I can't refrain from drawing one of those tenuous-seeming analogies that I usually hurry to disallow when drawn by other people. As given as they were to sculpture and the sculptural, the art in which the Indians have, I think, excelled most signally (as Christian Europe has excelled in music) is that of the dance. They are the incomparable masters of human physical movement as a means to artistic creation. The movements of dance start from within the body. Well, I sense a kind of analogous movement not only in the painting of old India but also in her sculpture and architecture, Buddhist, Hindu, and Jain. Surfaces, shapes,

masses, spaces do not so much gather around a center as issue from it: swelling, thrusting, bristling. The stupa is, of course, an archexample of this centrifugal pressure. So, in a different way, are the cliffside reliefs at Mamallapuram. But something similar is exemplified, even if much less obviously, in the sculpture of a cave shrine like the one in Elephanta.

This movement outward from an inner center—once again it's the Indian centrifugal urge. Or has the analogizing become too facile and overdone by now? Is this the sort of thing the understanding grasps at in order to explain to itself what's beyond conceptual understanding? As all art, good and bad, Indian and other, is. Quite likely. But at any rate my addiction to Indian sculpture does not derive from any intellectual construct or analogizing interpretation; it derives from direct experience, plain experience.

(1972)

• •

Influences of Matisse

• •

THE WORD "DECORATIVE" IS NO LONGER USED AS FREELY as it once was in finding fault with works of pictorial art. Too much of the best art of our time was criticized, when first seen, for being too "decorative." Matisse's art in particular was criticized for that, and it continued to be criticized for that. But if the word is now largely discredited, at least in its pejorative sense, it's Matisse's doing more than anyone else's.

That's but one of the ways in which Matisse upset received ideas or received attitudes. No doubt every great artist has done that, more or less, and especially the great artists of the last hundred-odd years. But Matisse's art, peculiarly, has done so by again and again escaping from the place or places assigned to it by critical opinion, even the best critical opinion.

Thirty years ago and less he was supposed to be beside the point as far as ambitious new art was concerned. The excitement was with Picasso, Miró, Mondrian, Klee. Things have changed since then. I would say that, for a while now, Matisse has been a more relevant and fertile source for ambitious new painting than any other single master before or after him. But even at the time I'm speaking of, thirty years ago, things were already beginning to change, in a gradual way. Milton Avery had long been painting under Matisse's influence, and Hans Hofmann, having begun to paint

again some years before, was carrying that influence over into abstract art. And in his teaching Hofmann was insisting on Matisse's exemplary virtues as he insisted on little else. At the same time there were a few very serious young artists in New York who were learning about Matisse for themselves, sometimes in a more unconscious than conscious way. You found your path to Matisse, not because you were told he was a great painter—often, back then, you were told he wasn't—but because the more you came to ask of painting as sheer painting, the more you were stopped and held by him.

By the later 1940s I dare say Matisse was being looked at harder and longer by younger painters in New York than by younger painters elsewhere. That shows in their art. For I would also say that Matisse's influence, whether direct or indirect, accounts for some of the features that distinguish abstract painting in this country since the 1940s from most abstract painting elsewhere, and particularly in France. It's as though American art, in its handling of paint and of the color of paint, has maintained French tradition more faithfully than French art itself has since that time. If this is so, it's thanks to Matisse's assimilation by Americans more than to anything else.

What was assimilated was not only Matisse's color, but also his *touch*. That touch, Matisse's way of putting painting to canvas, hasn't been celebrated enough—not nearly enough. That touch was a great acquisition, and not only for Matisse himself, but for other, younger painters, particularly American ones. What should be noticed is how Matisse laid on and stroked varying thinnesses of paint so that the white ground breathed as well as showed through. But even when he laid his paint on evenly or more densely, or when he used a palette knife—which was seldom—the paint surface would still manage to breathe. The paint surface, even when the picture as a whole failed, would maintain its liveness. (The exceptions were surfaces that had been covered with too many coats of paint—too much "corrected"—but as many as these exceptions may have been they were still exceptions.) Not all the American artists who learned from Matisse—whether directly or through Hofmann or Avery—followed him in the matter of touch. Certainly, Hofmann himself didn't. But even when they troweled their paint on, built it up in layers or films, dripped, or sprayed it—even then an awareness of Matisse's "aerated" surfaces seems somehow to have been present and to have informed what

they did. And I think that that awareness is still present in the best of more recent American painting, whether abstract or figurative.

There was of course, more to Matisse's influence on American abstract expressionism than his touch. There was also, and not least, his very approach to easel painting. Matisse's smallest, tightest, most involuted pictures are still not quite "cabinet" pictures in the way that Picasso's, Braque's, or Léger's largest paintings are. Picasso's pictures tend to close in on themselves, no matter what; Matisse's, to open out, no matter what. It's as though Matisse (along with Monet, but in a quite different way) tried to wrench easel painting away from every one of its sources except wall painting. For the sake of sheer spaciousness and airiness, for the sake of an art that would be utterly pictorial without being claustrophobic. Not that there's any necessary virtue in spaciousness and airiness, or any necessary vice in smallness and tightness. But it was as though Matisse (like Monet) felt that in order to expand the range of easel painting, he had to deconvolute it and make it centrifugal in organization instead of centripetal. (Of course, neither Matisse nor Monet felt literally "required"; all they did was go where temperament and inspiration impelled them—and where the circumstances of art in their time permitted them to go.)

Matisse's larger paintings—those of them that got seen in this country in the late 1930s and in the 1940s—had a momentous effect on abstract expressionism. I remember his *Bathers by a River*, c. 1916. It hung for a long while during the late 1930s in a Fifty-seventh Street art gallery (it now belongs to the Chicago Art Institute). Its broad vertical bands used to give me trouble: they were too even and made the picture itself too dispersed. My eye was used to concentric, compact, and more closely inflected pictures. This big picture slid my eye over its surface and seemingly out through its sides and corners. It was years later that I got to see Monet's lily-pad murals in the Orangerie in Paris, and they were even more centrifugal in organization than *Bathers by a River,* but they weren't as "flat" and didn't cause my eye to "slide" nearly as much—though they, too, seemed to leak through their sides and corners. But by that time I knew more of what it was all about, and so did my eye.

Picasso and Braque, when their cubism was analytical, used to have trouble with their corners, trouble bringing them into the rest of the picture (which may explain why they would often resort to tondo or oval formats). In the early and mid-1940s certain American abstract painters

(who were beginning to learn from analytical as well as synthetic cubism) had trouble with their corners too and also with the vertical margins of their pictures. It was a question of bringing them into the ambiguous illusion of space that the main part of the picture showed. Matisse's bigger paintings, with their centrifugality, brought the solution, in defiance of what till then had been (for Pollock as well as for Gorky) an essential part of the notion of the well-made picture. The abstract expressionists became able to let their paintings spread and expand, in terms of design as well as in size. Now the corners and the margins of the picture could take care of themselves. They no longer had to be filled in or specified. Matisse's influence was far from being the only factor in this development. But that it was a very important one seems to me to be indisputable. Just as it seems to me indisputable that it was his example, most of all, that helped Miró open up the picture and deal in the broad and relatively uninflected, relatively empty expanses that show in the extraordinarily original (if not always achieved) paintings he did from 1924 to 1927 (which in their turn, too, greatly influenced American abstract art).

I've just said that Matisse was far from being the only factor in the opening up and expanding of the abstract expressionist picture. There was also the later Monet (whose art Matisse himself seems to have been untouched by). Monet's influence comes a little later and was particularly important to Barnett Newman and Clyfford Still and—indirectly—to Morris Louis as well as Rothko. But I don't think I'm claiming too much for "my" Matisse when I say that his influence on American painting at its best continues after Monet's leaves off. He sensed better, more prophetically, that heightened sensitivity of the pictorial surface which is now making the latter more and more allergic to whatever interrupts, whatever takes away from, its feeling as a taut continuum. It's this hypersensitivity that now summons (in the wake of Jules Olitski) those "emptinesses" which invade the best of recent abstract painting (in lieu of the allover repetitions that likewise preserve the tautness and the continuum, but in a way that, since Pollock and Tobey, has become more or less academic except in the hands of a Noland or a Poons). Well, Matisse was the first to admit anything like those "emptinesses" into respectable art, sixty years ago and more. Rather, he made those "emptinesses" themselves respectable.

The superior artist is the one who knows how to be influenced. Matisse certainly knew how, especially when, as in the 1920s, he reached back into the past, to Chardin and Manet. But there was one moment, before that,

when he let himself be influenced, profoundly, by art done by people younger than himself and to the greater advantage of his own art. Maybe it was to the very greatest advantage of his own art. I'm referring to the time during which Matisse "felt" cubism. I can see that beginning to happen in 1912, if not earlier. Black came into, or back into, his palette in that year, but settled there only in 1914. This could also be attributed to a general darkening of palettes in advanced French painting around that time. But cubism had to have something to do with it. The evidence is there in the way Matisse began, in 1914, to true and fair his drawing, as well as to introduce other than prismatic colors to his paint. By that time he had already done enough with color to plant himself across Western tradition in as epochal a way as Titian, Caravaggio, Rubens, Rembrandt, Manet, the impressionists, and Cézanne had. All the same, I think that his color gained from 1912 on and especially after 1914. Bringing in frank blacks and grays and also franker whites and then, later on, earth colors (umbers, ochers, sienas) gave Matisse's color a new weight and at the same time a new smoothness and new airiness and lambency. Somehow his prismatic colors became pearlier and furrier through their juxtaposition with non-prismatic colors, or through the mere presence of the latter somewhere in the picture; by the same token the blacks, whites, grays, and earths began to act like prismatic colors themselves. Color, now being employed across its whole, more-than-impressionist range, became owned by Matisse in the years right after 1916 as it was never owned by any other artist, or in any other art, that I have seen. And it doesn't affect the case that Matisse's paintings after 1917 became much more modest in seeming ambition, as well as in size and "vision," than those of the years previous. They remain and they *weigh,* as Raphael's small earlier pictures remain and weigh.

It tells that it was Matisse's postprismatic color that influenced Miró most, especially with regard to black, white, and gray. It also tells that Avery's color was most influenced and formed, in its own individual way, by Matisse's postprismatic phase; it's from that phase that Avery learned how to cool and clear his view of nature. And maybe Hofmann, who could never forget the fauve and immediately postfauve Matisse, would have steadied the quality of his own art—as high as it is—had he learned more about that same cooling and clearing.

Two of Matisse's strongest paintings have for their respective subjects a window, table, two chairs, and a bowl of flowers (*The Window* of 1916, in the Detroit Institute of Arts); and a marble-topped table in the open with

a few small objects on it (*The Rose Marble Table* of 1917, in the Museum of Modern Art). These pictures were painted during the darkest days of the First World War. Matisse lived through and amid two world wars. During the second one, most of his subjects were of a kind, and visualized in a way, that wouldn't have been out of place in a fashion magazine (which isn't quite to say that the sheer pictorial quality—as uneven as it was—of these paintings sank to that level). What are we to make of this apparent distance of Matisse's from the terrible events of his time and his place? What are we to make of his "coolness" in general? What I make of it is something that I want to celebrate Matisse's character and person for, Matisse as apart from his art. It's as though he set himself early on against the cant, the false feeling and falsely expressed feeling that afflict the discussion of art in our culture. He challenged and defied that cant, in what he said aloud as well as in what he did in his art. I can't admire enough the kind of courage that *permitted* him to write for publication, back in 1908, that he dreamt of an art that would be like an easy chair for the tired "brain worker"—that is, the businessman and the intellectual and even the bureaucrat, not the "toiler." And it was an art that would refresh the brain worker rather than uplift him. That Matisse's art actually does ever so much more than that—including "uplifting"—isn't to the point here. What is, is that he himself was willing to claim only so much and no more, for it. And maybe those who might want to bestow their own rhetoric on his art were being warned off. His art would speak for itself— just as all art does when it comes down to it, good and bad art alike.

Matisse's art speaks for itself through its "mechanics," its "form," and through the feeling which that "form" makes manifest. It's not by far the first to do so and to transcend the illustrated subject by doing so. (All good painting and sculpture does that to some extent.) But just as Matisse rejected verbal rhetoric, so he kept every last trace of illustrational rhetoric out of his art. He may have been the first painter in our tradition to do that in a really radical way. This doesn't make his art better than a Giotto's or Caravaggio's or Goya's or David's, not necessarily. But it does make it a salutary example for all those people who find it hard, in any medium, to mean what they say.

(1973)

• •

FOUR SCOTTISH PAINTERS

• •

THE ARTIST GOES TOWARD MATURITY through a succession of acts
of taste, decisions of taste. In the course of these he comes to terms with
the art preceding him, and crucially with the art immediately preceding
him. Doing this, he begins to decide just how ambitious he'll be. The
ones who've turned out the best artists (or writers or composers or per-
formers) have usually been those—or among those—able to sort out the
best, or enough of the best, in the art immediately preceding them. The
sorting out is a necessary, if not sufficient, condition for the unfolding of
their art.

Sorting out, discriminating the best, means rejecting the less than best
(it can even mean rejecting, for yourself, what's good but not good enough
to be the best). Sometimes the rejecting comes before anything else—as I
think it did in Manet's case (his revulsion at the "stews and gravies," at the
dull, neutralized color he saw in most of the painting being done around
him when he was starting out in the 1850s, was crucial to the development
of his originality; the revulsion led to his more positive acts of taste).

Abercrombie, Gouk, McLean, and Pollock had, as I see it, to do a lot
of rejecting in order to arrive at what they affirm. What bulked in the
foreground of the scene of contemporary art when they came upon it, as

Salon painting did in Manet's time? Pop art and Francis Bacon, minimal and conceptual, process and land art, and *tutti guanti*. They turned their backs on all that, to home in on a tendency in recent North American painting that's better known from the attacks than from the praise it has received.

These four young men looked for themselves; that is, they weren't afraid to do so, they weren't afraid to go where their eyes led them, against the scene and against the publicity. Well, the genuinely ambitious, "serious" artist does look for himself and does let himself be guided, willy-nilly, by his eye or taste—that belongs to being genuinely ambitious and "serious": you may want to go for Bacon (as I do) but having to do (as I do) for Olitski instead (which is to put it mildly—not that I rate myself with "serious" artists, but that I think I do know how they, and not they alone, receive, and don't all take, the decisions of their taste).

These four Scots aren't the only painters in London or elsewhere in Britain to home in on "color-field" (a label I detest) painting for their point of departure. But they appear to me to have done so with a certain distinctive resoluteness as well as independence, unencouraged by anything seen around them in London, that is, anything belonging to London. They saw not only how good Louis, Noland, and Olitski were; they also saw—or at least John McLean did—how good Jack Hamilton Bush was.

But I don't want to imply that the North American influence accounts for everything in the art of these four. It accounts for more than Cézanne's influence did in the case of Matisse or the cubists. The painters at hand aren't slavish to their main influences. They add something; that's why they're noticeable. Nor are they all of a piece. What they have most in common, aside from the abstractness of their art and the New American influence, is their level, the level of their quality (which comes only in part from that influence). Otherwise they go their separate ways—not too separate, but separate enough.

All I ask is that they keep going. They're young, they haven't done enough yet; the highness of their aspirations, of their sense of quality, is still a promise that has to be fulfilled. I've just said that they'd added something already, but they'll have to add still more. They'll have to maintain their isolation from the current scene, and that's a challenge to character more than anything else. The art scene has, as it looks, become more formidable than ever, now that avant-gardism has become the affair of officials—directors, curators, ministers of culture, art councils—as well

as of art dealers, collectors, bohemians, critics, let alone aggressive artists (I remember when aggressiveness couldn't belong to anything but the authentic avant-garde). So character will decide. And Scotsmen are supposed to have character when they have nothing else. That's the impression on my side of the Atlantic.

I myself am particularly intrigued by the fact that the "serious" painters at the Stockwell Depot in London should be, but with one exception (Jennifer Durrant), Scots. Has this something to do with Scottishness, or just with outsideness—and with outsideness that is barely that? And which, being barely that, can confer a great advantage.

Over here, in America, our notion of Scottishness is rather vague: dourness, a brogue full of what may be wrongly called burrs, character (as I've said), want of sensuality, and so forth. For the rest, hardly distinguishable from English Anglo-Saxons, though very different from the Irish. (The Celticness of Highlanders isn't discerned over here, not even when it comes to the Highlanders in Cape Breton in Nova Scotia, who happen to be Catholics. Well, being just barely outside is being outside enough. Being far or further outside is liable to be intimidating and to make for conforming, submitting.)

Let me say it again: these young artists may take their direction from North American influences, but they don't submit to these. They're not defined by them. They are on their own. And being on their own, they'll have their ups and downs. That's when their character will show.

Meanwhile I keep on being bemused by the fact of these four painters: that they should have discerned, amid all the confusion and against the preponderance of opinion, where the best art of this time was; that they should have done this in London of all places; and that all four of them should be Scots. It's made me more curious than ever about what goes on in Scotland.

<div style="text-align: right">(1977)</div>

• •

Picasso

• •

HOW PICASSO AND BRAQUE GOT TO THEIR CUBISM of 1910, and proceeded thence to 1914, remains unimaginable to me. I can follow the logic of it, but can't imagine enough what went on in their minds as they worked that logic out (about which there's nothing intellectual or ratiocinative; it's solely intuitive). Retrospectively, I can put myself in their place just before 1910, when they were analyzing depicted surfaces into facet-planes. But I can't see myself bringing those facets forward to the picture plane in 1910, and going on from there to articulate that very physical plane into a new kind of illusion of depth. The wonder of it lies as well in the perfection of the art they produced as in the consciousness of the two artists as they followed their inspired "logic." No other art stops me in quite this way, and no other artists do. Not even Léger, who in 1912–14 matched Braque's and Picasso's classical perfection. But I have the fancy that I can see further into Léger's mental processes at that time than into theirs.

How did they manage to do what they did so stupendously from 1910 to 1914 with so little apparent guidance by precedent, with so few ostensible coordinates of style or taste? Cézanne's influence alone doesn't account for enough. The unhelpful answer has to be that, because they *had* to, they did find enough precedent and enough coordinates. Genius and

inspiration made them have to, and made them search out and find what they had to: coordinates and "parameters" and precedent inaccessible to others in their time (with the exception of Léger). Here genius and inspiration made themselves felt more in insights of taste than in conception, invention, or execution. To explain: superior art has always had, so far, to take off from a past, it has never come out of the blue; high Paleolithic rock painting didn't. Picasso and Braque singled themselves out, in their cubism, by the inspired taste with which they consulted the past in order to create art new enough, and good enough, for the present.

The mammoth Picasso show at the Museum of Modern Art does justice to his analytic cubism. The works of 1910–13, seen side by side in such number, make an extraordinary impression. With their inflections of neutral color they convey a shadowy depth. It's not the unlimited depth—or the bulging relief either—of the Old Masters, but it relates more to them than to impressionism or fauvism. The curious shadowiness has to do with ambiguity; the fictive space of the Old Masters has been turned inside out, but somehow it's still a good deal their space. By reembracing the past and by transforming rather than abandoning that illusion of the third dimension on which Western pictorial art had hitherto depended, Picasso (and Braque) brought painting out of the past without disconnecting it from the past. Yet the final importance of Picasso's (and Braque's and Léger's) cubism doesn't rest in what it did to change art; it rests in its own supernal quality sheerly as art. Without that it wouldn't have changed art.

Full justice may not have been done by the show at the Modern to Picasso's synthetic cubism after 1919. True, Picasso had become more uneven by then, but still, not enough of the very best works of 1920–25 were present. (It's likely that difficulties in borrowing got in the way.)

Its size gives the Modern's show something of the character of a tour de force. The size is welcome for the documentation it affords. But it doesn't justify itself aesthetically. Too much of Picasso after the 1930s is shown. His quality began to fall off after 1925, but stayed high enough till the end of the 1930s. Then it did more than fall off; it sank, and it stayed sunk, at least in his paintings. The last part of the show is oppressive. The only relief is in the drawings and prints and some of the sculpture. The paintings suffer from the tiredness of the paint itself and the way it's put on, and also from their boxed-in-ness, their Cézannian respect for the rectangle, which became an academic subservience to it. The drawings and prints, however, maintain a level right to the end. Picasso seems never to

have lost his feeling for line and monochrome lights and darks away from paint. But I already knew that.

The one, the only real, surprise for me in the latter part of the show was a folded and painted metal cutout, about four feet by two and a half, called *Woman with Hat.* Sculptured in 1961, it had had paint added two years later (according to the wall label). Seeing it in the flesh, I hardly noticed that it represented a figure; it took the catalogue photograph to bring that home. The piece has a compactness unusual in Picasso's constructed sculpture: a happy transposition into three dimensions of Cézannian boxing in. The flat metal bands writhe in front of and protrude a little beyond the edges of the upright sheet of metal to which they're attached—or rather from which they emanate—but still come to rest more or less within the rectangle. The explanation I suggest of why Picasso didn't do more sculptures like this one is that his taste had stopped being inspired.

Maybe not so incidentally: I see Rembrandt, too, as drawing and printing better, by and large, than painting in old age (which isn't to discount what he painted then, far from it; he could still handle paint as Picasso couldn't anymore—but no longer compose with more than one figure). What significance is to be extracted from this, I can't say.

(1980)

CLYFFORD STILL

I WAS IN THE CASTELLI GALLERY LAST FALL at the time of Noland's show there. A shortish, nice-looking young man unknown to me came in, saw me, came over, and without introducing himself asked me what I thought of the Clyfford Still show then on at the Metropolitan. I parried by asking him what he thought of it. He said he'd been overwhelmed—or words to that effect. I said I hadn't, that I'd found too many of the pictures a yard or more too wide for themselves. The young man exclaimed at that, saying how could something like that matter in Still's case. I forget what I answered. But I didn't have the presence of mind to say that yards and inches mattered with Rembrandt, so why not with Still? Anyhow, the young man turned rather abruptly and strode out of the gallery. I was struck by his walking away in such a straight line, and so resolutely. I was also struck by his not having given the Nolands a glance. What had he come into Castelli's for? But obviously, he was disappointed in me. I did feel that his manners could have been better; he could have shown his disappointment in a gentler way (and also not deprived himself of a look at the Nolands).

This little incident is told because it says something about how Still's art has gotten itself taken. It's imposed itself—*imposed* is the exact word—as

the artist imposed himself in person. The blurb on the front flap of the jacket of the Metropolitan's sumptuous catalogue states that he "is America's most important, most significant, and most daring artist." Whoever committed this to print must have had a lot of confidence, or else pressure, behind him or her. I say "behind" and not "in." Still was still alive then. Most of the text of the catalogue was provided by him, and that text might deserve a review of its own, as evidence and symptom of a state of being that's far from common.

This article began germinating a while ago. The exhibition at the Metropolitan brought it to a head, but only a few days after (though not because of) Still's death did I begin writing it. How I regret that he won't be here to read it; I would in all likelihood have gotten a rather rough letter then, and an unanswerable one. And I would have taken a petty satisfaction from it. Clyff wounded easily, but seemed not to realize that other people wounded at all. (If I call him "Clyff" now and then here, it's because he used to sign his pictures early on only with "Clyfford," also because we called each other "Clyff" and "Clem" the very few times we talked face to face, and last but not least because his pompousness invited, and still invites, it. Telling in the Met catalogue of the late Peggy Guggenheim's invitation to show at her gallery, he has it that he "concurred." And that he "gave [Rothko] permission to write the foreword for the leaflet introducing" that show. Only in this country and its art world . . .).

Philippe de Montebello, director of the Metropolitan, writes in the foreword of the catalogue that Still's "free and startling forms owe nothing to the regularity or limitations of the canvas." That "nothing" is much too strong. The persistent verticality of those "forms" owes a great deal to the "regularity" of the canvas. Still's knifed-on drawing in detail, his outlining, breaks with the cubist-and-Cézannian canon of truing and fairing, but his designing or laying out, as original as it is, still pays heed to the ups and downs and the side to sides of the rectangle.

Katherine Kuh, to something of the same effect, writes in the catalogue that "Still's canvases rarely recognize routine limitations as they push beyond their borders in all directions." Assuming that there are limitations that are "routine," the last thing Still's pictures do is push against them vertically. His best paintings may (as Walter Darby Bannard says) push against them horizontally, but fortunately they don't push too hard. After the beginning of the 1950s the trouble is precisely, and chronically, that Clyff's canvases become too wide for their "forms," or else the "forms" are

not wide enough for their canvases. Would from then on that his canvases did push beyond their borders.

Of the seventy-nine paintings hung in the Met show, I'd say that fewer than twenty came anywhere near success. Maybe four or five actually achieved it (*PH-384* of 1946, *PH-185* of 1945, *PH-114, 1947-8-W No. 1, PH-372, 1950-E, PH-949* of 1951). But even of these my eye isn't sure. Not one of them comes off in a way that shuts out all doubt, conclusively and absolutely (the way, say, a good Pollock does, or a good Raphael). On the other hand, I remember seeing in the past a dozen or more Stills—all from between 1946 and 1950, all modest if not small in size, and all much higher than wide—that were better than anything at the Met.

The emphasis there, in point of sheer quantity, was on the thirty years since 1950—which were, after all, when most of Still's art was produced. But that was also when its quality began falling off, at first sporadically and then, after 1955 or so, consistently if not exactly steadily. (Rothko's quality began to fall off after that same year.) There are no more modest-sized pictures—at least no more get shown. Size seems to become an issue. Still's post-1950 canvases aren't just large, they proclaim that they're large. And they become too large for themselves, for the artist himself. There's a loss of needed "compression." (The word and the perception are Bannard's, whose article, "Touch and Scale," in *Artforum* of June 1971, anticipates, embarrassingly, a lot of what I have to say here.) Compression, the interlocking of shapes or areas, is what Still at his best had depended on, in the latter 1940s—that, along with "interlocking" color. This compression and interlocking had required a modest-sized support (no more than six or so by three or four feet). Within these dimensions there had to be tightness of layout—for Clyff—and then his kind of color relations could come to full bloom, with their muffling of light and dark contrasts that did so much to make his zigzag drawing plausible.

In the 1950s he began to go wide, not necessarily wider than high in most cases, but still wider proportionally than before. The largeness of the canvases he *chose* to paint on then had to have had something to do with that. But he couldn't manage even relative wideness, let alone a canvas whose width exceeded its height. This latter seems to have left him too much alone with himself: walls limit height as they don't width, and if any abstract painter ever needed the benefit of externally imposed limits it was Still. He should have been commissioned to do pictures that fitted into alcoves.

The color reproductions in the Met catalogue are rather good as color reproductions go. And Still often looks better in reproduction than in the original. Some of the plates of paintings that are wider than high spread across two pages, but five of these are printed on single pages that are extended by folded-in flaps. At first glance the flaps, left folded in with only their blank sides visible, looked to me like wide white margins, so that the uncovered parts of the plates seemed to show complete pictures. The effect was startling: I'd seen none of these in the show, and three of them looked better than almost anything I had seen, at least among the post-1950 paintings. In the next instant I became aware of the inadvertent cropping. But the surprise kept repeating itself thanks to the cursoriness with which I continued to leaf through the catalogue. Also when I left the flaps unfolded so that they alone were in sight when the book was closed. That tickled me. Long ago I'd felt that vertical cropping would have helped ever so many of Clyff's canvases, narrow as well as wide ones. Some of the wide ones had seemed to me to call not just for cropping but for bisecting, for dividing one picture into two better ones. But in the actual presence of these canvases I'd been able to visualize the crops and bisections only by holding my hand in front of my eyes. Now, if solely on the evidence of reproductions, and allowing for what the reduced size did to compress the originals—and also allowing for my distrust of reproductions in general—I felt confirmed.

Well, Still had all along shown what I thought was a lack of feeling for the format, the enclosing shape, as well as scale, of the support. But in this he wasn't so different from most of his eminent contemporaries among American abstract painters: Hofmann, de Kooning, Kline, Motherwell (whose wide paintings, as good as they are, tend to go too high), Gottlieb to a lesser extent. Pollock, Rothko, and Newman were the first to become aware, even if not altogether consciously, that abstract painting could no longer take the shape and scale or size of the support as much for granted as representational painting could, or had done. Nor could it any longer take for granted the other physical aspects of the medium: the tautness and texture of the picture surface, the substance of paint, the instrument with which it was applied, the position of the support while being worked on, whether upright or flat on the ground . . . Well, Clyff belonged altogether to his generation—though when he let expanses of what look like raw canvas into his pictures it was under the influence of the next generation, as I see it, more than Pollock's directly. It having been left to that

next generation, and the one after it, to search the medium and métier of pictorial art more radically than ever before.

It's been said, I don't know by whom, that the great artist "rises to faults true critics dare not mend." Well said, and in wanting to crop and otherwise mend art not made by myself I ought to feel more diffident. Still's faults as I see them may be necessary to his virtues. But I find that, in less than the long run, his faults overcome his virtues. And I'm quite willing to be an "untrue" critic in the matter of cropping his pictures, and in other matters too, and with other artists (including Raphael and Rembrandt). Being a "true" critic takes too much away from the fun of being a critic at all.

Still was among the most genuinely original artists of his time. But originality doesn't take care of everything. There's the conspicuous case of Gauguin, who was original all right, but so few of whose pictures, after his first, impressionist period and maybe then his Bretonese one, really come off. It's thinkable that he wasn't original enough, that his originality didn't follow through, wasn't consistent enough, was too one-sided. The same may be true of Clyff's originality, at least after the early 1950s. (Curious how his looks resembled the Gauguin of self-portraits and photographs: the similar lean and dark intentness, the similar unrevealingness of eyes, the similar aquilinity.)

Still's originality lay, among other things, in his laying out, designing, composition—more than in his detailed drawing, whose torn or feathering knifing stays quirky and idiosyncratic (and without influence—not that that says anything about its quality). The influence of 1924–28 Miró is there in his earliest abstract paintings—and what genius it took, back in the early 1940s, to see (as Gorky, a better painter all in all, didn't) how innovative and fructifying and wonderful Miró was in those years (even though he did still better pictures in the 1930s). And it also took independence to stay away from Miró's color, as Clyff did in those 1940s paintings of his, with their heavy gloom and darkness. To begin with, these pictures were gauche and weird, clotted and gnarled. When I saw them first I thought they came from a near amateur (there were already amateur abstract painters in the late 1930s) who was also an eccentric. Looking back now with the benefit of hindsight, I can see all the character. But it's only after 1946 (when Clyff had his first New York show) that the pictures begin to *succeed,* to show more than character. I remember that 1946 show. I was blind to the individuality, the character; all I could see

was the failure as art. The first successes came shortly afterward (though I believe Clyff's dating of pictures for those years only a little more than I believe Barnett Newman's dating of his own pictures between 1953 and 1960; both artists had a cavalier attitude to the truth, and not only with respect to dating). Anyhow, what Still got from Miró of 1924–28 was his stringy layout and vertical orientation; that was all, and enough.

That Still and Newman, in the latter 1940s, looked at impressionism, especially late Monet (if only in reproduction), and Turner rather than at Cézanne attests again to Still's genius, and to Newman's too. Genius seems to require percipience even more than talent. At that time it took a lot of percipience, and independence along with it, to see how good the late Monet was, and how good Turner could be (as overrated as his late art has since become). Whether or not learned from impressionism, Still's suppression of light and dark contrast became what was most specifically original in his early and best paintings, not his design or layout. This suppression always tipped toward the dark end of the value scale. And it made his quirky, never-quite-right drawing plausible. Many painters were influenced, from the mid-1950s on, by Still's lower-key muffling of value contrast—most notably Reinhardt—and it soon became an academic device. (This was sadly true in Reinhardt's case: his "black" paintings remain far-out gestures, but only gestures: as timid at bottom as his art was before, when he painted under Rothko's and Newman's influence, and even before that, when he was a "college cubist.")

Later on Still would now and then tip the scale toward light, with oranges and yellows played off against one another or against a gray or off-white ground; he was highly original here too. But he never went as far into lightness as into darkness (which answered his temperament?). And just as he couldn't let his dark paintings go without a relieving touch of brightness, so he couldn't let his light paintings go without a saving touch of darkness. These touches smacked of artiness—and Clyff was somehow arty from the first, and to the end; artiness, of 1920s provenance, explains a lot in his art. As an "untrue" critic, I can't resist imagining what might have happened had Clyff let himself go all the way in a high key, with value contrast suppressed throughout by lightness instead of darkness. Yes, that would have gone against the grain of all pictorial tradition, and not only in the West. (It certainly goes against the grain of anyone who paints from nature, which is of course where painting started from.)

As an "untrue" critic, I can see another direction Still's color could

have taken. Those best, modest-sized pictures of the late 1940s show him neutralizing color, again in an original way: not using just neutral hues themselves, but neutralizing, discoloring, tarnishing reds, yellows, blues, and whites—beautifully. But he got even more beauty from colors he didn't have to neutralize: the earths, blacks, blue blacks, brown blacks, dead blues, and all sorts of grays. And he further neutralized the neutrals, torturing them into something, with his knife, that I can't see him getting with palette mixtures alone. From still another angle, the heart of Still's originality could be said to lie in great part in the chromatic relationships he got from his neutrals and neutralized nonneutrals. He wrested effulgence from their very lack of effulgence. Yet it was in so few pictures that he brought this off.

I say, as "untrue" critic, that he didn't lead enough in the direction of his strength; he should have pushed the neutrals, particularly the earth browns, more than he did, and especially when he went into large canvases after 1950. I'm aware, incidentally, of how presumptuous it must sound to say "should" here, and all the more because the artist I'm addressing is dead. I'd feel more comfortable saying it were he still alive. But there are no rules of decorum for "formalist" criticism. The fact is, as I see it, that Still should have done more conclusively good pictures than he did. He had it in him to do more; that he didn't makes him a "problem." And problems ask for the suggestion of solutions.

His going in more and more for outspokenly spectrum color from the 1950s on cost Still quality almost as much as his going in for the larger canvas. Just as he went in for bigness, so he seems to have gone to declamatory color for the sake of impact—not out of inner urge. To judge from the Met show, the case got worse in the 1960s. On my three visits it seemed to get still worse in the 1970s. But my notes show that while I found only one painting possible in the whole of the 1960s (*PH-376*, 1963), I found half a dozen possible in the 1970s. The show went on too long, and maybe the last pictures suffered from that under a superficial impression; I have to go by my notes, and they'd say that Still's art picked up some in the last decade of his life. Yet I find it hard to believe my notes.

"Possible": the sorrow of the Met show was that there were so few works in it that were more than possible. I come back to the question of cropping. Every one of those "possibles" would have benefited from cropping. The daring—at that time—of Still's great expanses of uniform hue slightly, and with rhythmic regularity, inflected by soft alternations of

light and dark; the shapes that have become areas; the jagged or scraped edgings of dry paint—all this misses fire, often enough just barely, because of an inch, a foot, a yard too much of flanking canvas. As his paintings got bigger, Still's sense of what the enclosing shape of the support was doing to what was inside it got dimmer and dimmer. I've heard of painters who, like some photographers years back, made it a point of principle never to crop. I doubt whether this was Clyff's attitude. I doubt whether it ever entered his mind. He painted on stretched canvases and let himself be controlled by that, just as most painters before his time were. He never made a move that was innovative in a technical, medium-intrinsic way. For all his New World bluster, he stayed as tied to tradition and Europe as he had to be in order to try for high art. It says something in this connection that his fellow abstract expressionists in New York accepted his art long before they did Pollock's and also before they did Newman's. Not that this has anything to do necessarily with quality. Or that innovativeness as such has. Nor would cropping have been so innovative when all it meant was rebuilding the stretcher. But on second thought, yes—maybe cropping would have been innovative for Still in his time: Bonnard, before Pollock, painted on unstretched canvas, but neither he nor Pollock actually cropped; they just cut out, without cutting into, the painted parts of their canvases. "Real" cropping means eliminating painted as well as unpainted areas.

So many paintings in the Met show looked as though they ought to be good. One after another would bring me to a stop, and in the same—not the next—instant let me down. Clyff knew, from the early 1950s on, how to set up, how to stage, a picture. He wasn't alone in that. There are the gorgeous post-1955 Rothkos that look as though they ought to be good, and aren't. There are also some Morris Louises that should be good and aren't. But I don't think that either Rothko or Louis had it in him to *stage;* their gorgeousness came differently: they could overdo in their conceiving but not calculate. Clyff, with his misbegotten coldness, could, to miscalculated effect. Nor was he alone in his time in that. There was Henry Moore in England, not so cold, and there was Francis Bacon, not quite so cold. Did they too look as if they ought to be good, and are they not!

On more than one of the few times Clyff and I talked with one another, he brought up Longinus's *On the Sublime.* I can't remember what at all he said, but it did seem that Longinus was on his mind. The Sublime, the Grand Manner, that's what Moore and Bacon have been after,

in a British tradition going back to Edmund Burke and James Barry in the eighteenth century. That was what Still was after too, after the 1940s. The Grand Manner, once recognized as grand, after being established by Michelangelo, became mostly a question of effect rather than cause (though not always, not even for Giulio Romano, let alone for Rubens or Poussin, or even for the underrated Charles Le Brun). In Still's, as in Moore's and Bacon's cases, effect did definitely take precedence over cause—effect as notion, idea, preconception, which cause can never be as long as it's really cause, that is, impulse, vision, inspiration. Yet Still was so much better an artist than either Moore or Bacon, in realization as well as in potentiality. He should have known better. But it was not in his character to know better, alas.

I say "not in his character": Clyff's character interferes with his art all along: his preposterous character. That's why, in effect, I've been chipping away at him as well as at his art. But had I never known him or read his inimitable prose, would I say that his character spoiled his art? Maybe not so emphatically. Yet it's only by his character that I can try to explain all his aborted, yea collapsed, masterpieces. I believe in masterpieces, and they were there, but remained only potential. Still was small in the face of his gift, his vision, his inspiration; he distorted, formed them into the service of effects that would project an image of himself, a crass and worldly image. He made his art reflect too much in himself that didn't belong to art, any kind of art, but only to megalomania.

Barnett Newman had his troubles too with the huge canvas. His best largish pictures are, like Still's, much higher than wide. In his case too, tallness made somehow, and paradoxically, for modesty, and the modesty allowed the picture to come off. But Newman also did some smallish paintings, wider than they are high, and even some quite small ones, that succeed with a conclusiveness hard to find in anything Still did even in the 1940s. On the other hand, none of Newman's big wide pictures make it. *Vir Heroicus Sublimis* in the Museum of Modern Art extends too far on the left, or rather the few vertical bands on that side just don't sit right. (Again I'm being an "untrue" critic.) I do remember another huge painting, *Cathedra* of 1951(?), as looking superb twenty years ago, but letting me down when seen at Newman's Museum of Modern Art retrospective, which I can account for only by the apparent fading of the blueness of its "field." (Bannard makes a point in his *Artforum* article of the crucial importance to Newman's larger pictures of what I would call "flooded" color.)

The case is different with Rothko, but not altogether. His best larger pictures come between 1949 and 1955 or so, are all taller than wide, and usually stick to the proportions, and often the sizes too, of most of Matisse's wonderful big paintings of 1914–17. Those proportions are roughly four feet up by three across, and the sizes range from under six feet to as much as nine feet high. (Richard Diebenkorn adheres, strikingly, to similar proportions and sizes.) After 1955 (as I've said), Rothko's quality falls off, "gorgeous" though his art keeps looking. As far as I know, his only really successful paintings from then on are middle-sized or quite small, but especially the middle-sized ones that are wider than high and stay in a high color key. (None of these was included in Rothko's retrospective at the Guggenheim a while ago.) The various sets of portable murals he did all fail in my opinion. Being murals, they mostly go wider than high, and in some of them Rothko tried dark-on-light calligraphy, which doesn't work. But in one or two of these sets I glimpse something that I hazard might have been brought to fruition had he only changed the consistency of his paint or his way of applying it. (As an "untrue" critic I've surmised the same about the later Picasso.)

I've brought Newman and Rothko in because both of them were strongly influenced by Still, influenced him in turn, and with him formed a kind of faction or school during the later 1940s. They shared attitudes and for a while presented a solid front toward the rest of the New York art world. What they also shared was a want of humility that was singular even among artists. I think that Clyff suffered by that lack more than the two others did (Newman was an egomaniac—but not quite a megalomaniac). Also, all three made a point of the big picture—though Newman did so less than the other two.

About Still's influence there's a question, as Bannard, again, saw ten years ago. I've already said that close-valued darkness in abstract painting, deriving from him, has not come to all that much. His color is something to be learned from in general, but not, apparently, to be influenced by. It's not his color as such, and certainly not his knifed drawing, but his layouts, his compositional schemes, his overall designing that have had the most productive influence. From the beginning of the 1950s, these told abstract painters that if they still wanted marked contrasts of light and dark it was best to keep them to the edges of the canvas where they would least disrupt a surface whose flatness was becoming more and more present and insistent, more and more sensitive, tenderer. (Though there

were other ways to cope with this: Pollock's allover repetition of value contrasts; Noland's concentricity, rhythmic repetition in general.)

Morris Louis may not have been the first to get and act on the lesson of Still's "marginality." Sam Francis may have done so just before him, at the end of the 1950s or beginning of the 1960s, but Francis's art sputtered out shortly afterward (rather his color did). In his *Unfurled* paintings Louis made something far more important out of that lesson. Then it was Olitski, with the "selvaging" of his monochromatic pictures of the mid-1960s. But I myself saw Olitski finding his own way to the "selvaging," by trial and error, and believe he would have arrived at it had he never seen a Still. Which isn't to say that Still didn't get inside him in other ways. By the 1960s it had become as essential for a seriously ambitious painter to assimilate Still as it was in Matisse's early days to assimilate Gauguin (though it was still more essential then to assimilate Cézanne, as it's been more essential these past twenty years to assimilate Pollock).

Louis certainly did such assimilating. For a while, at the very end of the 1950s, he was obsessed by Still, did a run of bad paintings under that obsession, then purged himself and continued on his way. (Incidentally, I wasn't the only one to recognize Louis's own influence in one or two of Clyff's paintings in the Met show, and the influence of Gottlieb in one or two others. I shudder as I write this, but keep on wanting Clyff to be alive to read it.) Louis, before (in his *Veils*) as well as (in his *Unfurleds*) after his bout with Still's influence, turned out better wider-than-high large paintings than the older artist ever did. Well, so has Olitski; so has Noland (who was only brushed, if at all, by Still's influence); so has Poons (who felt that influence only by way of osmosis); so, too, has Dzubas (in whose art influences seem dissolved, even the later Monet's, past specification). For all five of these later painters the decisive influence, if there was one decisive one, was Pollock's—though not particularly through his big paintings. Pollock did, however, bring off several huge wide pictures with a triumphant conclusiveness that Still, Newman, Rothko never approached: masterpieces like *One* and *Autumn Rhythm*. But the big picture was never for Pollock a "production," an aimed-at thing. The huge canvas spread on the floor gave him a way to escape the control of the enclosing, framing shape, at which he could arrive in the end instead of being confronted with in the beginning.

My going on about the big and the wide painting may lead the reader to suppose that I see inherent quality in bigness and wideness. Not at all.

Nothing as specific as bigness or wideness confers quality inherently, necessarily, apart from everything else. Of course not. I've harped on size and on wideness—which after a point becomes necessary to the size of pictorial art that's housed indoors—because that was an issue for Still, as well as for most of his best contemporaries. Why it should have been, I don't want to speculate on here. Why, for that matter, was size an issue off and on for Géricault, Delacroix, Courbet, James Ward, and still others in the first half of the nineteenth century, then stopped being one for Barbizon and impressionism, became one for Vuillard and Bonnard and—but only incidentally—for Monet, yet hardly at all for the cubists in their prime, let along for the fauves, though it was an issue for Matisse between 1914 and 1917? And for Miró off and on? I've forgotten: Cézanne went to size in the different versions of his late *Nudes in a Landscape,* which seem his attempts at a "masterpiece." Well, let some phenomenologist go into this question.

Anyhow, Still seems not to have been meant to paint big, and his going for spectacular bigness appears to me the main immediate reason for his falling short of himself from 1955 on, if not before. That the five younger painters I've mentioned did, all of them, better large pictures than he did is also part of the fact that each of them had, or have, done *more* good paintings, large and small, than he did or, for that matter, any one of his great contemporaries did. *Horribile dictu.* I take my life in my hands saying this. But E. A. Carmean and Kenworth Moffett have already said it in effect, and more than once.

Yes, I've been chipping away at Still. I have to ask myself how much I'm reacting *against* his personality aside from his art in itself. I try to imagine how I would react to that art had I never known him or anything about him. The answer is always the same. I've had to like art by people whom I didn't like; I've had to dislike art by people whom I liked. What remains for me is that Still simply didn't produce enough good-enough pictures. That's a fact of experience, and in art there's no appeal from experience. But there's also the fact of Still's originality; there's no gainsaying that. His discoveries have been essential to the very best of recent painting, and will continue to be so to the very best painting of tomorrow.

(1980)

The Golden Floating World

of Sotatsu

• •

BACK IN OCTOBER 1966, in the museum in Nagoya, on the eastern side of Japan, I was brought up short by an old large painted screen that showed only an expanse of rhythmically, almost mechanically repeated "carved" green waves under a flat gold sky. It wasn't just the distilled splendor of the screen that stopped me; I was stopped too by its "far-outness." Repetition was being pushed to its *pictorial* limits, given that the screen was intended, obviously, as more than decoration alone. It seemed to anticipate avant-garde painting in our time.

A label on the wall next to the screen, which was spread flat, said in Roman letters that the artist was one Tawaraya Sotatsu, who was born on an uncertain date in the latter sixteenth century and died, it is presumed, in 1643. (Very little, I found out later, is known about his life.) After leaving Nagoya I made a point of looking for more Sotatsus and discovered that he was the rage in Japan. Many Japanese thought him the greatest of all their painters. In Kyoto a big sign outside a complex of booths next to the temple that houses a thousand and one images of the bodhisattva Kannon announced in Roman capitals that a painting by Sotatsu could be seen inside. I went in among the booths, saw a big painting of a lion on wood, and was disappointed. But afterward I found more and better

Sotatsus, though not nearly enough—too much of the best old painting in Japan seems to be in private collections that take effort to get into.

The Metropolitan Museum has a six-paneled screen that it cautiously "attributes" to Sotatsu. Except for the narrow brocaded borders, it is made entirely of paper, several layers glued together. The surface has been indurated with a heavy sizing (animal-skin glue dissolved in boiling water), which is also the vehicle, or medium, for the colors. This technique is known in the West as distemper. Its point, or part of its point, is the unshiny, matte effect it achieves. Japanese painting seems to set much store by that effect in conjunction with the opposing effect of gilt.

Sotatsu laid his screen flat on the ground in order to work on it. That's obvious. The grainy gold areas were obtained by sprinkling gold dust through a sieve onto the sizing of the paper while it was still wet. And the greens and browns and off-blacks of the three curious islets were gotten by dripping and puddling the paint in a way somewhat—but only somewhat—like Jackson Pollock's. Also, the screen has had its paint dusted from above with gold. Furthermore, the very precise and regular gold and gray-ink lines that "carve" the waves could have been inscribed only on a horizontal surface.

Here and there the screen has suffered from mishandling, but hardly from age. You have to come close to notice that. But you can't come close so easily when the screen is freestanding, with its panels jutting out and in. Then it holds you off almost the way a big sculpture would. And then too the experience becomes ambiguous: Is the screen a picture? If not, what else can it be? But the question really doesn't have to be answered; the screen is there in all its beauty, and the classification of it doesn't matter; the ambiguity is part of the beauty.

What "makes" the screen, what makes its beauty, is simply—and then not so simply—the gray-blue waves with their alternation of darker gray and gold contouring lines. The two empty boats are at the same time essential, in themselves and as part of the whole. What they mean, nobody knows, which somehow makes them all the more affecting. The shapes and colors of the islet outcroppings, and the trees with their leaves, sing out against the blue grayness and the abstract gold, and they also make for a "composition."

In "reading" the screen I find the areas of gold puzzling (apart from their aesthetic effect). Obviously they represent dry land. But they do so in such a way as to change places with the billows, and look in their ab-

stractness more like the sea than the billows do. After all, the sea, water in general, does appear more "abstract" than solid ground. Did Sotatsu mean to puzzle us here? Perhaps the Japanese eye became so accustomed to gold that it instantly felt what gold represented in any context. Even if this was so, I still sense a certain mischievousness in what I know of Sotatsu's art.

It's a mischievousness that's apt to belong to a headstrong master, especially a Japanese one, and to a master with such a range. It's not just that he painted fans, sliding doors, and walls as well as screens; it's that he did so with such a variety of effect. The only Western parallel I can think of is Picasso (who had his own mischievousness).

Sotatsu helped found a school of painting that can't be matched for sheer gorgeousness. He and Ogata Korin (1658–1716) after him, especially Korin, created art of a supernal "prettiness," a decorative sumptuousness, that manages to be overpowering. Not the Greco-Romans, not even the Chinese or the Persians, anticipated this kind of gorgeousness. It's a kind that by now underlies, I think, Western notions of the utterly pretty. But this takes nothing away from it. When the pretty becomes overpowering it transcends itself, becomes something other than the "merely" pretty.

The Met's screen isn't an example of Sotatsu's gorgeousness. One of his flower screens, like one of Korin's, might look deceptively familiar to Western eyes. This screen gives a better idea of his range—and it's also, as I've said, the best work of his that I've seen. It's certainly more eye-opening.

"Formalist" that I'm supposed to be, I haven't yet said what the screen—the painting on it—is about. It illustrates an episode from the tenth-century *Tales of Ise,* a Japanese classic. The tales are prose in part, but mostly verse. The attributed title of the screen is *Sumiyoshi,* which is the name of a white-sand beach south of Osaka (now much built over). In this episode an emperor visits the beach with a courtier, and is so moved by the scene that he composes and recites a short poem. The tutelary god of poets—who is also the god of seafarers—happens to belong to Sumiyoshi beach; he manifests himself and delivers a poem of his own in response to the emperor's, the way any cultivated Japanese is, or was, supposed to. That's all.

Sotatsu shows us nothing of this event. All he illustrates is what the emperor and the courtier, and maybe the god too, might have seen as they stood looking out from the beach, and not even the white sand beneath their feet. And all the two poems deal with is the feeling derived from what was seen, namely, nature; no mention is made in either the prose

or the verse of the two drifting boats, man-made. There's a kind of "coolness" in all this. Nature induces distance, makes the artist noncommittal even when there's nothing to commit himself to. This distancing means a very high degree of aesthetic sophistication. This was Japanese culture three centuries ago.

(1982)

NOTE

Thanks are due to Barbara Ford and Mitsuhiro Abe of the Metropolitan Museum of Art, and Miyeko Murase of Columbia University, for what they told me about the making and the meaning of the *Sumiyoshi* screen.

Glass as High Art

• •

FIVE YEARS AGO ALMOST TO THE DAY, I spoke at a conference on ceramic art held at Syracuse University. I know only little more about clay than I do about glass, but I could see what was on the minds of most of the conferees: the status of their medium, "graduating" from craft to fine art. And how did ceramists hope to get that done? By becoming full-fledged sculptors or even pictorial artists. That's what was conveyed to me.

This might look like, but really isn't, an academic question. There has been ceramic sculpture all along, long before the beginning of urban art in Mesopotamia and elsewhere. But it was still felt that clay hadn't yet asserted itself in its own nonutilitarian right. The question was whether ceramics as a craft could become more than that, could become a "sculptural genre" (as Garth Clark put it); whether ceramists could make high sculpture and remain ceramists instead of becoming sculptors who happened to use clay as a medium. This is no mere terminological quibble. There is a distinction between ceramists who make sculpture and sculptors who resort to clay (as they would wax or another medium). It's there in the way craft lines are drawn, there in the minds of ceramists and in the minds of sculptors too.

The case may be different with glass, but not radically so, though it

does look more "difficult." Glass carries fewer reminiscences of fine-art tradition. It's only relatively late that medieval stained glass gained the status of fine art as distinct from decoration, and it has done so as pictorial art, not glassmaking. There has been no equivalent to stained glass in glass sculpture, no equally large and splendid equivalent. Objects sculpted in glass remained objets d'art, curiosities for the most part. True, this was due in some part to the small size to which glass objects were confined in the past. But I think there was still another reason. Experience shows that human and animal forms sculpted in glass tend to have about them a quality of tour de force, of displayed skill and also of improbability— improbability of the kind that "simple" people marvel at as at all "improbable" feats of skill, beautiful and unbeautiful.

Such was the plight of glass art as I see it. I say "was" advisedly. For now *abstractness* has come to the rescue; abstractness as other than decoration. A sculpted work in glass that doesn't represent anything seen in nature can escape the cluster of associations just mentioned. An abstract object in glass stands freer, has more of the autonomy that belongs to fine art. Pictorial glass, too, stands freer when it's abstract. (But I'm tentative in saying this last, for I'm not so sure that pictorial glass needs liberation the way sculpted glass does: I can imagine a fauve glass painting, with color *in*, not just *on*, the glass that would compare with anything done in the same vein on canvas.) I entertain the notion in any case that abstractness may bring greater benefit to glass than to any other medium in terms of aesthetic results.

But will the advent of ambitiously realized glass sculpture and pictorial art erase the distinction such as that which persists in ceramics between craft and high fine art? Sheer quality would, I feel, do that, in glass as in ceramics. And anyhow that distinction is becoming beside the point, as well it should, no matter what happens with respect to aesthetic quality. The consciousness of that distinction is becoming more and more—to adapt a fashionable Marxist term—a false consciousness.

Ceramic artists complain about lacking serious critical attention. I say make art good enough and it won't be denied such attention in the long run (and serious art nowadays, in most mediums, demands the long run— alas). I say the same to glass artists. And don't let yourselves be closed off by craft lines—by the notion of "craft"—which may be the hardest thing of all to do, harder even than making superior art.

P.S. It was reported to me after I gave this talk in Corning that many in the audience felt I'd been patronizing, condescending, in what I said. Maybe. All I can say in self-justification is that I'd not yet seen much in recent glass art that stood up against the best in recent sculpture and painting in their conventional mediums. The note of exhortation with which my talk ended must have reflected that. When you exhort artists it means you don't yet like enough what they've done.

(1984–85)

· ·

ART AND CULTURE

· ·

WHETHER THE COUNTRY AND ITS CULTURE HAVE CHANGED
"enormously" over the past fifty years, I wonder about. I'm not being cap-
tious. Continuity in this country has gotten to be underestimated.

I wouldn't say that my "literary" or "cultural" views have changed all
that much during the same time. Maybe they've evolved or been revised—
I hope so. I would also hope they've been expanded. But *changed:* no.

My political views have indeed changed enormously. I no longer "be-
lieve" in socialism, though I may still want it ideally. I've become some-
thing of a political agnostic (yet it still goes against the grain to vote Re-
publican). At the same time I've turned more anti-Bolshevik than ever (I
can't call Leninism, communism; communism, too, remains an ideal). My
revulsion (a repentant sinner's) against leftist cant, leftist right thinking,
has become overriding. Consequences bear it out, and I've come to take
actual consequences far more seriously than I used to. I read *Commentary*
with relish for its own allergy to leftist cant (I don't take its "conservatism"
seriously; it's not the same thing as reaction, which is the only thing I do
take seriously in that direction).

Culture. I keep thinking, as I have for many years now, that Western
high culture is in decline, Spenglerian decline. But I think I can isolate

the decline: it's largely in point of cultivatedness and literature, on which cultivatedness depends most. I can't tell whether or not music is in decline; I suspect it, but distrust my suspicion; there are those who know better. Science thrives, of course; Spengler was so wrong in anticipating its decline in this century. More importantly, the world has become more humane in temper, despite all appearances to the contrary; I believe this because outrage has become more frequent and widespread. What awful things used to go on unnoticed in effect when I was young.

It may be my bias as an art critic that leads me to see visual art as a special case. (Visual art was a special case under decadence in late Rome too.) Yes, the very best new painting and sculpture remain in the background for the time being, but they've been there during each succeeding phase of modernism since Manet, if not before. In the foreground everything philistines say, or used to say, about modern art is being borne out: in the museums that pay attention to contemporary art, in the market, in the art press, in official grants.

Some more canting of a sort, this time journalistic: about the postmodern or postmodernism. Modernism in the arts began and continues as a response to the threat of decadence. The visual arts have been by and large the most resolute in this response (painting is the "avant-garde" art above all others). If *major* visual art is going to keep on being made in the foreseeable time, it won't be anything but modernist. And as valuable as minor art can be and still is, major has to be insisted on.

(1984)

• •

Drawing

• •

THERE ARE THE USUAL THINGS SAID ABOUT DRAWING: that it's direct, spontaneous, intimate; that it gives more insight into an artist's temperament or character and into his processes of creation and so on. When the same things are said over and over again about the same thing they cease to cast light; they may even cast darkness. I myself happen to wonder whether Michelangelo's drawings tell us more about him than his frescoes do. And I doubt whether Picasso's drawings go deeper into himself than many of his paintings do. Talking about drawings as such, drawing in general as distinguished from pictorial art in general, is hard for me. There's so little I can say about drawing in itself that I can't also say about painting. There are the differences of medium and technique, to be sure, that make it possible to call drawings drawings and paintings paintings, but I'm not sure that these differences count much for the appreciation as such of art, for aesthetic experience.

There used to be "unfinished" and "finished" drawings. Painters working from nature used to make preparatory drawings, sketches, studies, notations—"unfinished" drawings. That practice began to fade with open-air landscape painting in the nineteenth century, and it had never had much of a place in portrait painting. "Finished" drawings were something

else: they amounted to *pictures*. The preparatory drawings, the studies, the notations, the exercises usually didn't; they wouldn't fill out the sheet in most cases, or they would pay less heed to its shape and size, or the sheet might contain two or more different drawings. "Unfinished" drawings were more in the nature of *images* than pictures, and they demanded a different kind of focusing for appreciation. They challenged the discriminatory capacities of the eye as the wholeness of a picture didn't. You grasped the drawing of, say, a human figure more in the way that you grasped, and assessed, a freestanding sculpture: that is, by its internal relations, relations of contour, shading, proportion. Or, as often as not, sheerly by the "feel" of the artist's hand.

All the same, it turned out usually in the past that the best draftsmen were also the best picture makers, the best painters. Prowess in drawing couldn't be separated from prowess in painting. Maybe there were exceptions. Maybe Holbein and Watteau and Ingres drew better than they painted—but I would hesitate to say so. Maybe Delacroix painted, by and large, better than he drew, but again I would hesitate to say so. (But what I won't hesitate to say is that Picasso over his last decades drew far better than he painted.)

The advent of nonrealistic art has largely changed the relation of drawing to painting. Abstract painters (if not abstract sculptors) seldom make preliminary drawings, and even when they do they can't so easily escape the control of the sheet. Even their merest notations tend to be pictures, "finished," that is. (The case of drawing shows, more clearly than anything else maybe, how difficult it is for abstract pictorial art to work in terms of parts, let alone details.) And then drawing as drawing—let's say as line—tends to get less covered up as it were in abstract or quasi-abstract painting or in painting that takes broad liberties with nature. So many Klees could be called painted drawings. In so much of Braque's and Picasso's painted cubism, not to mention their collages, it's hard to say what is drawing as drawing and what isn't. The same for Léger's paintings of 1912–14.

I notice that I've let myself slip into the assumption that drawing can be defined more or less as line, as explicitly linear. This might do in the short run, but not in the long run. As I said earlier, drawing can't be satisfyingly distinguished from pictorial art at large: not for actual appreciation or, for that matter, for the purposes of criticism.

(1985)

Response to "New York

in the Eighties"

● ●

THE MORE I PONDERED THESE QUESTIONS ABOUT NEW YORK
the less I felt able to answer them usefully. Where I can offer something
to the point—i.e., that the best painting and sculpture over here now
seem to be being produced in the hinterland—I would have to qualify at
length, and I simply don't want to. So I'd say that *much* of the best art, not
all of it, is being made outside New York, and then I'd name names and
places. Again, I don't want to. I just want to state what I think is a large
fact and leave the details for some other occasion.

Yes, there are now important centers of artistic production away from
New York—not large but important. This is as new for us as it would be for
the French with respect to Paris and the British with respect to London. It
could be the most innovative cultural phenomenon of the time.

These new centers of production may be provincial in location, but the
art produced is not at all provincial. And it certainly isn't "regional." (And
anyhow, how can regional art or culture come to much under advanced
industrialism?) The art produced is not provincial because it gets its suste-
nance from New York. The artists involved would be the last to deny that.
New York is where more of recent art can be seen than anywhere else.
This matters very much to the seriously ambitious painter or sculptor.

New York remains the center also because it remains the center of attention and of attention giving. It's where new art gets validated, for better or worse—and more importantly, in terms of attention rather than in those of money. (I don't mean "media" attention.) That's why your "heralded new talents" from abroad flock to New York; they can make just as much money staying home.

So New York remains the effective center, retains its dominance, despite its losses as a center of production. (I'm still confining myself to visual art.) Do I like this? No. Visual art began to be centralized in the West in the fifteenth century, and its centers became fewer and fewer, till in the nineteenth century there was only Paris (don't tell me about Munich and Düsseldorf), and now there's only New York. And now New York spreads bad taste, incubates it. (Those outlying centers of artistic production talk about profit by their distance from New York.) Trends may not be born in New York—trends, fashions—but New York is where they get certified for the time being, and whence they spread. I would welcome New York's displacement, and not for this reason alone. I would welcome a decentralization of visual art in general. But I can't imagine how it might come about, despite what I've said here about the centers of superior production away from New York. I don't see decentralization coming nearer over here than in France or Britain. In the visual arts one seemingly petty reason explains why: the fact that reproductions don't suffice, as they do in literature, and possibly in music. Malraux's "museum without walls" was an imposture.

(1986)

IV

. .

INTERVIEWS

. .

• •

CLEMENT GREENBERG

• •

James Faure Walker

JAMES FAURE WALKER: *What have you seen here this visit?*
CLEMENT GREENBERG: I saw the four Scottish painters [Douglas Abercrombie, Alan Gouk, John McLean, and Fred Pollock], and Durrant, one or two others. There was also sculpture, Peter Hide's notably, then Gili's and Smart's, all at Stockwell.

What was your opinion of their work?
I thought both painters and sculptors damn serious—the painters very much American-influenced, and making no bones about it. Theirs were better than most of the pictorial art I've seen over here, or on the Continent, not because they're following a certain line, but because they were assimilating what I think the strongest recent tendency. Just as, say, in 1907 in Paris there was a lot of good painting that wasn't done by Braque or Picasso or Matisse, yet looking back we have to say they produced the strongest painting of that period, and in some part because they had taken a good look at Cézanne, as well as having assimilated the impressionists, whom they thought they were reacting against, but whom they could only react against because they had assimilated them. I've been accused of believing in a mainstream and only in a mainstream. I just point

to the record, and say: look, there *has* been a mainstream in Western art, largely a mainstream, not invariably. It isn't a dogmatic outlook, a position, or a line; just something that emerges through quality, through superior quality.

In assimilating the best of Parisian art, the mainstream, there must have been, in the thirties and forties in America, a huge inferiority complex to overcome. Oh, yes indeed, and how.

I wonder how objective your idea of the recent mainstream is, or rather how objectively art in Britain can be seen, given that there's a similar sense of inferiority, sometimes resentful, toward America. Patrick Heron made a case out of this, about how derivations have been misread. Are you conscious of this problem looking at art outside America? That's no issue.

In 1949 you wrote of the difficulty of looking at American art— Not *looking,* but taking it seriously enough to take a real look at it, that's what it came down to. Geoffrey Grigson came over to America in the late forties and wrote something about how the poor Americans still believed in abstract art, not knowing in their provincialism that it was finished elsewhere. Then he found the best art in the Western world in Cuba and French Canada, on the assumption, of course, that the Latins inevitably paint better than Anglo-Saxons. That was a common assumption, in my country as well as in yours. And then there was this big comedy, that when the English found out that Pollock was being taken seriously in Paris, and then Clyfford Still; well, it had a traumatic effect. If anybody couldn't paint it must be the Americans—the English were bad enough, but the Americans were even worse. I used to get very irritated by that. Now it's all changed, now it's overdone the other way, and American art is taken too seriously elsewhere. Rauschenberg and Johns and Wyeth—who I think is just as good as they are, better mostly—are taken so seriously abroad, but Eakins, who could paint circles around all three of them, isn't. You can't export Eakins.

There's always the danger, surely, that you can be fooled by your taste, that you can dismiss original art as being local or idiosyncratic when there's no nearby mainstream to relate it to?

I can't exclude that. You are supposed to make every effort, as it were, to overcome yourself. You travel abroad, you look at art with an innocent eye, no preconceptions. You may have accumulated experience behind you, but the accumulated experience only serves to make your eye more innocent, I believe. I've praised contemporary art elsewhere: Hosiasson in France, Mathieu—nobody agrees with me about Mathieu—Carl-Henning Pedersen in Denmark. I saw a Louis Cane show in Montreal, there were some very good pictures in it; Dubuffet when he's good—you can say it's American taste, but Dubuffet hadn't seen any American art. The first Dubuffets I saw I liked, back in the forties. Relativism of taste is a construction, a received idea.

In 1964 you wrote of abstract expressionism: "Having produced art of major importance, it turned into a school, then into a manner, and finally into a set of mannerisms. Its leaders attracted imitators, many of them, and then some of these leaders took to imitating themselves." How can you persuade those who regard the one-color textural painting of Olitski, and the work of Poons, Noland, Dzubas, and so on, as just such a mannered school, that they're wrong?
If it turns into a school it will be a school. It's on the way to becoming one, right now. That doesn't compromise Olitski or Bannard, or the others, any more than the fact that alloverness, which became a manner, and a mannerism, compromised Pollock or Tobey. It's a question of time and quantity, how many people do it.

It doesn't work its way back into Olitski?
Olitski moves ahead of the people influenced by him. It's not a statistical question. It's very pragmatic like everything else in art. The evidence that something has turned into a school in the pejorative sense is there in the art, and nowhere else. At the same time there's no rule, no law that says you can't go ahead and work out of Olitski, or out of Cézanne, endlessly, and still produce good work. What happened with abstract expressionism is contained in the evidence of the works. By '53 it was turning into a school in the pejorative sense, and the evidence accumulated all through the fifties. It was just the bad painting that said that, nothing else.

You've said that a "vehemently hostile reaction is almost always a sign that habits of taste are being threatened." Over the last six or seven years one might

well describe your attitude to what you call "novelty art" or "far-out art" as "vehemently hostile."
Well put. I would say "usually," I wouldn't have used the word "always" had I thought—I said "almost." I should have said "often." All the same, I would like to object to characterizing my attitude as *vehemently* hostile. Hostile, not vehement. Now it's true I've gone on about it, in more than three articles, but my reaction is more against the audience than the art. As I think about it, it's the acceptance—it's not the art itself that affronts me, the art itself bores me—it's the audience I get worked up about. That's come to a head lately. Reading Baudelaire—a Salon of '57, I think—in which he says that if decadence is upon us, it's among the art public, not in the studios.

This has been a recurrent theme in your writing, going right back, and a characteristic of Rosenberg's and Kozloff's writing too, giving American criticism a sense of purpose lacking in English criticism. It's the feeling that culture is threatened, not so much from outside, but from within.
I'm not sure. That plays some part, and concern for the weal and woe of art—not culture. A lot of the concern is an inheritance from the days of Marxism. Rosenberg, I think, still considers himself a Marxist, so does Kozloff, without being so explicit about it. This feeling of culture being threatened, you grew up with that notion.

What were the specific threats at that time—the fear of fascism in America?
Oh no! No one in their right mind was afraid of fascism in America. Hell no. It wasn't political at all. And then it turns out that our "Marxism"—I don't want to speak for the other two because I don't think the other two look at art really, they do something else—it was inherited from the early avant-garde. It was Baudelaire, and Manet—who never took an attitude. It was the notion among a certain group of Frenchmen that culture was under assault from the bourgeoisie. I myself wouldn't put it that way— the bourgeoisie, the poor bourgeoisie. But that's part of what called the avant-garde into being, the feeling that standards were being lowered. Manet didn't think he had any cultural mission when he got fed up with what he called the "soups and gravies" in the painting he saw around him in the 1850s. There's a stereotyped attitude that things are going to pot, there are political threats and whatnot, and you denounce. It's a very Jewish thing too. It's a nice comfortable posture. I used to wallow in it—if you can wallow in a posture—and think: crisis! crisis! There are threats

and menaces—you wouldn't have to specify it as fascism or whatever, just deterioration and so forth.

When you were one of the editors of "Partisan Review," from '41 to '43, you wallowed in it then?
Yes, and how. It was one of those received ideas you just went along with, unexamined ideas you grew up with. My early stuff is full of it, and I blush when I reread it.

So it wasn't political.
No. That's a notion just because I happened to be what was called a Marxist. I still regard Marx as a great man, and a lot of things he says I still agree with and find useful. But as far as I talked about art, politics had nothing to do with it. If you read me carefully you won't find any political factors entering my writing about art. Maybe about culture in general, yes, but about art as art, never.

You separate the two?
I certainly do. Let's not say "culture" but "civilization," and not "between" but art inside civilization. I separate carpentry inside civilization too. They're not entirely autonomous, but you can't deal with them without allowing them a certain autonomy. You can't always attribute everything that's happening in art, literature, and music to political, social, and historical factors.

You regard other writers as social critics rather than art critics because they don't look at the art, but you yourself have approached "far-out art" as a social or cultural critic. You don't deal with specific works but with social tendencies.
To some extent, true. What I do find is the mass of it bad as art, that's all. And then I try and find why it's bad art, and why it's appeared in this particular way: the new middle class and all that. That's about the only explanation I've been able to come up with, and it's not an exclusive one either.

You're prepared to provide an explanation for bad art in social terms. In other words bad art is not autonomous, but linked with social causes—
A bad audience, I'd say. An audience that has allowed these things. The audience that takes Duchamp seriously as an artist rather than as a cultural figure—and he is a very serious manifestation, culturally, if not artistic

or aesthetic, in my opinion. The audience that would have him be a good artist as well as an important cultural figure, the blame lies there.

Conversely, if the audience were more alert, more aware of art values rather than cultural values—
Or fashion or whatever. Let's not dignify the audience too much.

—that would have an effect on the art being produced?
Of course. It has. My original explanation of what became novelty art had to do with the triumph of the avant-garde, and the fact that it became a popular triumph. So I was leaving social factors out. It was finally in the fifties recognized that most of the best art of the past hundred years had come from the avant-garde, from modernism. And certain conclusions were drawn by younger artists; that the thing to do was to be far-out, because all the great modernists had appeared to be far-out when they first came on.

Back in the days when you wrote as a champion of an unrecognized avant-garde, wouldn't you have heard those same words spoken by a conservative, claiming the artists were after a new look?
Not the same. It was as though those people in the sixties had set out deliberately to confirm everything philistines had said about modernist art. I've written about that.

You've written of a conventional taste underlying the purveyors of an advanced look. This would be true of the minimalists. Andre, for instance?
Carl Andre simply lacks, as Judd does to a less extent, a sense of proportion. I think you can bring off anything in art in principle: square plates on the floor and all that, these could be made to work; it's conceivable. But Andre doesn't make them work. When Andre was doing upright, elevated sculpture, you could see the conventional sensibility coming out and taking resort to module—the bricklike forms laid up, one inverted pyramid on top of another. This guy, with his conventional sensibility, was resorting to something far-out, and also he had to grab a module to do it. Now someone else could conceivably make something great out of that, driven by different impulses. The far-out had become the refuge of people who were conventional to the core. Robert Morris particularly. His sensibility comes into full view when he does those things in felt, that tasteful sym-

metry. I rather like them as interior decoration, but they're not much. At heart he has an academic sensibility, and it peeks out, and in order to disguise it you throw boards around, big pieces of steel at random. I remember the first things Morris showed, framed shallow bas-reliefs made out of lead, at Dick Bellamy's Green Gallery, and I remember telling Dick they were too damned pat and set, conventional, good designing. Judd's a different case, he's flat-footed. But now and then he runs into something. It's not a question of conventional sensibility. Judd has nothing to hide except a certain obtuseness, which is not as bad as conventionality. And, again, now and then he runs into something.

You've also written that while the audience is accepting far-out art, the best art, which is still innovatory, goes on underground, interrogating the conventions it has assimilated.
Of course "underground" is a metaphor. I would say that someone like Walter Darby Bannard, who is somewhat known, not "underground" perhaps, is one of the best painters working in the world today. Yet he's not well known, he's not prominent, not even as an artist to be disliked the way Olitski is. I'd say there are some sculptors in America, as there are over here, who are not as well known, who are in the background. "Underground" is the wrong word. When Morris Louis was doing his best painting and already showing he was still in the background.

Can you point to the conventions, even the purely formal ones, that are being dealt with in the present, say in the last ten years?
You've stuck me there: the last ten years. I'd have to sit down and say there's the convention of the balanced picture, the four corners accounted for, explicitly. That was a particular handicap of French abstract painting in the fifties. Someone like Pollock, and someone who was very much influenced by Pollock like Frankenthaler, began to feel that some of the corners could take care of themselves, and didn't have to be accounted for explicitly, that is, painted into. Or that the convention was to be guided by the shape of the picture. Cézanne made that explicit, as no one before him had, though the Old Masters had all along paid attention to their formats without making a case of it. Pollock would fool around with that convention. In the end he would acknowledge the shape, he'd find his way back. I've written that the reason he painted on very big canvases was he didn't want to have that rectangle in sight while he was working.

Then there are the conventions of dark and light. Clyfford Still, I think, was the first one to begin tampering with those in an explicit way, though the impressionists had already begun to violate them; and then of course Bonnard and Vuillard—not Matisse so much. And there are other conventions which I'm probably not consciously aware of, that I might recognize without being able to define, or specify. Sometimes you recognize a convention's been there only when someone's broken it, and then you become aware that yes, it's been a convention.

You see no case in which the stretched canvas is abandoned where meaningful interrogation is going on? You saw something in Dorothea Rockburne.
Yes, she's got something. But it's curious, in abandoning the stretched canvas, and the rectangular canvas—and she's done some good things, I think—she remains minor. It's like socialism in Russia: she's a little premature in her innovation. Gauguin was, and *premature* innovation somehow doesn't usually succeed, not in the way the Old Masters used to when they did succeed.

The shaped canvas brings back sculptural drawing?
It has tended to. There's nothing wrong with that per se—if it's good, it's good. What's happened is that it's turned out to be an escape, an escape from painting, instead of an extension, an expansion of painting.

Your "Modernist Painting" essay—the closest you get to advocating a "line"— provokes a lot of misinterpretation.
It's being republished in a book edited by Richard Kostelanetz, and I've added a postscript explaining that it might have been the fault of my rhetoric. The article was taken for a statement of position when it was nothing but a description.

Granted that it doesn't actually say that each art has to discover, through a process of self-criticism, those means proper to itself, this is what it's often been taken to imply, each "medium" remorselessly defining itself. What of the case of photography, where "artist's" photography tends toward the self-reflexive, "exploring the medium," and "photographer's photography," which is less solipsistic, more communicative about the thing being photographed?
I started doing a big piece on realism and photography in '64, and I gave it up because I realized that the criticism of photography was tough, tough,

tough. There are so many contradictions. There are photographs that will reproduce anywhere and remain great—reproduce in a newspaper. There are others, like Paul Strand's, where if you don't see the original print, you'll miss it. And I thought, well, in either case you say that's just the way it is. You can't say anything further than that. And at the same time you notice that photography has been at its best so far when it's been literary, when it tells a story; and storytelling in photography is a new kind of storytelling. Atget, when he photographs a street, tells a hell of a lot of a story, more than when he photographs a human being—which he often tends to convert into a dummy.

Was one of the difficulties the impossibility of looking at photographs as totally formal and autonomous?
No. I had the mistaken notion—I want someday to go back to that piece— I thought I was going to wrap up the question of realism and photography. I take photography very seriously. I think it's got as much status as any of the other arts. But I must say I don't pursue it the way I do painting and sculpture. There are only so many things you can really pursue.

For some time you've been writing this book on aesthetics?
Yes, my homemade aesthetics.

Why did you move over from descriptive writing, about looking, and advancing some historical analyses, to aesthetics?
Out of presumptuous ambition. I found that even Kant, even Croce, had not dealt with certain things—Kant and Croce were the only philosophers I'd learned anything real from in the line of aesthetics. And then a lot of other estimable philosophers of aesthetics didn't seem to be practical enough, and I hoped that I had a contribution to make. Spot reviewing is as important as anything else, but I'd had enough of it after the *Nation* and *Partisan Review.*

In these recent essays on aesthetics, the "Seminars," you try to locate what is specifically aesthetic about the decisions and judgments made in art, taking the problem in Kantian terms, differentiating the aesthetic judgment from moral or intellectual choice. Now one of the most noticed, and most controversial, features of your criticism has been the way you have explicitly discounted artists' intentions, the way you maintain that Monet or Cézanne—not to

mention more recent art—succeeded despite their conscious aims. You've written, too, of how one can't program oneself, of the difficulty in art of meaning what you say. So it's curious that in accounting for the discrepancy between intentions and results you've made no use of psychological, or psychoanalytical, concepts.

I've found them irrelevant. Depth psychology seems to me to be able to say in some cases a lot, or at least something relevant, about the person of the artist or writer or composer, but nothing significant or really relevant about the art itself. It can always pull what is called "post hoc, propter hoc."

It's always after the fact.

Yes, well, Marxists, or quasi-Marxist critics of culture will often practice that: if so-and-so happened, and this and that happened, at this or that time, then there must be a causal connection. You reason from the state of society at a certain time to the art that was produced at that time, and make an easy equation.

But given that these essays are dealing with certain problems, why is aesthetics any better as a means of analyzing and homing in on them?

Aesthetics isn't a method or anything. Aesthetics is a field in which you try, let's say, to delimit art, delimit aesthetic experience.

And find the limits to what can be meaningfully said about it?

Yes, I have touched on it, but I want to devote a whole Seminar to how do you talk and write about art, or literature and music for that matter. But aesthetics is, I think, useful in telling you what you can't say about art, warning you that what you're saying at a certain point is not about the art as *art,* but about the art as something else. I harp on that "art as art," art qua art, and then art as something else: as a document, as a revelation, as a sign of the times, and so forth.

This is where so much criticism fails, it doesn't talk about the art as art?

The difficulty of art criticism is to generate words and stay relevant. The trouble with art criticism, especially of late, is it's too much loaded with culture. It's as though the world's become self-educated instead of educated. So art has to bear the burden not only of being experienced, being judged, but of being interpreted. Sometimes it's phenomenology, sometimes it's Wittgenstein, sometimes it's structuralism, sometimes it's Walter Benjamin. So art is there in order to be talked about, to be written about,

instead of simply being experienced. In art the area of relevance, as far as discourse is concerned, is rather confined. In visual art, and in music, when you escape from that area of relevance it's more obvious. When it comes to literature you can slide right off into questions of morality and so forth—and a lot of literary criticism is irrelevant in my opinion. The great contradiction for me is Leavis, such a marvelous . . . my God, he's an aesthete to the core, and whether you agree with him or not, he's always making aesthetic judgments, and I think he's got a great ear. Again and again I find Leavis putting his finger right on it, and giving the wrong reasons; like James's late novels, which he puts down, and he's right on target. Sometimes he gives the right reasons. He says *The Ambassadors* is really an expanded short story. His sensibility will surprise you—he likes Meredith's *Egoist,* and by God he's right. That's real criticism, and I find it fascinating because it bears right on experience, and no culture crap, no highfalutin . . .

If you pursued that to its extreme you could cut out the explaining and inter-preting entirely, and just publish a list of points scored.
Oh, no. In music you can say something is too slow or too fast. In paint-ing you can say there's a hole here and it jumps there. But you don't have the picture there. Reproductions I regard as unreliable, and slides betray pictures. The few times I've been able to walk around in front of a picture with people, then I'm most comfortable. You walk up to the picture, or the piece of sculpture, and you take your forefinger, and you point.

One point where you reach this limit of discourse is content. You found that whatever you said about it you could always say something different. This is where a lot of your critics are dissatisfied, they want to know more.
Right.

But you've said that depth of content is equivalent to quality, and you've spo-ken of range of feeling, the way, for example, the surfaces in Matisse breathe. Couldn't you go beyond that, without necessarily going into depth psychology, and explore that kind of feeling further?
Maybe some other person can, but I'm reluctant. So much I've read that deals purportedly with the content of art has struck me as not necessarily attaching to the art under discussion. So much of it could attach to an infinite variety of art. I remember having a squabble with the late Dr. Goldwater, who said that Franz Kline had "grace under pressure." I said

you could say that about any good art maybe. I didn't see anything in Kline that showed me that.

Isn't one function of criticism to elucidate, to make apparent? Wouldn't this be appropriate with Mondrian, or Newman, where the visual and the verbal can inform each other?
As far as I know, Newman's art has gotten very little comment, relatively little anyhow. And when I first saw Newman's work in 1950 and liked it, I certainly didn't need the help of anybody's words, and I haven't since. I first began liking Mondrian when I got old enough, and certainly there was nothing said or written about Mondrian that I'd heard or read that helped me, and certainly Mondrian's own words were no help. You looked first. Now it's a widespread notion, Tom Wolfe and so forth—a German named Gelden had already written that some fifteen to twenty years ago—that modernist art depends on titles and what's said about it, otherwise it's opaque. Of course, that's preposterous. It's a vulgar notion, it really belongs to Tom Wolfe.

Didn't Newman object to the interpretations you made of his paintings?
Descriptive ones, and not the interpretations. I never interpreted his paintings. What he objected to actually was in this piece I did on the abstract expressionists in '54. I said he was influenced by Still.

I thought Newman objected, too, to the notion of pure art.
I never upheld the notion of pure art. I said that was a notion upheld by artists, that's all. I never characterized Newman's stuff as pure art.

You believe pure art to be a fiction?
A useful one. It was a useful one, and maybe it's no longer useful. Not a fiction, an illusion. That was the motive power behind a lot of very good art of the past hundred years. But that *I* subscribe to the notion of pure art? I should say not. I just don't know what pure art might mean, except as an illusion, a guiding idea in the Kantian sense: an idea you never achieve, an ideal.

Wasn't there a change of attitude with Stella, Rauschenberg, Johns, a rejection of the seriousness of abstract expressionism, not just its style? Weren't the previous generation intent on making images of some sort, charged with symbolic power?

No, not necessarily. No, that's a lot after the fact. Gottlieb used forms, derived forms from other forms that originally had symbolic meaning, like Northwest Indian art, Jungian symbols, and all that. But it's unthinkable that any of these artists would stand in front of a canvas and say, "Now I have to put a symbol down; there's a symbol for this." They were trying to make good art.

They weren't literal, one-to-one symbols—presumably you discount Hess's book on Newman?
Absolutely, totally. The whole cabala thing, and all that. That's Newman after the fact, his way of inflating his paintings and himself. You search for titles, and sometimes you find an inspired title, like *Onement*—no one knew what it meant, but it was good. Barney was a great fabulator anyhow. Newman, Rothko, and Still were very pretentious, in a very American way. But the main thing was to make good pictures, and in the showdown it was the question of which of Newman's paintings were better than which. He had a very good eye, by the way. I remember his being a little surprised at my liking one of his pictures, that he thought maybe it wasn't that good. But he hadn't thought it an utter failure, otherwise he wouldn't have kept it. It was as pragmatic as that. All the culture crap came afterward.

This was true of Motherwell too?
He's pretentious in his own ineffable way. Often, when painting abstract pictures you have to tell yourself a story to get started. I've never known any artist to report the story he told himself in order to get started. Rothko maintained his art wasn't abstract, it was narrative. He said that in conversation. But you, the beholder, you're there with the art, and you're alone with the art, and nothing else but the art and your accumulated experience of art. Then the critic may come along and point to something in the work that you may not have paid enough attention to. You might agree with the critic that it was something that added virtue to the work, or took away from its virtue. That's about all there is to it.

So there wasn't a change of attitude?
There was a change of attitude insofar as the following generation regarded art less preciously. Art was not quite as sacral, or quasi-sacred, for them as for my generation. In some ways they were more enlightened, I think.

Did you have to adjust to that change?
Hell, no. I just look at the art. What's an artist's attitude? What do I know about Titian's attitude, or Caravaggio's, except what I see in the paintings? So you see a difference of attitude in Caravaggio, in Watteau, in Goya. So what? All right, there it is in the art. I see a lot of playfulness in Johns and Rauschenberg. At the same time underneath the playfulness is a very serious ambition: the hope that this works, just as a comedian on the stage hopes that his humor works.

Hasn't reverence crept back into Caro a little? The sculptures are tighter, more enclosed—you see it coming out more in his followers.
Tony has become a little more elaborate of late. You mean the enclosing profile has become tighter?

They're more biomorphic too.
Unconsciously, very unconsciously, biomorphic maybe. Tony is an incorrigibly additive artist, and when he adds too much it goes off. When he's working right he'll add too much and then take off.

Caro used to be less precious with materials. He'd say you could make art out of anything.
It's not only making art out of anything. It's no longer having an attitude of reverence to one's own art, or to art in general. Tony's attitude is still like that of his painter friends. A work of art isn't sacred, that's why he'll accept suggestions from anybody. Tony's last New York show was a smashing success, and yet it was his first bad show, I thought. This time his wonderful hankering after the grand manner had played him false— that was precisely what made the show a worldly success and spoiled the pieces. The only piece in the show I halfway liked didn't sell at all. Tony himself realized all this. He had laid it on. Francis Bacon cashes in on the grand manner. It may be an English failing. But anyhow Caro is one of the least reverential artists, in the sense just mentioned, that I know of.

Your own taste diverged from Michael Fried's over Stella.
I didn't think Stella was as good as Fried thought he was.

What was it about Stella you couldn't take?
I liked his aluminum paintings, and then the black pictures, some of them I liked. But in many of them, after the first impact I found that the

drawing, the layout, was childish. I think the aluminum ones do stand up, but since then it's been off and on. If I were to write about Stella I'd want to qualify very much. And I'd say—to use a jargon word—that he was a problematic artist, in a way in which Noland, Olitski and Louis, and Bannard and Dzubas and Poons aren't. They paint bad pictures, but somehow their good pictures don't come along as *exceptions* the way Stella's good ones do. Stella's got a very good eye, and there's a knowingness there, knowing how to set a picture up. But you have to have more than an eye, you have to be inspired. You can't figure it out in art, and Frank has too often tried to figure it out.

Your sense of a work's value is instantaneous?
It's got to be instantaneous. There are reasons and reasons when it comes to painting and sculpture. You can't recapture the experience of visual art except in the presence of the work of art itself. You can remember music, to some extent, because you can hum it to yourself, literature because you can memorize words. It's been very rare—until lately maybe—that any human being has been able to memorize a picture. The proof of that would be to go and copy it without looking at it. You can memorize sculpture sometimes maybe, one view, one aspect anyhow. Of course, I'm simplifying grossly here.

You've written that it's a question of the relation between the parts, proportion is what it comes down to.
It seems art is all relation, that's one way of putting it. I'd not say that art is *just* that.

But, going back to Mondrian for a moment, perceiving those relationships, measuring this proportion against that, surely takes time. It's not an instantaneous unity, like other kinds of pictures where it's immediately apparent.
Really? I look at a Mondrian the way I look at any other kind of picture, for that instantaneous unity. And I "know" certain things about Mondrian; that where he opens up the middle, the way Olitski does, he tends to be more successful: those pictures of the late twenties and early thirties, and especially the diamonds, where the bands are just at the sides—I noticed that again and again at the Mondrian retrospective in the Guggenheim five or six years ago. It reminded me of Jules, and of what Sam Francis has tried to do too.

You're not just seeing Mondrian through Olitski?
No. Olitski will at times fail opening up the middle. Every time Mondrian did it he succeeded, apparently. That was his magic talisman, that device, if you can call it that. I want to write about that sometime: about how terribly tender the surface of the abstract picture has become. It's why Jules can't come too far into the picture with linear drawing or abrupt changes of hue or value. The only alternative is Noland's, or what used to be his, being concentric, starting in the middle, and emphasizing it.

Are you sometimes seduced by color?
You make mistakes, you like something too much. Usually my mistakes are not liking something enough. You can't account for it simply by saying it's *this* element. I used to be seduced by painterly painting, brushy, free. I remember how some of the late Vlamincks got me, done with a palette knife. I used to overrate them some. But I still don't dismiss them today. I've been reproached often for wanting to jettison all the big questions about art: criteria, content, so forth. I say I'm not interested, and then people say, "You're being evasive, or lazy, or arrogant." I'm not interested because I don't think these questions relevant; we can't get anywhere dealing with them. Young people will raise the questions, thinking they can be answered, and I know that when I was younger I thought they could be.

How did you come to realize they couldn't?
I don't remember. Hindsight would only tell me lies. When I started writing literary criticism, art criticism, I wasn't all that aware that you couldn't explain a verdict of taste. I maybe thought I could. My kid brother wrote a piece for some magazine on Conrad—this was the late forties—and I remember Delmore Schwartz's ex-wife exclaiming against it because instead of dealing with Conrad's art it went into what Conrad symptomatized in other terms than literature, and my seeing her point. She meant that he had gone away from the art in Conrad . . . I read Kant for the first time, really closely, in '41 or '42. I do know that when I started to write criticism about anything—art or literature—the question about good and bad came first. I took that for granted.

Was it your ambition, from an early age, to be a critic?
No. I was a child prodigy as an artist. I could draw—I won't say that what

I did was of any value, but I could draw photographically. Some people are like that, it doesn't say anything about your potentiality as an artist.

Did your parents encourage you to become an artist?
No. They didn't take me seriously. I came to know sometime when at college that I was going to be a writer. I wrote about literature; it was in the forefront of my attention, at that time. And looking at art later on—it was '38 or '39—I was reading art criticism then, and I thought, God, most of it was poor stuff. Then the *Nation's* art critic went on vacation, and I knew the literary editor, and I said, "Let me have a shot at it." I did and stayed on. I was educating myself in public. I was so sure of my eye at that time, and I'd read very little about art.

What had your parents wanted you to be?
My father wanted me to be a businessman. If I wasn't to be a doctor, lawyer, or dentist, then a businessman.

He was a businessman himself?
Yes, real estate.

If you had this facility for drawing, why didn't you become an artist?
With hindsight I can probably give a very interesting reason, but only with hindsight. I went to the Art Students League when I was sixteen. Some very nice man who worked for my father and to whom my father showed my drawings—my father at that time had a factory—this man said you should send the boy to art school, and he sent me to the Art Students League, to Richard Lahey, who turned out to be a wonderful teacher as well as a wonderful human being, and I went and drew from the model. My father was quite shocked that the models were naked females, and he said to me, "Had I known that, I wouldn't have let you go to art school." But it was too late by then. Again, I photographed the model—drew the model photographically—and I remember Richard Lahey saying, "Well, obviously you have talent, but there's more to it than that." He would point to Degas and Renoir, he'd even bring reproductions in. I didn't know what the hell he was talking about. I wanted to paint like Norman Rockwell. I used to go to the Art Students League every evening after high school, and then I remember I told Mr. Lahey that I intended to go to college, and that might interfere.

Was that to study literature?

I didn't know then. I think I wanted to be an intellectual. That was family too, it was a typical Jewish situation, where you were being encouraged to make money and at the same time be an intellectual. And I remember Mr. Lahey's saying, "Well, George Bellows went to college." And that was that. I went to college, still drew obsessively, but took no art courses except one survey course in the history of art. I didn't make a point of looking at art much. I got out of college, worked for my father a bit, then didn't do much for several years—the depression and so forth, and then went to work for the United States Customs. I began writing then—I had a sinecure and a lot of free time—and I wrote about literature. I did go and look at art, but I didn't *follow* it. Writing for *Partisan Review* and the *Nation* I was looking over my shoulder at art from time to time, knowing people on Eighth Street, knowing Pollock's wife-to-be, knowing Gorky, and other people, going to lectures at Hofmann's school. Then after the army—I was in the army for about a year—I got more and more interested in art, and then sort of drifted over into art writing. It wasn't only because I thought I knew art from the inside simply because I could draw from life and paint passably—not well, but passably. It was something else. Literature was much easier to write about, for obvious reasons. Art was much harder to write about, and calling your shots in contemporary art, too, was much chancier. There seemed to me more of a challenge there, and I thought I'd bet my eye against whatever. But there's always more than one motive, reason. Anyhow, I do think in America art has been a more exciting thing these past twenty-five years than literature. Not to discount literature, but there's simply been more life in art.

Did you subsequently regret giving up your art studies?

There are moments when I regretted not going ahead and trying to paint seriously. I painted off and on through the forties and the fifties. I wasn't too happy with what I did.

It was mostly figurative?

I tried abstract painting a lot in the forties. There was my eye and my guts—I simply didn't have the courage to do certain things. At the time I wasn't so aware of that; looking back now I realize it. I found I had more fun painting from nature anyhow—a nude or landscape was way more fun

than painting abstract. Again there was a mixture of motives. Sometime around the middle fifties I gave up painting almost entirely, except for a watercolor now and then. I want to go back to watercolor, it intrigues me, just for myself. You have to get your hand in, you have to paint a whole week before you can really handle watercolor. But I haven't somehow set apart that week to work out in. I'm always behind in my writing.

Your relations with artists have sometimes been difficult—
Very difficult, artists are difficult.

Because you don't take their intentions seriously?
No, that's never created difficulty. I have my way of saying, "Don't talk to me about your art, I just want to look at it. Talk to me about something else." People usually don't take that amiss, as long as you're looking at their stuff.

You must have trouble communicating your criticisms.
My criticisms are usually formal, or about attitude, but not about outlook, if that distinction can be made. Most artists, when you're in the studio talking about their stuff, they know—without knowing they know—they don't want to hear any bullshit about what you see in their work. They want to know whether you like it or don't like it. The first thing they want is, "Is it good or isn't it good?" in your opinion.

You must be aware of being used sometimes. Doesn't your approval lend status to the work?
No, not necessarily. People who know the state of affairs well enough don't have that illusion. Some may, but your main idea is to be helpful, not to sit in judgment so much as to be helpful, and maybe learn something for yourself, and often you do. Back thirty years ago I went to several studios with the Pollocks, and when they didn't like anything they wouldn't say anything, which was devastating. A couple of times I was a sensitive enough human being, or perceptive enough—and I'm not usually very perceptive—to put myself in the place of the artist and say, "This is murder." So when I visit a studio I make it my policy to say what I don't like, and then, of all the things I don't like, to pick out what I like the most. And you have to convey to the artist that your likes and

dislikes can't define his eventual capacities as an artist, or his potentialities; that like all other human beings, he holds infinite possibilities. That will usually take a good hour and a half of talking. If you visit someone's studio you put yourself under an obligation. That makes me sound very nice, I know.

(1978)

• •

A Conversation with Clement

Greenberg in Three Parts

• •

Trish Evans and Charles Harrison

CLEMENT GREENBERG, WHO HAS BEEN HIGHLY INFLUENTIAL
in art criticism since the 1940s, is now in his midseventies. He has been
the foremost proponent of the critical approach to art that has been iden-
tified as modernist. His work is notable for its evaluation of abstract ex-
pressionism and especially the work of Jackson Pollock. However, he has
had an influence on the understanding not simply of modern art but also
on the nature of the continuity of modern painting with the art of the
past. More recently he has been associated with the critical appraisal of
such artists as Noland, Louis, Olitski, and Caro. His book of collected es-
says, *Art and Culture,* which was originally published in 1961, has recently
been republished by Thames and Hudson.

In the following conversation, which took place on 20 November 1983
in Greenberg's New York apartment, he talks to Charles Harrison and my-
self. Harrison is a member of Art & Language and was also involved in
the preparation and writing of the Open University course "Modern Art
and Modernism: Manet to Pollock" in which much of Greenberg's work
as a critic is included and reviewed. He gave the Durning-Lawrence lec-
ture series for 1982–83 at University College, London, under the title "Art
and Its Languages: The Last Twenty Years." These lectures included an

evaluation and critique of modernism and an account of the work of Art & Language. Harrison sent typescripts of the earlier lectures to Greenberg, and this initiated a correspondence, which resulted in the visit.

In the first part Greenberg begins with some autobiographical material and then enters into a general discussion on critical approaches to art. In the second part the conversation centers on abstract expressionism and a consideration of the work of Pollock. The third part concerns more recent painting, from the 1960s onward, and deals with the contemporary conditions for the production of art.

—Trish Evans

PART I

CLEMENT GREENBERG: I was brought up in a family where socialism was the only religion. My father's and mother's culture was Italian opera and Russian novels, and being an intellectual was supposed to be the height. The conversion came after my first year and half at college. I had just wanted to have a good time. I got good marks and all that, no trouble, but I wasn't in it. And one afternoon I took a nap in the fraternity house—that awful place—and woke up. I had an anthology of English romantic poets on the floor and I opened it by chance at the "Ode to a Nightingale":

> Darkling I listen; and, for many a time
> I have been half in love with easeful Death.
> Call'd him soft names in many a musèd rhyme.

And I thought, good God, this is something.

It sounds too dramatic, that's the trouble. It sounds like one of those things made up afterward. But it was just like that, and from then on I became damned interested. I left the fraternity house that year and became a greasy grinder. And from then on—I was a bad swimmer on the swimming team, but I hung on until I graduated—I got more interested in literature than in anything else. I'd already learned French at high school, and I learned German and Italian.

TRISH EVANS: *So how did you move on to art?*
I'd been a child prodigy. I could draw from nature photographically from about five. At home they didn't take me seriously because they didn't

think anything their children did amounted to much. But finally my father showed some of my drawings to a fellow who did designing for him, and he said, "You ought to send the boy to the Art Students League," and he named the teacher, Richard Lahey. I was sixteen then and went to the Art Students League three nights a week after high school—a long haul from Brooklyn. And there I saw naked women for the first time in my life. Afterward my father said, "If I had known you were going to draw from naked women I wouldn't have let you go. It's too late now." This wonderful teacher, Richard Lahey, who was a pretty fair landscape painter, looked at my stuff and once he asked me, "What do you intend to do?" and I said I was going to college afterward. "I'm not going to art school." And I remember his saying, "Well, George Bellows went to college and it didn't hurt him."

I went to college the next year when I was seventeen and stopped going to the Art Students League, though I still drew obsessively. And finally it was all literature. I paid relatively little attention to art, though Syracuse, where I went, had at that time the best studio art department in the country. It was the first university to give you academic credit for painting and sculpture. After college I worked for my father for a while and finally got a job in the Civil Service and from Civil Service to Customs Service, as a clerk in the department of wines and liquors.

I started writing there because I had an office of my own and a lot of free time. I published in *Partisan Review* in 1939. It was a piece on Bert Brecht's novel, the one he made out of the *Dreigroschenoper*. The next thing, I wrote a piece called "Avant-Garde and Kitsch" and in 1940 I became one of the editors of *Partisan Review*. There were five of us. I could write my own ticket in *Partisan Review*—get printed. I published art criticism in the *Nation*. I knew the lady, Margaret Marshall, who ran "the back of the book" (I dedicated *Art and Culture* to her). The art critic of the *Nation* had gone on vacation, and I said I'd like to take a shot at it. And then I stayed on, and except for a year in the army I wrote for the *Nation* until '49, and I wrote for *Partisan Review* off and on until '55. (I resigned from the latter in '42.)

CHARLES HARRISON: *"Avant-Garde and Kitsch" reads like the fruits of some deliberations. It says some very specific things about what art is like.*
I'd started looking again really about '36. I began thinking about "Avant-Garde and Kitsch" on account of Brecht and the business of making high

art that a broad public could get and why that wasn't being done and couldn't be done at that time. An émigré German magazine touched something off. I've got the magazine somewhere, and I find it every five years or so. But it was Brecht most of all. I didn't hear of Benjamin till Hannah Arendt was over here in the late forties. He didn't give me much—much as I admire him. I went on to review T. S. Eliot's *Notes towards a Definition of Culture*, then dropped the subject. I didn't have anything more to say about it—the question of culture and the masses. (I hate that word "the masses.") "Avant-Garde and Kitsch" was the fruit of three or more years thinking about the subject.

T.E.: *At what stage were you in direct contact with the artists? Early forties?*
I'd known Lee Krasner, I'd known Harold Rosenberg and May Rosenberg. I'd met de Kooning. I knew Gorky and some others. I hung around Hans Hofmann's school. It was the only place to be if you wanted to talk about art in '37, '39. I'd gone to WPA art classes around '36, '37. You got a model for free. I went about twice a week. I went back to drawing from the figure.

I met Pollock outside the Appraiser's Stores of the Customs Service. There on the sidewalk was Lee with this gentleman wearing a gray fedora hat of all things and a nice, proper gray topcoat. She introduced me and said, "This guy's going to be a great painter." He had this open face. It was the only time I ever saw him wear a hat; he looked even more respectable than I did. Then I was in the army for a year. After I came out I saw Jackson's first show in '43. I was impressed by it and I wrote about it in the *Nation*, but I didn't glow about it. A while later he painted this picture, the end of '43, a portable mural for the foyer of Peggy Guggenheim's apartment. It's now at the University of Iowa. It went on and on repeating itself, and I thought it was great. We got to be much closer friends after that.

I quit the *Nation*, not for political reasons as so many people have it. I felt I'd had enough of reviewing. From then on I did occasional reviews for *Partisan Review*. In the course of time I stopped reviewing.

In '45 I got a job with a magazine published by the American Jewish Committee called the *Contemporary Jewish Record*, which turned into *Commentary*. I worked for *Commentary* till '57, when I got fired. The reasons for that are beside the point. I haven't worked for anybody since then. I got married in '56, second marriage.

C.H.: *Was there a certain point at which you thought of yourself as a critic?*
From the very beginning, I think. Or rather I didn't think of myself as a critic. I felt a certain *confidence* as a critic because I felt I could do the same thing as artists. Not as good. Not at all. But I knew what it was about from the inside.

T.E.: *Do you feel that an art critic should—*
No "shoulds" here. An art critic should have an eye and I can't say any more.

T.E.: *But do you think it's helpful for an art critic to have some idea of the practice of painting?*
I can't really say because a great critic like Meier-Graefe didn't paint at all. On the other hand, a great art critic like Roger Fry did paint—and, I think, better than most people realize.

T.E.: *But you think it helped you?*
It gave me a certain confidence that I might not have had otherwise.

C.H.: *If the art critic should have an "eye" and you felt confidence as a critic, there must have been a point at which you became sufficiently confident that you did have an "eye."*
Enough of an eye. It was after getting the hook of abstract art, which I couldn't see until '37. I'd been around these abstract artists but I couldn't see abstract painting till '37.

C.H.: *What made that possible?*
Looking enough. And coming across something like Klee's *Twittering Machine* in the Museum of Modern Art. Good God, you know, it just sat there. I tried to paint like that, but I gave up on abstract art. It's no fun, for me. Landscapes, the figure—not that I went about it seriously—that was fun. But abstract painting—no fun. But I realized I could *see* abstract art, tell the difference between good and bad, get a bang out of what's good. It's the same for nonabstract art, just the same: you look enough. People ask me, "How do you tell the difference between good and bad in abstract art?" And I say, "The same way you tell the difference between good and bad in Raphael." It's the same in essence. Of course!

T.E.: *How did you see the relation between art criticism and literary criticism?*
I didn't think about it. I thought art criticism was tougher. Tougher to write. Whether literary criticism is really easier than art criticism? I think, no. It's just easier to be plausible.

T.E.: *How do you see the function of the art critic in the art world?*
That damn question! It gets asked all the time, and it isn't worth asking. He points, OK? He points.

T.E.: *So what's the difference between the critic's pointing and anyone else's pointing?*
The critic supposedly tries harder, sees more. Supposedly. And maybe reflects more. Supposedly. And the critic makes his pointing public. Somebody else doesn't have to.

T.E.: *In making his pointing public, in print, the critic needs to justify it to some degree?*
Well, you know you can't demonstrate aesthetic judgments, as Kant pointed out. You can't prove them. You can't prove anything when it comes to art, literature, music, so far as value judgment's concerned.

T.E.: *You can't prove anything, but you might need to justify it.*
You spend some adjectives and thus implicitly you say, "Go and see for yourself." Now it's true that people in Peoria can't come to New York so easily, and that's frustrating. In the case of literature and music, which are reproducible, you can ask that the reader read for himself, the listener hear for himself. But since I don't believe in reproductions of the visual arts and have no faith in them, I feel in a bind.

T.E.: *When the critic writes about art he must write about it in relation to other art and that's how he justifies?*
"Justifies" is a questionable word here. He tries to back up his seeing, not to justify. All I can say is, it's something I wrestle with all the time and I read my stuff and see how I go about it. What I prefer to do is to say, "this is good," "that's not so good"—to walk through a gallery with somebody.

T.E.: *But is something good in relation to the art that preceded it? It can't just be good in isolation, can it?*

You're asking a question that's answerable, but it takes a lot of words. I think even cave painting had to have some kind of tradition behind it. You can say the first art might have been handprints or whatever, we don't know about that. All we know is that the best art always hooks on to previous art, even among nonurban people. That's a matter of record. There seems to be no exception, nothing that comes out of the blue, in urban art and as far as we can tell not in nonurban art either. (I won't call it primitive art because that's the wrong term.) West African sculpture comes out of Ife—I finally found out when they had a show of Ife heads in the Met. I'd seen them in reproduction, but it wasn't till I saw them in the flesh here that I realized how much of West African art comes out of Ife. Where Ife comes from is a great mystery.

T.E.: *But is the goodness or badness of the art in relation to its antecedents?*
It's absolute. The *production* depends on its hooking on to tradition, but its quality doesn't. Otherwise, how could we appreciate Japanese or Hindu or Persian art? Sometimes you don't know the tradition at all. It helps to bathe yourself in Japanese or Hindu art—to find your eye some—but there've been times for me in the past when those prints—Hokusai and Hiroshige—looked so good to me, and this goes back forty or fifty years when I knew nothing about Japanese or Chinese art.

T.E.: *So it would be possible to hypothesize a good piece of art which didn't hook on to a tradition?*
It is possible, but on record everything does.

T.E.: *But you'd allow for that possibility?*
Yes. In art you allow for anything. There are no rules in art, either in the seeing of it or the making of it, the hearing of it or the reading of it. You're asking me questions which have troubled the philosophers of aesthetics a great deal. Better minds than mine. And these questions can't be coped with in an interview. The other big question is: Are judgments of taste objective? Or are they just subjective; you like what you like and so on? Even someone as great as Croce dodged that. And he also dodged the question of whether bad art is art at all. He just said bad art was not art, which is a cop-out. What do we do with bad art? Given the human mind, we have to classify it. What do we say it is? In this damned book I'm trying to write I want one final chapter toward the end about bad art

and where you put it. I haven't gotten the answer yet. Kant was the only one, the first one, who really tried to wrestle with the question of whether taste is just subjective. I don't think he really came up with enough of an answer, but he came up with half an answer in his *Critique of Aesthetic Judgment.* But you have to read the *Critique of Pure Reason* in order to be able to understand it.

c.h.: *The question of disinterestedness of aesthetic judgments is an* open *question.*
It's partly closed, I think. But I won't go into how closed it is or how open because it has to do with intuitive experience. All the evidence of experimental psychology shows that no one has gotten inside intuitive experience or been able to analyze it. Why do we see the sky as blue? We know the wave lengths are "blue," but that still doesn't do the job. You can't tell a color-blind man what red is like. (Incidentally, women can name colors better than men can, which is not the same as recognizing.)

c.h.: *Causal theories of reference suggest that the uses of different names are to a certain extent matters of different histories—different contexts of learning, let's say. Let's go back to the matter of "spending some adjectives" to back up one's seeing. The adjectives you spend will not be the same as the adjectives I spend, and that's partly by virtue of different causal histories to our respective terms of reference.*
And a temperamental difference comes in.

c.h.: *You've also said you reread your writing.*
You do that before you send the copy to the printer.

c.h.: *But what happens when you reread and you decide you pointed at the wrong thing or spent the wrong adjectives?*
You change it.

c.h.: *What if it's something you wrote five years ago?*
Oh, then I . . . oh . . . squirm. There's plenty. Oh, man, there's plenty!

c.h.: *But do you ask why?*
I ask why and usually it's aesthetic. I get no satisfactory answer. People quote me and show I've changed my mind sometimes. They want to nail

me on that and know why I've changed my mind. Greater experience, that's all. It's all about educating oneself in public. I've said that in the foreword to my selected essays. I did educate myself in public. I'll add that if you don't change your mind you're lost. The fun has gone out of it.

c.h.: *Could you ever look back on anything you've changed your mind about and say it wasn't so much lack of experience but because some mechanism was in the way?*
My eye was off.

c.h.: *What sets it off?*
I don't know. Let the experimental psychologists find that out. My eye was off. Your eye goes off. As I get older my taste gets more and more catholic. I maintain that it's evidence that your eye is still developing—as you like more and more art instead of less. That's my experience, and I set my experience, up in this respect as final court of appeal.

c.h.: *Does this make you more open to what you were previously closed to?*
Yes.

c.h.: *Can you identify the closures?*
Yes, but not the reasons for them. I didn't have enough of an eye then. My eye's got better. That's the best I can say.

c.h.: *Do you equate "more catholic" with "better"?*
It means you've got a better eye—according to my experience. And it doesn't mean that you need experience of more exotic art either, in order for expansion of taste to take place. I don't think it's necessary to see what China or Japan or Persia have produced. You just keep on looking.
I'd like to go back to myself. I have a knack of getting myself misunderstood, and twice lately it's been said that I'm for abstract art. Things I've written get quoted back at me, always a little off. One case is a sheet called *Art World*, the other case is the *New Criterion*, quoting things said by Fairfield Porter in an interview for the Archives of American Art. "Towards a Newer Lacoön" was quoted back at me in a letter protesting what I'd said in a previous letter. That thing was published in 1942. The writer didn't allow for the fact that I might have changed my mind, but that's beside the point. I was very rigid then in a Marxist way. I failed to make

a distinction between major and minor art. That hadn't come up for me as that important in 1942. It was only with the abstract expressionists that that came up. We'd had some wonderful American painters in the nineteenth century; so had the Germans and the Italians. I had not yet made that distinction between major and minor art. The quotation you'll find in the *New Criterion.* Someone called Rackstraw Downs wrote the rejoinder to my letter. Every word he quoted needs qualifying in terms of the difference between major and minor. I said that abstract art was inevitable given the conditions of history. I should have said that abstract art as a *major* way of painting was inevitable, but that this didn't exclude the representational.

c.h.: *I've always felt the soft spot in your more general theoretical arguments, for instance, in "Modernist Painting," is the claim for necessity in the tendencies you describe. That seems to lay you open to criticisms of historicism.*
I did a postscript to that piece when it was included in Kostelanetz's anthology *Esthetics Contemporary.* I said it was the fault of my rhetoric not to spell out the fact that I wasn't prescribing but describing the internal logic of modernism. It was taken as prescription, and I must say I was shocked.

c.h.: *To call it logic is to close an open system.*
But there are logical setups all over the place. There's a logical development of carpentry. The word "logical" is open, that's the trouble. And I did say in the postscript that I didn't imply it had *had* to be this way but that this was the way it had been, in fact, and that there was a logic to it. It wasn't supposed to be prescription, but it was taken as that and that was the fault of my rhetoric. And I am careless. I sounded as though I was laying down the law.

c.h.: *I would want to criticize what you wrote, not so much on the grounds that it is prescriptive of the future of art, but because it turns the open systems of history into a closed logic of development which produces the present—or the present according to a specific view.*
In the different disciplines it looks that way in retrospect. It need not have been that way. But if you're going to deal with the past you have to see some logic in the way one event follows another. You can't say it's random. There's free choice, I'm sure, but somehow as it happens you can see some inexorabilities. And a series. It's the way to make sense of the thing.

C.H.: *It sounds to me like a way to make sense of the present.*
I don't see the difference. Or rather I *do* see the difference because the present's too present. When I talked about the purity of art, about pure art in that article, I didn't point out that it was an illusion—a useful one. It was a useful illusion for Mallarmé, even for Picasso. I don't believe in purity at all. It acts as some kind of beacon. It's there, but it's not possible. It has no ultimate reality.

C.H.: *You accord a disinterested and involuntary status to the immediate aesthetic response.*
I do indeed.

C.H.: *The aesthetic response is what informs you that you have the logic right.*
True.

C.H.: *So what we have is a circularity, where the disinterestedness of taste and consensus in response and the inevitability of the development impose a logical necessity upon each other.*
No. Experience decides that. Consensus of taste decides. Kant had some inkling of it. There hadn't been enough art criticism before him or something. What the people who've seen most, read most, heard most—and who've worked most on what they've seen, read, heard—decide in the way of value judgments proves in the long run to be right. How do you test that? You go to Italy and there's this Milanese fresco painter you've never heard of. Borgognone, pieces of fresco in the Brera, and you think, wow, they're good! And you reread Berenson and he refers to this guy as a great painter. And you think, good God you've made this discovery and Berenson's been there ahead of you. There's consensus. Berenson was good. He's not so hot about the Sistine ceiling. The consensus slips sometimes, or for a long while it operates without including someone like Georges de La Tour. They hadn't identified Vermeer, so they waited for Thoré-Burger to come along in the nineteenth century and isolate him. But those are the fringes of the consensus—*not* of art itself.

C.H.: *Have you had the experience with the art of the past of seeing someone who's not incorporated in the canon, and seeking validation (as with the case of Berenson) but not finding it?*
I didn't feel validated there. Not even confirmed. Beaten to the point rather. I didn't need confirmation. I'm that arrogant. I can't remember. There

are these fifteenth-century Flemish paintings in the Wallraf-Richartz Museum in Cologne, by unknown artists, and they're great. But the curators had already beaten me to it. (Incidentally, the Europeans criticize us Americans for going by names so much. We haven't got enough "Ignoti" or "Unbekannte" hanging in our museums.) I can't remember discovering anything for myself that was outside the canon. I may find some late-nineteenth-century German painter, but that's a local issue. It's a matter of the work being underrated outside Germany. Trübner, Liebl, for instance. Or Stobbaerts in Belgium. I find all along artists who are underrated. There's a mid-nineteenth-century American sculptor called Ball. He turned me on, and I found he'd no name at all. I came across a work in the Louisville museum and they included him in the Whitney American sculpture show a couple of years back. They had one Ball, solely for historical reasons. And lo and behold Kenworth Moffet, who'd never heard of him—and I'd never mentioned Ball's name to him—came back and said, "Hey, there's a new sculptor there." That shows how good Ken's eye is. These bronzes aren't supposed to be good, they're too literally realistic. They are good. But these artists are never major. The major ones hardly ever get overlooked. (La Tour and Vermeer were exceptions.)

T.E.: *What do you mean by that distinction between major and minor?*
Aesthetic judgment. A major artist gives you more punch, though sometimes a minor artist can be major in one work.

T.E.: *And a major artist is one who sustains it?*
More or less. It's tough, like good and bad. What do you mean by good, and what do you mean by bad?

T.E.: *Is the aesthetic response gradable?*
Judgment is gradable. There are degrees, in my experience.

T.E.: *That seems to conflict with the idea of its being absolute.*
The *degrees* are absolute. Why not? When the temperature is fifty degrees, it's absolute; for our experience it's absolute. It's there and you can't get underneath aesthetic experience, at least not yet. It's not something you can change by circumstance. Fifty degrees of temperature are not changed by circumstance.

C.H.: *By absolute do you mean mind-independent?*
I hesitate to say that. I go along a little bit with Bishop Berkeley. The instruments we have for measuring temperature are human. And they're not mind-independent. We establish the gradations in relation to other mind-dependent facts.

T.E.: *So what is the "instrument" for measuring aesthetic quality?*
Sensibility, which is all we have when it comes to art.

T.E.: *And that's something we develop?*
All people are born with the faculty, but I don't think anyone is born with taste. I can't say you're born "amusisch"; I have to believe all people are born with the faculty, the capacity.

T.E.: *So how would you describe its development? How much is sensibility developed through education, through spending one's time in the company of people with taste, and so on?*
That's an open question. In our culture it does seem to be the case that females tend to be more readily "musisch" than men. But there may be social reasons for that. It may have nothing to do with hormones. I don't know. I'm so happy to be able to say I don't know. It's such a relief.

C.H.: *How far do you go with Bishop Berkeley? Do you withhold assent from scientific realism altogether?*
No. Only in certain contexts.

C.H.: *The big question seems to be, to what extent is aesthetic response a response to some mind-independent property of the work of art?*
To no extent whatsoever. Aesthetic experience is outside material circumstance or consequence. Hard to explain that, but that's my experience. I'm ready for some subtler philosophic mind to come along and correct me.

PART II

In this second part, Clement Greenberg and Charles Harrison first consider the nature of the critic's response to quality and consistency in an artist's work. Greenberg talks about the continuity of the European tradition in American art and then moves into a discussion of the mechanisms that govern art opinion and the art market. Harrison raises a question

about Greenberg's appreciation of the work of Johns and of the ways in which art of the past determines present production.

The second half is largely concerned with the work of Pollock and with Greenberg's assertion of the necessity of flatness in major modern painting.

c.h.: *The work of art is identified for you in terms of your response to it. That response is supposedly involuntary and disinterested. It is a special kind of experience. What sets the conditions of relevance to the response; what decides its status as aesthetic?*

When it comes to aesthetic experience you're all alone to start and end with. Other people's responses may put you under pressure, but what you then have to do is go back and look again, listen again, read again. You can only modify your judgment by reexperiencing. You don't change your mind on reflection. You may get doubts, but you have to go back and check again. It's not a matter of probative demonstration. When you can demonstrate an aesthetic judgment probatively art will cease—art as we've known it so far.

c.h.: *Can you recall any really decisive instances of reexperiencing?*

Too many to remember. I'll have a stab at it, though this may not be to the point. Clyfford Still gave me trouble when I first saw his art. There were so many who admired him who didn't admire Pollock's allover art. So I'm given pause. I go look again. In Still's case I did see a small picture at Alfonso Ossorio's that I got the point of. Then some more. I found myself taking him too much on blind faith. I'm talking now about the end of the fifties. Two years ago there was a huge show at the Met. It was largely a dud. There were two or three smallish early paintings which were OK. I decided to write about it and get personal too. In my original failure to see Still there had been the seed of something. Then there was Diebenkorn's first New York show in '54. It was the first show of abstract expressionism that sold in New York. I liked every picture. It was too good to be true. I could see why it sold out. Diebenkorn had a retrospective ten years ago at the Jewish Museum. Those early works had gone to pieces. I wondered about my eye at that time. Charles Hinman—someone I like enormously personally—had a show of sculptured canvases. This was a dozen years ago. I thought every one of them was right there. That show sold out too. I saw some of those three-dimensional canvases three, four years later; they'd gone away. Since that time I've gotten suspicious. Now when I like

everything an artist does, I suspect I'm wrong. I want to see failed paint-
ings, failed sculptures. I don't want to make that a rule, though.

C.H.: *Have you seen an interesting mixture of significant failure and signifi-
cant success in anything done over the last few years?*
I'd have to go back to be sure of what I say. In David Smith's case and
in Hans Hoffmann's case, they could fall on their faces so often and then
come up. And it was as if it were necessary for them to fall on their faces
in order to come up. Only as I've said before about Smith, no matter
how bad the piece was it always got better with time. It never got worse.
And the same for Jack Bush, the Canadian painter whose picture's hang-
ing over there. Bush usually looked worst the first time. That says more
about the artist than about my eye. And in Smith's case and Hofmann's
case there was no falling off with age as there has been with so many art-
ists. They have that ten-year run. A twenty-year run for Picasso and then
the slope downhill, though with interruptions always. As there were with
Rothko during his post-'55 decline. Hofmann and Smith were going to be
as good as they'd ever been had they lived to a hundred. There are ups and
downs. Again that's not a rule, it's just something I've noticed, just as I've
noticed that neither Titian nor Rembrandt could bring off group com-
positions after middle age. Again, with exceptions. What goes on I don't
know. Why do poets fall off? Wordsworth fell off; so did Auden.

C.H.: *Noland seems like someone who has a wide range between success and
failure.*
Noland will keep going till a hundred. The difference isn't as glaring as
in Smith's case or Hofmann's. Someone else who'll keep going is Olitski.
He's like Smith. He doesn't give a damn. His failures don't trouble him.
Hofmann was troubled by his misses, or rather by their being identified
as misses. Nobody could tell him anything. I wrote a little book about
Hofmann and talked about his bad pictures and he complained, "I never
painted any bad pictures." European hot air. And I thought Hofmann at
his best was a very great painter. And sometimes his mediocre pictures,
in group shows with Pollock and company, would in a curious way beat
them all—in a curious way that I can't put my finger on.

C.H.: *How about Europeans over the last ten years or so?*
About Europeans! I made the distinction between Europeans and Ameri-
cans only in the early fifties when I thought our painters were getting

better. Saying that was a reaction to circumstance, because the Modern Museum was then readier to buy a Mathieu than it was a de Kooning. And I think Mathieu is good by the way, and underrated. He's fallen off lately, I know, but he was damn good when he was good. But there was this tendency at the Museum of Modern Art for a while to accept a European quicker than an American and I was reacting to that. Otherwise—I've written this—the French tradition was being maintained in this country better than it was in France itself. And none of the abstract expressionists denied their debt to France; though people like Rothko and Gottlieb would murmur way back then and say, "Oh, you're buying French paintings instead of ours and we're just as good or better." But nobody denied his debt to Paris. That only came with the minimalists. They said, "We're American, nothing but American." There was a show, *Twenty Years of American Painting,* organized by the International Council of the Museum of Modern Art and sent to Tokyo, Kyoto, New Delhi, and Sydney, and the State Department decided to send me along with the show—half of which I thought was bad. And I went to the opening in Tokyo with this wonderful Japanese the USIS had assigned me as an escort. And he came into the first room of the show and there was a Gorky and a Pollock and I forget what else, and he said, "Oh, how French!" Those artists, had they been alive, would have loved to hear him say that. It's only the likes of younger Americans, brash ones, who say, "We're American, we don't do things the European way"—which is nonsense. Pollock, when interviewed, didn't go on about being American. He knew better. We came out of Europe, we're tied to Europe, and that's all there is to it. We're no more non-European than the Germans are or the Portuguese.

c.h.: *Do you feel that now? Do you feel that the moment of the mid-sixties, when Judd and company turned their backs on European art, is now over?*
I don't know whether it's over or not. I dare say there are plenty of American artists shooting their mouths off about how we're American, not European.

c.h.: *There's clearly plenty of hostility now, which I've heard expressed informally, to what seems like a European invasion—to put it in vulgar terms—a European invasion of the market.*
No, that's literal. That's the truth. It's there. But New York had become, as the fifties wore on and more so in the sixties, as parochial as Paris had

been in the old days. European art was given less of a chance until just lately with the Neue Wilden and the Italians. I like that, except that the European art that's broken into New York isn't so hot. But I like the breaking of the parochialism.

c.h.: *The impression I get, walking around SoHo, is something very like what it was like walking around the Left Bank of Paris in the early sixties, when what you had was the sense of a market based on the idea that Paris was the center, while what it was really was just the center of the market. So you had a lot of stuff produced to feed this market—which could swallow a lot of bad art. The argument I had with Michael S. the other night was over his suggestion that a wave of what he called nonart from Europe was destroying and impairing the conditions for the production of art. I see it differently. I see the academicism of the market and the capacity of the market to swallow everything as being what destroys the critical conditions.*

I disagree one hundred percent. The market is a handy factor to bring in—a handy explanation. There was a Bob Hughes piece in the *New York Review of Books* about what has happened in New York art—all about dealers, dealers, dealers. In my forty years around art that's not borne out. There's art opinion, whose moves are mysterious to me. I haven't seen the market or the dealers interfering with the production of good art—yet. Any more than market conditions in the 1890s, when Bouguereau was on top, interfered with the production of art by Cézanne or by Signac for that matter, or by Bonnard or Vuillard, who were maybe doing their best things then. Market conditions in the early 1900s in Paris—who was the great international star in painting in those days? Eugène Carrière, who wasn't a bad painter incidentally. He was world famous. He wasn't a great painter. He had a big influence on photography, with the soft focus and sepia. Again, he wasn't a bad painter. The Museum of Modern Art finally brought itself to acquire a Carrière a while ago. We want to find an agency for whatever happens. Somebody's engineered something. We prefer most of all conspiracies: things have been arranged; that explains it. And of course dealers and commercialism are always the bad boys. Everything's contrived and so forth. I say nonsense—in my experience. When Leslie Waddington puts on a show of Schnabel in London he's not furthering Schnabel's reputation. What's happened is that Schnabel's reputation has forced Leslie to show him. The agent is art opinion, not Leslie's venality or whatever.

c.h.: *So what happens if art opinion goes off?*
Well, it's gone off ever since Manet's day. Ingres was opposed early on. New art became controversial with David even before Ingres.

c.h.: *I wasn't trying to describe a conspiracy.*
No, I know you weren't. I was just scotching the notion.

c.h.: *I was trying to identify a tendency, just as you yourself have tried to identify a tendency.*
I haven't seen commercialism interfere with art in my time—with the production of art. Contemporary art fares, in scheme, the way it has since Manet's time. The best art starts off in the background. It comes to the foreground after ten or twenty years. Then another, later kind of "new" art comes to the foreground. We saw that in this country. Abstract expressionism was the top thing—but not on the market until the later fifties. Then there came a stock market decline from February to May '62 and abstract expressionism went out, stopped selling. The second-generation abstract expressionists disappeared the way flies do in the fall. Pop art came in in the fall of '62. Meanwhile—this is part of the ecology—the first-generation abstract expressionists rose again. There was pop art occupying the foreground, but there was also first-generation abstract expressionism becoming consecrated, and bought and valued and so forth, and the two things went together.

c.h.: *Would you see the enormous early success of Johns, and to a lesser extent Rauschenberg, as a reflection of that tendency for the market in second-generation abstract expressionism to collapse?*
It coincided. All I can say is that Johns and Rauschenberg—as bad as Rauschenberg could be—looked refreshing by comparison with the second-generation abstract expressionists—by comparison with Tenth Street abstract expressionism. Cause and effect here . . . I don't know enough. Somebody ought to do a dissertation on that. Another dissertation ought to be done on the ups and downs of art opinion in the second half of the nineteenth century and right up to the twenties, and still another on taste in the twenties and thirties.

c.h.: *You puzzled at Johns in that "After Abstract Expressionism" article in '62.*
Yes, because I liked him, but he wasn't good enough. He wasn't major.

c.h.: *So why do you feel you had to puzzle over him?*
It was a premonition, I guess. When he had his retrospective at the Whitney three to four years ago everything that I'd liked fell off. Not only the "number" and the "flag" paintings—I'd liked more than that. They all fell off. The record shows early success has been fatal since the 1850s in any art. Didn't T. S. Eliot write that when a book of new poems goes over fast we have every reason to suspect it's not so new? Eliot didn't specify at that time that "new" was not such a value. He knew better.

c.h.: *Do you think the "disaster" of early success is something it's possible to recover from?*
Sure. Anything is possible in art. So far it hasn't happened, but I want to see it happen.

c.h.: *I tend to see the best of Johns's cross-hatching paintings as showing a kind of recovery.*
The color isn't good enough, and it shows he doesn't know how good Olitski is. Not that he's got to paint like him. If right now you're an ambitious painter with major aspirations you've got to see how good Olitski is. Just as in the 1920s if you wanted to be major you had to see how good Picasso was, and Léger. Later on, Matisse, who came to the rescue as it were. That seems to be another constant: you'd better recognize who the best artists just before you are, in order to take off; not in order to paint like them, but in order to get enough pressure on yourself.

c.h.: *Would you agree that they are also in a sense your door of entry to what's good in the past?*
No, I wouldn't. There are painters who I don't see as major but who've seen the past damn well.

c.h.: *What I mean is that the capacity to identify what is most important in the art of the recent past may be a necessary condition for getting further back, practically.*
Possibly. I won't say yes or no. Manet's a special case. He says how good Courbet and Corot were, but he jumped back to Velázquez and Goya. Special case.

c.h.: *I have a personal ax to grind perhaps. I think that for Art & Language the recognition of Pollock—of the necessity of Pollock—has been very*

much a means of getting access to aspects of Manet, to Courbet . . . perhaps accidentally.
Well, I'll be damned. I wish you'd go on record saying that. It pleases me. I don't know for what reason.

C.H.: *It's paradoxically so, perhaps, in ways one certainly couldn't have predicted. That may be to say that it's a practical point of entry, not a theoretical one.*
There's no theory here. Come on. Accept your eye and nothing else. What's theory? What has theory got to do with art?

C.H.: *I think it's true that, however much you may admire, let's say, a painting by Manet or Courbet, you can't use it—you can't make anything practically of that interest—without some confrontation with something more recent.*
I'll grant you that without knowing it. Pollock refused after a while to visit the Old Masters. Once at my place, in the early fifties, I had a book of reproductions of Rubens landscapes. He slammed the book shut and said, "We paint better nowadays." I won't repeat what I said, it's too obscene. Now in a funny way he was borne out because I hadn't yet seen any of the Rubens landscapes in the flesh and then I saw them—and Rubens wasn't such a good landscape painter. But that's not what Jackson meant. And Rubens was otherwise a great, great painter (as long as his shop didn't work on his pictures). Morris Louis, when I visited him in Washington, would drive me to the National Gallery and then leave. I'd go in and he'd go home, then come back and pick me up. I asked him why and Louis replied, "They might get into my blood."

C.H.: *I have the intuition that in late '50, '51 Pollock let them get into his blood a bit more.*
It wasn't because of going to museums, that's for true. In '52 he began to lose, waver. He painted some all right pictures but . . .

C.H.: *I don't mean all that rubbishy stuff about how the black-and-white paintings are all depositions and lamentations and so on. But what I get is a sense of engagement, not exactly with the grand historical subjects of European art but with something which is contained in those subjects.*
There was something that happened to Pollock in the ten years during which he didn't go near nature—from '41, '42, say, to '52. He learned how to handle paint in an accepted way. And his drawing became way better.

He hadn't drawn from life at all during that time. But in 1953 he began to draw with facility, and paint with accomplishedness. All this was like taking place underground in those ten–twelve years. Jackson had been painting great pictures since '47, and before. And then those 1950 pictures.

c.h.: *Yes, but the works of 1950 are superbly* achieved *paintings. One of the great things in the early allover paintings is the sense of something being powerfully practiced and learned.*
The usual Pollock show would have five first-class pictures and then the other fifteen would be so-so. They got better with time, some of them; some of them didn't. Those *Eyes in the Heat* pictures which just preceded the drip paintings I always thought were good pictures. In '53 Jackson showed he could paint the way you were supposed to paint, handle paint according to tradition. But that didn't stop the 1953 picture in the recent Acquavella show from being bad.

c.h.: *But it's '50 to '51 that fascinates me: "Echo, No. 14." It seems to me there's an engagement, there's a marvelously practiced and articulate technique which has its accomplishment in that '50 show, and then—*
God, you're so intellectual! You're fancying it up. You may be on to something. But in '48, '49 he'd been doing terrific painting.

c.h.: *Yes, sure. I'm not talking about quality. I'm not talking about what you mean by quality.*
Oh, I beg your pardon. You're talking about the practiced bit.

c.h.: *I'm talking partly about what must have been his problems as regards what he was in a position to work with and go on with.*
Ah. I'm too intolerant. OK, go ahead.

c.h.: *That Lee Krasner quote, "What do you do after the '50 show?" That is* a practical *problem.*
That's a bit of hindsight. What went on was that Jackson went back to booze just before that great '50 show. There were wrangles. That's why I'll never write a book about Pollock. I was there.

c.h.: *I'm trying to think practically what it must have been like to have that '50 show and see the work on the walls. There's a certain sense in which the very quality of the work cuts off the possibility of just that being developed. He*

wrote to Ossorio in '51 that he was drawing on canvas "with some of my early images coming through." The early imagery refers to the '38 to '41 drawings— that's Picasso, there's a lot of Picasso in them. It's a kind of reengagement or reentry.

He liked Picasso even when he was bad.

c.h.: *I feel that in thinking again about Picasso he had to let back in a bit of what came with Picasso, Picasso's interest in Rembrandt, for instance: the kinds of themes that come up in those midforties etchings when Pollock must have looked at Picasso's graphics—reclining figures, self-portraits. Those black-and-white paintings are full not so much of reclining figures and portraits but of what was dealt with in dealing with those themes.*

Maybe. You know, I don't like this kind of talk because I was there. That entitles me to nothing, my being there. Jackson always longed for the third dimension. Unnatural painter though he was, with no gift for nature, he always longed to go back to modeling, just as Gorky did, and just as de Kooning did. But abstraction—I hate that word—abstractedness was liberating for Jackson. It wasn't for Gorky or de Kooning. You long to model when you paint. You not only long to do something from nature, you long to go into the third dimension. Man, that generation—I won't compare myself, but I know when I tried to paint abstract. Oh God, I yearned to be back carving around the figure. I fudged by going into landscape. Sure Jackson always was nostalgic for the figure.

c.h.: *But could it possibly be the priority of your "logic," your necessity—*

No.

c.h.: *—that would lead you to see it as nostalgia, as a kind of backwardness?*

When Pollock went back into modeling it didn't look good enough. He was guided by that. That's all. It didn't look good enough, or let's say "major." So he had to stay flatter. That's the way it works. Manet flattened art, for God's sake. It didn't look strong enough otherwise. That's all. That forced your hand. Hell, you wanted to do the figure, get involved with the female body and model it; you wanted to do apples or whatnot, model, model, model. But you couldn't anymore. It didn't come out good enough. Somebody had always done it a bit better.

Gorky longed to be able to paint from nature. De Kooning said to me he didn't like any damned abstract painting except Rothko's. That showed

what was wrong with Bill's eye. Rothko was a great painter for a while, but all the same de Kooning should have mentioned Pollock, but he couldn't see Pollock. Nor could Hofmann. Nor could hardly any of Pollock's painter contemporaries in New York, as he found out when he visited the Cedar Street Tavern. But sure. Even in the black-and-white paintings he couldn't let himself model.

c.h.: *I'm intrigued by that tension between the desire to model as you call it, the instinct—*
Or shade, let's get it right down to shade.

c.h.: *—and the impossibility of making a plausible painting by doing that, which I accept.*
Plausible, yes. No, come on, we choose our terms: not good enough; plausible, yes, but not good enough. The difference between major and minor.

c.h.: *OK, but that sense of "not good enough" becomes what feeds back into the practice as a working problem at some level—some intuitive level.*
That's the whole thing. That's what drove these people to go flat.

c.h.: *Now I'm suggesting that that tension, which is a grand tension, a historical tension, becomes a productive one.*
You should write that. Because I've maintained for a long time that if you didn't know Western art of the past you couldn't see abstract paintings in the present, and I didn't know how to put it.

c.h.: *You would misread it.*
That's right, you don't see enough of the picture.

c.h.: *And you don't see why it's difficult.*
Yes . . . that tension. I hate the word "tension," but I don't know what to put in place of it. *You* write it, that's fine. It's true that the Japanese and Indians now have seen the point of Western abstract painting. I witnessed that in the sixties in Japan and in India. They'd gotten the point. I kept wondering why, because I felt, before, that you had to know Rubens and Rembrandt and Titian and Raphael, and so on, in order to see how good Pollock was—if you *could* see how good he was, or as far as anyone could or still can.

C.H.: *I think a lot of the best modern art is born out of the encounter with what can't be done—with what's impossible.*
Well, it's not impossible because it comes out in good pictures.

C.H.: *No, when I say impossible I'm talking about the sort of thing you mean by shading.*
But you can't do it anymore. You're lost if you do it, so you do what? You just say good-bye to it for the purposes of major art.

C.H.: *But that hanging on to, and longing in respect of these people: your sense of respect for the achievement of doing it in the past—*
You want to do it yourself, but you can't because it won't come out good enough. The main thing for artists is to be able to make it good, and it's nothing to do with expressing yourself. Sometimes your vision comes in, yes, you've got a vision, but in order to be able to make it good—major rather—you have to go flat. Just as in Italy by the fourteenth century you could no longer stay Byzantine flat and make good enough painting.

C.H.: *Yes, but bad abstract painting, it seems to me, is produced out of the acceptance of the necessity of that flatness, abstraction. That's what produces bad art.*
No, that's too easy. What produces bad art in any time? If you go to the new André Meyer wing at the Met, you see this delicious small Gérôme, and elsewhere good smaller Landseers, and then when they had to go bigger they couldn't put the picture together. You see this larger-size Meissonier, the *Battle of Friedland,* and the thing's dull. Degas said of that picture that everything in it was made of steel except the armor. In order to paint bigger pictures from the 1860s onward (I mean pictures say at least three by four), you had to go flatter, inexorably. That's what hindsight shows. So Manet did it and then the impressionists did it. But the Salon virtuosi—and they were good—they couldn't bring it off. This is Schnabel today, painting big pictures. He can't bring them off, though he can put paint on. It's the business of putting a picture together.

I feel uncomfortable in talking about the necessity of flatness. I mean that only with regard to *major* pictorial art in this time. There's still so much good minor art that embraces illusion and modeling and shading. And I value minor art. I'm not just for big names. The nineteenth century is strewn with so much good, good minor art. The trouble is, I grew up

into art insisting on the "major" for American painting and sculpture. And in an article like "Towards a Newer Laocoön," which I did very early on and have been embarrassed by ever since, I was too short and dogmatic in my apotheosizing of the abstract without emphasizing that I was focusing on the major *alone*. I was so callow back then, with my quasi-Marxist rhetoric. At the same time, reviewing in the *Nation* and *Partisan Review*, I praised painters like Hopper and Friedman (who loathed abstract art), and still others who were far from abstract.

Part III

In this final part, the conversation takes a more informal and slightly wayward turn with Harrison and Greenberg covering a variety of topics. It begins with an assessment of some of the younger contemporary painters and then moves into considering the relative autonomy of the medium in defining what Greenberg calls "official art." The conversation then ranges over various movements in the sixties, the significance of the work of Johns, Olitski, and Noland, and touches on the work of Art & Language. The discussion continues regarding the plausibility of creating the conditions for the production of "good" art. It ends with Greenberg's assertion of the need for an "honest" aesthetic response that is divorced from any moral or political bias.

c.h.: *Do you see any figurative painting today which is large scale and which sustains itself?*
Balthus, when he's good. I think he's fallen off some, but he's good. But it's not major, dammit. There are others. Lucian Freud in your country, Peter Blake and William Thomson—especially Thomson, who should be better known. And Blake I've long had a special fondness for, though I haven't seen anything of his for maybe ten years now. Still others, but none of them major.

c.h.: *And younger? You mentioned Schnabel earlier. There are a lot of people Schnabel has been lumped with. Do you discriminate between them? Germans and Italians?*
I've only seen reproductions of Kiefer, but he always looks better to me than the other Germans. Except the other day I saw a big Penck—and I always thought better of Penck, too, than the other Germans—a real try; though if you compare him with Olitski or Noland he looks on a lower

level. Mike Steiner told me you don't like Olitski. That's your challenge. You'd better like him.

c.h.: *I don't like Penck or Kiefer either.*
Well, maybe I've got you wrong.

c.h.: *I've seen Pencks that look good in reproduction.*
They reproduce very well. Why shouldn't they? There was this tall one. I'd never seen one that big, and I had to ask who painted it because I couldn't believe it was Penck.

c.h.: *Chia, Cucchi, Clemente?*
I've told you about Clemente, that show in New York that had one sweet—and better—picture that was a giveaway. It's not because of that. The pictures are not much good, that's all. And the "bad painting" stuff must play a part: the tendency to say "let's paint bad." The explanation would take too long and I'd have to qualify too much.

c.h.: *Have a go.*
You've already heard me say this. In the early sixties a new generation of artists and art lovers came up. It seemed that the reputedly best art of the previous hundred-odd years had always been far out, had always created scandal: Manet, the impressionists, and so forth. The categorical imperative became "far out." And Pollock was the key example. Didn't the painters in downtown New York in the fifties used to say Pollock was a freak painter, not a real painter, not like de Kooning and not like Kline and not like Milton Resnick? And then it was like someone had bugle-called you up in the morning: "OK, now we know art. This is it. Far out, far out." The pop artists sensed it, and the minimalists and the conceptualists knew it.

c.h.: *I'd like to say something about that moment in the early sixties in relation to what came after. I remember you said something about it in an article called "Avant-Garde Attitudes"—it was a lecture you'd given in Sydney. It seems to me that that reading of Pollock was to do with mistaking the means of addressing the problem for the problem itself.*
That they misunderstood Pollock was beside the point in this context. I

still want to meet some people who can tell the difference between a good and a bad allover Pollock.

C.H.: *It seems to be an endemic weakness in American culture that a change of medium—a new medium—is mistaken for a new meaning.*
It's spread all over Western Europe too. Come on now, don't just pin it on us poor Americans. It's spread all over the Western world.

C.H.: *I'd like to try to defend my own history a bit. I'd like to defend what went on in the later sixties, early seventies. We suffered—by we I'm talking about Art & Language now, and I'm speaking largely for others than myself— we suffered people making precisely the same confusion of how we were doing what we were doing, with why we were doing it.*
Now you've gotten into art history. I bring it down to that. I don't think it was all that conscious about getting down to, referring to art history of the recent past. I'm simplifying, but at any rate far-outness has become by now official art in this country, and elsewhere.

C.H.: *But that was a terrible condition, and I think what we were trying to do was to work through that condition; to work through minimal art and what that did to art; to work through Duchamp and what he did to art, and so on. This is hindsight.*
OK, I want you to write those two thousand words or more to explain. Because I don't get the prose.

C.H.: *It interests me—and I could never have foreseen it—that what seems to have happened, more or less accidentally, was that we'd worked ourselves to Pollock and to Manet, to Courbet and to Picasso. It was the last thing I could have foreseen.*
Well, that showed there was something real going on.

C.H.: *There was.*
Which I doubted when I saw those pastiches of Pollock in magazines. I didn't draw any conclusions from them, but I was given pause.

C.H.: *They were serious.*
Yes, I was given pause. So poor Jackson is the culprit! He wouldn't have known what to make of it.

C.H.: *But he was also serious.*
Jackson was as serious an artist as there ever was.

C.H.: *I find it very hard to find anything more recent which is serious like that.*
Oh, look. All these paintings around here—not because I've got them—they're serious.

C.H.: *The long Noland over the bookshelf—*
That's not serious?

C.H.: *No, I guess it is.*
It sure is. Again about Pollock. Pollock was the first one to fool around with the shape, the format. And I remember seeing those first paintings in which he did that. And I wouldn't call them pictures. I called them "friezes." That shows . . . and they're some of the best things he ever did.

C.H.: *And some of the worst.*
Until that second show in '50 he always had shows with two-thirds failed pictures and one-third successes. That was taken as a matter of course, by me, and you know I think by his wife too, who had a better eye than I did back then. I learned a hell of a lot from her, just as Jackson did. Well, so the far-outness is here. You change that. This is the foreground. The foreground is official art, it's middlebrow art. Pop art is middlebrow. And some of the guys could paint. Jim Dine could paint, though he's dumb as the day's long. And Lichtenstein can paint. And Warhol had his moments, but when he did a show of all-abstract pictures you saw that he didn't have much at bottom. And Johns's cross-hatching pictures: he doesn't know what it's about. He hits the right color by accident, you can see that. When he hits the right color he's good, but—

C.H.: *Ah, but your theory must rule out—*
There's no theory.

C.H.: *OK, your aesthetic protocols, your morality must rule out—*
No morality. Don't bring that word in. Morality has nothing to do with the aesthetic. Rule out what?

C.H.: *Well, if you are told by your response—and your response is a response to quality—how can you justify saying that he hits it by accident?*
Because it looks like an accident. That I say "by accident" is of no importance. It's not important that I said that. That's beside the point. That's journalism.

C.H.: *Journalistic denigration.*
Denigration's right. But when you see the other pictures you realize Johns is on to something, maybe it's serious and all that, but that someone like Olitski, who can draw better than he, would spurn it, that doesn't matter. That doesn't pertain either. But how do you know it's color? In this case the choice of one color is going to make a Johns picture, and so it seems. Since so many of them fail when only one or two of them succeed, the successes must be by accident; otherwise he'd be closer in the other pictures.

C.H.: *But you said before that what you look for is a measure of success and failure.*
Yes, but there are failures and failures. If Johns in the last cross-hatching show of his I saw had had four good pictures I'd think that's enough to do it. But he only had one. That was it.

C.H.: *Four's enough, but one isn't.*
It's like Brice Marden, who is so ungifted, so untalented, but I've seen two good pictures by him; and they were accidents.

C.H.: *That's two more than I have.*
And one of them was a giveaway because it was pretty. He had to go to prettiness like Clemente did. When I use the word "pretty" I get flayed. People objected to Monet's water-lily paintings because they were pretty. They didn't know what they meant by pretty. They objected to Olitskis because they thought they were pretty, and they didn't know what they were talking about. Iridescence is pretty? No. Iridescence can be great. Thank God iridescence came in in the late nineteenth century to relieve Victorian mud and darkness. At the Carnegie Biennial I remember the public going for Jack Smith, an English artist, because he was the most iridescent.

C.H.: *Yes. He suddenly won a prize. He was best when he was what was called a "Kitchen Sink" painter in the early fifties.*
Yes. I remember Bratby too. Bratby's character is something else. Bratby had something, but he wasn't doing it.

C.H.: *I want to go back to this question of whether or not good art can be made by modeling. You want to do it but you can't.*
It doesn't turn out. It turns out . . . oh . . . all right, but it's not big, it's not the most.

C.H.: *OK. We—I don't know quite whether to say "we" or "my friends," because we have such funny relations of production—they're trying to make a painting at the moment. The idea is to set up the sense of drama. Always go back, go back, have a point of reference. The person they found was Delacroix. There's a sort of nightmare subject derived from Delacroix's "Hercules Feeding Diomedes to His Mares." The idea was to snow on top of it—the snow as a surface which would make recognition of the dream or nightmare implausible. What they found is that there is no way you can paint snow as a surface without its looking naturalistic, whether you drip the paint, whether you make brushstrokes look like brushstrokes or whatever. Absolutely no way.*
I can see that.

C.H.: *So they had again to have another point of reference, to have another configuration. There's a funny conjunction in what they found as reference points: Leonardo's "Deluges" and van Gogh's "Starry Night." You take the rhythm and make the snow conform to it. Now that's the intellectual bit—*
It's not intellectual. It's something else. It's not intellectual.

C.H.: *It's sort of systematic. But what seems to be necessary is that a problem should be generated, or something should happen that the system was not designed to take care of.*
What's my reaction to all this? God, it's a supercilious one. That's a *desperate* way of making art. Desperate, desperate, desperate.

C.H.: *Absolutely right.*
It still could come out great in spite of its being desperate.

c.h.: *I think the conditions are desperate. What we do have is a culture of ruins and fragments.*

Journalism. We've got maybe a culture threatened by decadence, but otherwise . . . I think how good mosaic art became in the throes of Roman decadence in the sixth century . . . I'd say that someone like this kid Hughto, he paints bad, he paints good, but it's got nothing to do with decadence. It's not desperate.

c.h.: *I'd see that painting as highly unsophisticated.*

Hey, look, if you can't see Olitski you're not where the best contemporary painting is at.

c.h.: *I had my "crisis" with Olitski in 1968. I wrote a piece about Olitski which he actually liked—whether that was quixotic or not, I don't know. The dilemma I was caught on the horns of then was that the invitation—I'm using terms you won't like at all—*

Of course not.

c.h.: *—the invitation to assent to the pictures was very seductive. I couldn't divorce the pictures from the conditions which that assent seemed to require of me.*

You have to explain when you talk about conditions.

c.h.: *I think I felt that I didn't want a culture in which that was "good painting." That's playing into your hands.*

It sure is. Good God, is it playing into my hands!

c.h.: *Now what I would say—I'll play English and say I can see why you and others would want to see that as good painting.*

We don't want to, we're forced to. Do you think we choose?

c.h.: *It doesn't force me.*

I know, that's too bad for you. That's aggressive on my part. I don't want to get aggressive. I want to add to the sum total of human happiness. A lot of people can see Noland. A lot of people can't see Olitski. He meets more resistance in Europe than over here. The resistance is so close and hard. And it's promising for Olitski's future.

c.h.: *That could be romanticized.*
It can be, but I'm not romanticizing. I'm not. I have my own take on Olitski's stuff, so I can't romanticize him. I don't think he's better than Noland, but he's where painting's at. Olitski's where painting's at, but it's not where painting has to go.

c.h.: *I wondered whether Noland's tendency to use higher-keyed colors in the late sixties and seventies might have had something to do with Olitski. If so I'd see it as a bad influence.*
Olitski can't use a red and only seldom a blue. He can use a yellow, he can use ocher. That came out fifteen years ago. He can't use saturated color except when staining back in the early sixties.

c.h.: *There was a painting at Kasmin's in London, back in '68 I think, which I tried to come to terms with. A big yellow one.*
He can fail when the canvas shape goes too high. It depends on the format, its proportions.

c.h.: *There seems to have been an attempt in the late sixties to get away from tone, to lighten painting.*
You mean values: dark and light. We take the French term, value.

c.h.: *Yes, and I think that was not like the forties' and fifties' need to do away with shading. It was something different. And I think that no good painting yet has got away from tonal values.*
Painting can go anywhere. Vuillard in the early 1900s is a good example. He did some landscapes where the values are so close . . .

c.h.: *One suggestion that I want to make is that if you keep going, persist, and if that persisting is, let's say, serious for want of a better word, you can't help at some point running up against what you would call the logic, the necessity. You must engage with problems which are historical, historically real, or you might as well not bother.*
"Historical" is a real problem. I want to know what you mean by that. What came up with modernism was that in order to make better art, art which measured up to the standards of the past, your hand was forced.

c.h.: *But surely what you must do is to work to get into that position where your hand is forced.*
Yes, that's right. It's by seeing how good the best art was or is. And especially how good the best art just before you was.

c.h.: *But what you can't predict is how to get into that position where your hand is forced.*
Of course you can't predict. You have to see first.

c.h.: *But also the procedures by which artists have got into that position must at times seem ludicrous, accidental.*
I don't know. It depends on where you live. You had to live in Paris from the 1840s on to get position. It's always mattered a lot where painters and sculptors lived.

c.h.: *One of the reasons why the notion of avant-gardism predicated on Pollock is so weak is because what it does is to take the accidental means of getting into that situation for the means of getting into a similar situation. That's the Robert Morris approach: that what's interesting about Pollock, is that you can recover the procedure directly from the work, so what you do is produce stuff, which you call "process art," which is all about recovering the procedure. That's a nonsense.*
Morris wasn't even that much interested. That's a judgment. What he did before he went—what? I won't call him conceptual, no; when you saw Morris's first plaques at the Green Gallery you saw conventional good taste. They were nice and they weren't good enough. In order to escape his good taste he had to go far out. That's a way of escaping conventionality. The same thing for Andre. So you go far out. Also you know that going far out is the way that art history, art history in terms of Pollock and so on, is supposed to be made.

c.h.: *But that's to mistake the tension in the procedures for what you call the logic of development.*
Of course. It's the way to score instead of making good art. And you've kept your conventional sensibility. The giveaway on Judd was the paintings he did. He hadn't got the point of good painting. He'd got the look of what good painting's supposed to look like, but he hadn't got good

painting. In Judd's case, his boxes were always too high for their bases. If he'd really had it the boxes would always have been lower. That's the way I saw it. I could always make his boxes better.

c.h.: *What was good about Judd, though, from a European point of view, was that some of the things he had to say about European art were effective.*
Did it help? With what artists?

c.h.: *I suppose I'm talking about some of my friends who'd see Judd now as ludicrous.*
He's never ludicrous. He's not laughable. He's not so hot, that's all. I'm tempted now to diagnose you, which is the most aggressive thing you can do to another human being—that is, unless somebody comes to you and says, "Look, I'm paying you to diagnose me."

t.e.: *He won't mind. He likes it.*
OK. There's a certain way in which you're literal. In my book it's the wrong way. It means you're being serious in the wrong direction. You've asked, so I've got to say why, which is even more aggressive. You don't look hard enough. You think too much. There's too much thinking going on. You can think about politics and you can think about personal relationships, which is the most important thing in life—though you have to do more feeling there than thinking—but when it comes to art, watch out for thinking. Let your eye or your ear, your taste, take over. Don't think too much. I think Leavis and Eliot—I've read French and I've read German literary criticism—but in my book they're the two greatest literary critics. And I would correct them by saying that where they go wrong is in thinking. When Leavis brought morality in—he didn't need to—he went a little wrong. Eliot had read philosophy and God dammit he's good when he's good. But it's still a sickly cast of thought that tricks him. I'd say you've got to be readier to just go with your eye and not decorate it. I sound American primitive. Just your eye: good and bad, good and bad, let's start from there. The hell with thinking. Let that come later, and the historical questions. History's there in our bones. It's there. You want to fantasticate things with all this culture. The culture's there, and we can't get it out of our flesh. "Penetrated" is too weak a word: it's part of our warp and woof. We don't need to bring it in. It's there—to use that awful word—inexorably. And so you go honest. If you want to make a career as

an art writer you'd better do more than that, but we're not talking about careers now, we're talking about the truth.

c.h.: *When I went in to lecture at the Fogg Art Museum there was this big building and over the door was written the word "Veritas."*
That's not Harvard's motto.

c.h.: *No, it's the Fogg's.*
Well, there is nothing better. Saint John said, "The truth shall make you free," and was he right. There's nothing like the truth. The truth is delicious. You can eat the truth, you can drink it, and you can sleep with it. There's nothing like the truth. And sometimes, when it's about yourself it hurts. It hurts, but it still makes you free. Alas, the truth can also be a weapon, a means of punishment instead of correction. But we're away from art now.

(1984)

An Interview with

Clement Greenberg

• •

Robert Kehlmann

ROBERT KEHLMANN, EDITORIAL ADVISER to *Glass Art Society Journal,* interviewed Clement Greenberg on 19 May 1984, shortly after Greenberg's presentation at the Corning Conference. What follows is an edited transcript of their conversation. —Ed.

ROBERT KEHLMANN: *When we were in Corning together for the jurying of "New Glass Review 4" we took a walk through the museum. As I recall, you were particularly impressed by the galleries of ancient works.*
CLEMENT GREENBERG: Yes, the lack of self-consciousness in the old art is remarkable. You see it written all over. You see self-consciousness in the contemporary work and you see it in the Gallé exhibition that's on display now. Uneasy self-consciousness. Self-consciousness is always uneasy. Nineteenth-century salon painting or sculpture wasn't so self-conscious but it was lost in a disarray of taste. At the same time a lot of nineteenth-century work is good.

In terms of twentieth-century work, could you be more specific about what you mean by the term "self-conscious"?

Contrasting it with the Egyptian, the Greco-Roman, and other ancient glass, you feel there's no effort in the old work to make art.

It just came from the viscera?
No, it just came from the natural order of things. Today, and I should have said this in my talk this morning, a glass artist or a ceramist has to make an effort to make art. I'm speaking about art-art, not a good vessel or anything like that. It relates to the way painters and sculptors today make a desperate effort to be original. But it's not quite the same thing with glass and clay. I haven't really thought about it fully. I'll have to think about it some more.

How much of the unself-consciousness of the ancient pieces do you think relates to their functionality? They were made for a purpose, and, as a result, they had a natural place in society. Most of the work in Corning's contemporary collection was ultimately made, I suppose, to be in a museum.
Yes, but some of the old glass was done, I'm sure, just to be looked at. Like some old clay was just to be looked at. I have a friend in Utica who collects ancient glass. He's got delicious pieces that are just there to be looked at. You can't use them.

This is something other people have written about. It has to do with the aging of a tradition. The aging of the Western tradition of art and of art in general. Western tradition is more than a thousand years old and you become conscious of it. It was noticed in the case of the Romans too. They inherited an old tradition, and they got "arty" in a way, but they were so much less self-conscious than we are. We're the most self-conscious culture there ever was—self-inspecting and self-conscious. It stands to reason, because we're the latest.

Do you think of the abstract expressionist artists as self-conscious?
Only insofar as they knew that the main idea in art was to be good. In spite of their dedication to, say, religious ends or state ends, artists in the final analysis have always wanted to be good.

So you think the urge to make good art is, in and of itself, self-conscious?
No. It's become more self-conscious since the mid-nineteenth century. The urge to be "fine-artistic" in the case of glass and clay has become more self-conscious in our time.

How about Gallé? How self-conscious do you find his work?
That's curious. If I had to write about Gallé, I'd have to say that the state of taste at the turn of the century was very much a reflection of an explosion of taste where anything went—except, unlike our 1960s, it couldn't be "far-out."

But some of those Gallé pieces in the exhibition are "far-out."
Yes, but he didn't mean to be far-out in an avant-garde way—that's the new thing since the sixties. Gallé was just letting go. He was indulging himself in old-fashioned decoration. But I don't mean to say his art is decorative. He was self-indulgent. He just elaborated pieces. His attitude was one of, "I'll let go and do whatever I damn please. I'll just lay it on and lay it on." Sometimes that's the way to do the best you can—other times it's self-indulgence. You can't draw rules here.

I felt the best pieces in the exhibition were the ones in which he was almost out of control. The pieces in which he just let go and let the material lead him. My least favorite piece was that decanter with those crazy red and green blobs on it and the ornate stopper that had nothing to do with the form of the vessel.
Oh, you mean *The Grapes.* That was out of control.

What did you think of that piece?
I didn't like it at all. The stopper is good all by itself, but it doesn't belong to the piece.

Can you remember other specific pieces that you liked?
If I only had a copy of the catalogue.

I have one here.

[The following comments are made while looking through the catalogue, *Émile Gallé: Dreams into Glass.*]

In a piece like *Cerebus* he went wild with the painting, and it's damn interesting, but I think he paid no attention to the shape. He made a big mistake in *Joan of Arc.* The piece is Victorian in the wrong way. He makes mistakes all over the place. He has no discipline of taste, and that's part

of what makes him extraordinary. I found myself liking him most when he was strict. You can say it's my modernist taste. I remember liking *Magnolia*. It's the clear glass in the piece—oh, I love the clear glass.

The success of *Forest and Wildflowers* depended upon the view. The problem is that he has some real illusionist painting and you begin looking at the painting instead of the vessel. The handles are wrong in *Olives and Pines*. I like the piece except for the handles. They don't belong. They're just stuck on. I thought *The Hazel Tree* was one of the best things I saw in the exhibition, though the people I was with from your organization didn't like it at all.

Did you like it because of its shape?
Both the shape and the way he was discreet in coloring it. Again you can say it's my modern taste. Now I thought *Thistles* stank.

It's so large. It's probably the largest piece in the exhibition.
Yes, and if you cut off the green base I think it would help. Again and again I quarrel with Gallé's bases. It's a problem in *Geology* and again in *Landscape*. Without the base *Landscape* would be good—he was going modern there. In the reproduction of *Rhubarb* in the catalog, the base looks better than in the original.

I liked "Rhubarb." It's one of those pieces that almost gets away, and I think that works in Gallé's favor. He lets the glass do what it wants to do.
I liked the piece also. It's supposed to be a ewer, or something, but you can't use it for anything. Again in *Violet*, the base or the pedestal overwhelms the piece. The base is a problem in *Orchids* too—it's too conventional. It's not that I'm against conventionality, but it doesn't work in this piece. . . . I like the *Dragonfly Coupe*.

That's one of the prize pieces from the Corning Collection. Does the base bother you in the piece?
For some reason he got away with it. But it would have been better sliced in half.

Cut the base off?
Cut the bronze-looking part of the base off the bottom.

You raise the issue here of how to deal critically with the visual appearance of a functional object. He's making a utilitarian object and dealing convention- ally with a way of allowing it to stand.

Convention is OK, but when the bases or pedestals interfere, you cut them out. If the piece is going in a certain way, and it can't take a pedestal, then you leave it out. In *Beetle Vase,* he should have taken the beetle out along with that heavy lip.

But the beetle is the subject of the work. That's why he made it.

He had a beautiful green there, and the beetle gets in the way of it. His decoration often gets in the way of some of his colors. I didn't have a clear take on *Cicadas* when I saw it. If I had it home and I was looking at it over a period of months and months, I'd end up liking it. I know that. I like my wife's grandfather's Chinese desk in that way. The piece is good, but it has too much base. He puts the base on it thinking, "I should put a base on it." And when he deals with his bases, art doesn't come in anymore. It becomes furniture.

What did you think of the "Mushroom Lamp"?

I thought that one really stank.

For the average person coming to the exhibition, I suspect the "Mushroom Lamp" would be the premier piece. It has colors. It has light inside it. It's a real eye-catcher.

The average person, like my neighbors in Norwich, would rather come to this glass museum than walk around the block to see a painting.

Why is that? Do you think it's the material itself that just has that type of attraction?

Yes. Especially for women. *Butterflies* is a good piece, but with *Tadpoles* I wanted to cut the top off—right above the lettering.

The proportions would be a lot better.

That red is all wrong in *Deep Sea.* The brown red is all wrong in *Blue Melancholy* also. The *Hand* is kitsch—and did he let himself go here! I can see him letting himself go—and why shouldn't he? We can like it and

camp it up. Sometimes we can like things we really don't feel entitled to like.

I'm sure you know that Gallé and Tiffany are thought of by many as the high priests of glass. Given all the problems you've pointed out in Gallé's work, do you think students learning how to work with glass should study his work?
It's important that you look at everything. But to make glass high art . . . I don't know what to tell them. What you tell a painter or a sculptor is, find out for yourself what is the best art done just before you. Not that you should imitate it but that you should cope with it. It's of the essence—just as Picasso recognized that Cézanne was the best painter just before his time. Braque recognized that too. It was necessary for Pollock to recognize that Picasso was the best painter just before his time. Pollock would have done better if he had also recognized just how good Matisse was sooner—it was only late in his life that he recognized that. That, I would say, is essential to major artists.

The problem here is that if you look at the best before you as a glassmaker, it's not unreasonable for a teacher to suggest to his or her students that they study Gallé.
But the student has to find out for himself. Just as Manet found out for himself. He had a damn good teacher in Couture, but he found out for himself that he had to reach back to Goya to find a jumping-off point. It was easier for Pollock and the others of his generation because Picasso and Miró were there. It wasn't so easy for them to see Matisse.

Perhaps you're suggesting that someone working sculpturally with glass shouldn't necessarily be looking at the precedents in glass but rather those in modern sculpture. And someone working two-dimensionally should be looking at the precedents in painting rather than at contemporary German designers or Tiffany and La Farge.
I couldn't agree with you more. You said it though, and you're right. You're absolutely right. I could say that to you about your rather good piece in the Corning Collection. You should have looked more at what's called color-field painting—that awful label—and I'd say you would have made the picture better if you had left out the whole upper-right-hand

corner . . . just omitted it; left it blank and not worried about the corners in a cubist way.

I understand you went through the Corning Museum's contemporary gallery today.
Yes, I went through it with some of the kids attending the conference.

Do you remember any specific pieces which you felt were focusing upon interesting visual concerns?
Yes, but I didn't note them . . . I don't remember the names. There were very few, by the way. You saw this desire for original art all over, and yet the artists hadn't looked enough at good sculpture and good painting. It's as you said. The realization came to me in the museum today that glass artists have not yet done anything in the way of major art. As delicious as so much glass is . . .

You're saying that about twentieth-century glass?
The whole history of glass from the Egyptians on. And I'd say the first steps in that direction are two-dimensional, pictorial. I make this statement based upon what you've done and by the work of one or two other people that I've seen.

Needless to say, I'm flattered to hear that.
I'm not trying to flatter you, because that piece of yours in the museum could have been a lot better. You got too piously cubist. A couple of the three-dimensional pieces I saw in the museum would have been better in steel. The artists didn't realize this. They would have been way better off without the transparency. There was one piece, and unfortunately I don't remember the artist's name, that had two definite planes coming together. If the piece were made in steel the artist would have made his point. But the fact that one plane is showing through the other spoils what he did. He should have known that if one plane is going to show through the other, you work with that in mind—you exploit it. You turn a liability into an asset; it's been done in art all along.

I suspect you're arguing in favor of artistic flexibility. Aren't you saying that if you're going to be an artist, be an artist—don't be a glass artist unless glass is appropriate to what you're doing.

What I should have said this morning in my talk is that you glass artists don't know about the best art being done in your time. You go along with Kim Levin. But that's what's happened in art since the early sixties; it's this trendy stuff.

As I see it, part of the problem is that people who work with glass think in terms of the decorative arts, and I don't use that term pejoratively in any way at all. But I do think it's a dangerous mind-set to get into if you're aspiring to make what you call major art.
The work must be ambitious in the best sense.

Let's switch subjects and go back a year to when we jointly juried "New Glass Review 4." I'd be interested to know the criteria you used in selecting objects.
I don't have conscious criteria. There are no valid conscious criteria in the aesthetic experience of any medium. You must depend upon your taste as formed and developed by experience. Your eye is almost naive in that respect. There's nothing but its experience behind it.

At one point during the jurying I remember your saying that you were including pieces if they were objects you would buy for your wife.
Yes, I was checking myself in a way. What I buy for my wife is the best art I can spot.

In retrospect, what was your sense of the review when you got home and received a copy of it in the mail?
I felt I could stand behind most of the items we chose. But it only came to me today in the museum that there's not yet any major art in glass—and I insist upon the distinction between major and minor, as I do in painting and sculpture. Not yet.

What about the material itself and its potential? In the context of contemporary sculpture is there any artist in particular who you think could successfully exploit the properties of glass?
I saw Tim Scott use Plexiglas, if you can call that glass, in his best works. Tim, being a defeatist, dropped that, but I think some of the best pieces made in this century were the big pieces Tim Scott made using Plexiglas. The material sort of delivered something to him, released something in him.

Do you think glass would be an interesting medium for Anthony Caro if somehow he had the proper facilities available?
It sure would be. Good Lord, would it be. Man, what a challenge that would be to him.

When you think of sculptors using glass, do you think of artists with a particular aesthetic which would lend itself to the material, or do you just think of people who are very good with—
Direct metal. I think of sculptors who are good and can shape things. And I think that if they were confronted with glass . . . wow!

What are the properties of glass that make that thought exciting to you?
Glass is such an ungrateful material. The shaping of form without color is interesting. Contemporary sculptors who haven't worked with it before would be forced to color it, and I think they'd enjoy the challenge. God knows they'd botch a lot of stuff.

They sure would. What about two-dimensional work in glass?
I think there's more of an immediate future for glass in the pictorial direction than in the direction of sculpture.

Pictorial being two-dimensional?
Yes.

I'm inclined to agree with you.
God, what you can do with glass by making a picture out of it!

Can you think of any specific contemporary painters who you'd like to see try their hand in the medium?
Any good ones, except the representational ones. If you begin doing illusionistic painting in glass you get into fancy effects.

So you think the material lends itself more toward abstraction?
Absolutely.

You made the comment in your talk this morning, and I assume you were talking more about sculpture than about two-dimensional work, that the human figure done in glass tends to become an objet d'art.
So far that's been the case.

Is that a comment on the material or the scale of most works in glass?
It has to do with the fact that the material attracts too much attention to itself in a way that clay, stone, and bronze don't. It all relates to translucency, transparency, and so forth. Now someone will come along someday and do the human figure, the animal figure, in glass, and they'll bring it off. But it hasn't been brought off yet, and I'd say, as I said in my talk, that the way for glass art to become high art is through abstraction. In doing a landscape in the flat on glass you'd work for a piquant effect, but it's a kind of piquancy you wouldn't want. But still and all, you can do anything in art.

When I think of landscapes in glass I immediately think of Tiffany and those who have imitated his work. I instinctively wince at the very notion of working in that mode.
Well, it depends upon who does it. If somebody had suggested it to Picasso when he was good, before the late 1920s, God knows what he might have done. Pollock did one thing on glass, but it's paint on glass. The glass is used as a ground. I talked to him about it. Glass has been used as a support, as a ground, for a long time.

What did Pollock think of that piece?
He knew it was good. He never repeated it, though. He did it because they had a movie camera under the glass photographing him at work.

We showed the Hans Namuth movie at our New York conference two years ago. The actual piece is in Canada now, isn't it?
I think it's in Ottawa in the National Gallery.

How do they display it?
I haven't been to Ottawa, but usually it's hung so that you can see through it. You put a white ground behind it, a white wall, and the white blocks out the things that would get in the way of looking at it.

Does the wall deny the transparency of the glass?
It does deny it, but your eye makes allowances. How can you hang it otherwise without seeing things through it? It's clear glass, after all.

That's a tough question and one I've thought about for many years. Duchamp offered one solution in his "Large Glass." As I recall, he made the statement

that painters up to his time had always worried about what to do with the background. He felt he had solved the problem by making his piece clear. By doing this he didn't have to worry about the background because whatever the viewer saw through the work became the background.

I don't remember his saying that. *The Large Glass* was one of the best things he made. His luck was to go wild at a time when it was almost one of the best things to do—go wild, get out of the cubist vise. He succeeded just in those few glass pieces and in a couple of paintings, and that was it. And it was his luck, because he didn't want to know what he was doing.

I find the breaks in "The Large Glass" interesting. They were accidental, yet they enhance the piece.

Yes, I agree. Fifteen years later he couldn't have done a piece like that.

Do any contemporary painters come to mind who you think could make interesting use of glass?

I know nothing about the handling of glass, but I do think that a painter like Jules Olitski would find it interesting to work with. He fools around with media more than any painter I've known—he has a kind of restlessness, dissatisfaction. He's now using some kind of gel combined with "interference" color that gives him a glittering surface. I think he wants something more than that glittering surface. Some glassmaker should take him in hand and say, "Look, here it is. I'll help you do it, but here it is."

I guess there have been a number of projects like that in different media. Wasn't there one in ceramics?

Oh, yes, and it was successful too.

What artists were involved in that project?

Helen Frankenthaler and Olitski, Dzubas, Noland . . .

Who organized the project?

Margie Hughto at Syracuse University. The work that came out of it was damn good.

That's a nice challenge for you to throw out to the glass factories and schools around the country that have the facilities to do something like that.

Someone should really get Olitski. He's been so adventurous with materi-

als during the past twenty years. Let him tear loose on that. He's always looking for something.

I appreciated your response to the question this morning about why good criticism isn't written about glass. You said, "Make glass good enough and it will be written about."
Yes. It's the art that pulls. The critics can't resist when that happens. You don't wait for the critics to decide, "Today I'm going to write about it." The art pulls. Critics don't decide anything . . . they follow.

Do you have any concluding reflections on the glass art movement which you'd like to share with our readers?
I can only repeat what I've said before. The run of glass artists, like the run of artists in New York or elsewhere, go by the latest trends. They think that what's up is where it's at, and they won't look beyond that. If they looked beyond that they'd see that "formalist" art is still the best art of our times. If they don't catch on to that, if they don't catch on to this tough art that looks elegant—a lot of people say, "It's pretty," just as they said Monet's *Lily Pads* were pretty—if artists don't catch on to that, they're not up to where the test is.

(1984–85)

• •

Clement Greenberg:

Modernism or Barbarism

• •

Karlheinz Lüdeking Translated by Paul Lundgren

CLEMENT GREENBERG WAS PROBABLY THE MOST INFLUENTIAL
art critic of the twentieth century. Through his effective support for ab-
stract expressionist painting, he was instrumental in changing the center
of the international art world after World War II from Paris to New
York. Already at the beginning of the 1940s he recognized the exceptional
abilities of Jackson Pollock, whose further artistic career he very much
influenced. In addition, Greenberg supported Hans Hofmann, whom
he especially appreciated as a teacher. Other artists that Greenberg sup-
ported were Willem de Kooning, Arshile Gorky, David Smith, Adolph
Gottlieb, Barnett Newman, and, later, Morris Louis, Kenneth Noland, and
Jules Olitski. Greenberg was active as a curator of numerous exhibitions.

In 1961 Greenberg published *Art and Culture,* a selection of already pub-
lished essays, which he revised, sometimes substantially. Since then or per-
haps even before, he has been considered the most important advocate of a
modernist conception of art. With this concept, he became a central father
figure for many art theorists in the United States and continues to be today,
although his indisputed authority decreased with the increasing success of
pop art and minimalism. If an art theorist didn't want to follow him, then
he would have to differentiate himself from Greenberg in some way.

In 1986, the first two volumes of *Clement Greenberg: The Collected Essays and Criticism,* a collection of Greenberg texts in their original versions, appeared. This collection was edited by John O'Brian. At the beginning of this year, volumes 3 and 4 were published. A little later, in May, the Centre Georges Pompidou held a colloquium about Clement Greenberg, in which famous art theorists such as Yve-Alain Bois, Hubert Damisch, Arthur C. Danto, Thierry de Duve, and Rosalind Krauss participated.

Although Greenberg is already eighty-four years old, he still seems very energetic. He continues to go to galleries and exhibitions and reads very much, including the writings of the French structuralists whom he undoubtedly does not hold in high regard. He continues to hold individualistic views. He speaks like he writes: in short, precise, and pointed sentences. The following interview took place on 5 April of this year in his apartment on the seventeenth floor of an elegant old building next to Central Park in New York.

—Karlheinz Lüdeking

KARLHEINZ LÜDEKING: *Clement Greenberg, you are surely the most famous art critic of our century.*
CLEMENT GREENBERG: That's hard to believe, but go on.

I wanted to begin with a very simple question: what is the value of art criticism, in your opinion?
It is supposed to call attention to art. Therefore, the ability of the art critic is the most important thing. To be able to make judgments about what he likes and does not like. I believe that an art critic should be quite clear about his likes and dislikes. And he should invite the reader to look at works of art to see if he agrees with the critic. This would be ideal. However, the reader is often far away from the art centers where the works of art are. This is difficult, because reproductions of works of art are not very good.

You believe, then, that someone who reads an art critic should go to the exhibition and look at the artworks.
Exactly.

And try to find out if you were right or not.
That's right. He has to see for himself. But he does not try to find something out, as you said. Aesthetic experience is intuitive. And up to now no one has succeeded in looking at intuition and telling us exactly what happens when we intuitively understand something.

Does that mean that one cannot define criteria?
One can try to define criteria.

What kind of criteria?
You can't specify beforehand. Usually it is the work of art itself that dictates the criteria. I am known as a formalist. This designation doesn't bother me. I always try to look closely at the work of art first. And that is what we should always do when we are dealing with the fine arts. Then you begin with an interpretation, if you have one. If you are dealing with abstract art, then the possibilities for criticism are very limited. Then you can't just start interpreting. However, this does not always keep the critic from interpreting. The formalistic art (some say method) of art criticism evolves on its own when one is dealing with abstract art. However, I do not limit it to abstract art.

Can one transfer this way of looking at art to other forms of art?
Oh, yes. In fact, this is how it developed. But there have always been formalists, even before Roger Fry. Look at a Giotto or a Vermeer. But here you can only hold on to what you are seeing.

That's right. But your opponents would perhaps criticize you for forcing your way of looking at art on the paintings. They would say that Giotto himself wouldn't have looked at his paintings in that way.
I don't care how Giotto himself looked at his paintings. It is what I see that counts for me.

Isn't that imperialistic in a certain way?
No, it isn't. I am not forcing anybody to do anything. The reader has the freedom to reject my views. He can say that my opinions are trivial or too narrow. People have already said that.

That sounds very pluralistic. Are you really saying that the reader can look at things and then see if he agrees or not, and that he is completely free to do so?

No, the reader is not the lawmaker. He is more like an evaluator. You hand your writings to the reader. Then you have to let the reader decide if the writings say something to him or not. That is what the reader does anyway. He decides what he likes.

Usually the reader prefers TV shows and similar things which you, in one of your famous essays, called "kitsch."
Wait a minute; that's not exactly right. It's true that most of what one sees on television is junk. Also in the movie theater. But not everything. I'm not going to make a blanket judgment.

Would you say that the art critic has an educational function?
Let's assume that someone says this is a good painting. But I have a different opinion. Then I will still respect the "eye" of the other person.

Really?
In any case, I'll take another look. That's how I learned to see. I looked again and again.

And one tries to convince others—or oneself. How is that done?
You can't. You can't prove an aesthetic judgment. That is my opinion and I'm not the first person to say that.

No, Immanuel Kant said that too.
Who? Yes, exactly, Immanuel Kant.

There is a completely different idea about art criticism which says that it is not so much a matter of stating value judgments but rather the meaning and role of a work inside of a definite context.
Oh, yes, that is helpful. At least, it can be helpful. But what one finds out doing that applies to both good and bad art.

Would that be a criterion to differentiate good art criticism from bad art criticism?
No, no. The criterion relates to the value judgments of the critic.

But what I wanted to ask is this: would a criterion for good art criticism be that it concentrates on good art, while a criterion for mediocre art criticism is that their methods can be used everywhere?

Oh, you mean the methods of criticism. Yes, a method can, of course, be used everywhere. One can talk about everything, every type of kitsch. And there are actually people who are not all that bad and nevertheless deal with all kinds of inferior stuff. Because it is interesting to dissect this stuff into individual parts. Why not?

But that is not what you are after.
No. I've never done that. Naturally I could have. I am thinking here of Maxfield Parrish, someone who does not have much of a name.

At least not in Germany.
He was, like all kitsch painters, a star in his time and today nobody remembers him anymore. But he could use paint and canvas very well. And it would certainly be fun to write about his wall paintings in the bar of the Hotel Ritz. I've never done that. There was never a reason to do that.

Let me ask again. You are not exclusively interested in the inherent qualities of a work of art. As far as I know, you also try to put art in the context of a historic development.
I used to do that much more in the past. And why not?

One of your basic principles has been that art started to research its own essence at the beginning of the modern era, at the latest. Could you clarify that a bit? That is probably not as well known in Germany as here.
The art of the modern era is experimenting with the limits of art. It wants to find out how far one can go in painting, sculpture, et cetera, without stepping over the boundaries outside of which one cannot make art. This is what artists are doing. One must let them do that. This seems to me to be part of the logic of modernism. In the modern era, art is working on its own definition of itself. But, in doing so, it is not following any specific plan or purpose.

But rather as a consequence of its continual experimentation?
Artists have only the worry of making good art. That is the main thing. A conscious and continual experimentation began in painting in 1860 with Manet.

And you are convinced that there is more and more concentration on the two basic conditions of art: the flat canvas and the paint pigment.

Anybody could have said the same thing. What other fundamental things could there be? And besides, that is not exactly what I said.

Certainly that is extremely simplified. But someone else could assert that only the signature of the artist is important.
Oh, we all know that this is simply a matter of chance.

Duchamp apparently practiced that by selecting an object, signing it, and giving it a title.
Duchamp is, in my opinion, not a good artist. He was at his best when he created his least typical works of art—for example, *Nude Descending a Staircase*. It's not bad, but also not especially good. I take Duchamp seriously as a cultural phenomenon. Yes, he presents a challenge. From a cultural standpoint, he is of interest. But he made very little good art. And his provocations remain without lasting effect, except perhaps for his devotees, who are also not especially good artists.

Couldn't what Duchamp wanted to portray be of interest to a real painter?
Not in my opinion.

One could say that Duchamp was important because he did not concentrate on the object itself but rather on the conditions under which the object could become a work of art.
I don't know about that. It would be hard to prove such a theory on the basis of Duchamp's works. But over and beyond that, he did have a certain talent, just like Beuys had a certain talent. One sees that in his drawings, for example. However, Beuys had, unfortunately, certain messages that he always talked about: fate of humanity, politics, et cetera. I find that boring. He doesn't try to test the boundaries of art. He is content with an "art of installation." He fills a certain space with all kinds of things and hopes that the whole thing has some kind of meaning. Until now, that kind of thing has always bored me. But I don't want to reject the possibility that one day a really talented artist in this direction will appear, who can give the arrangement of things an aesthetic significance.

Would that be for you decisive in finding that kind of thing acceptable?
Yes, aesthetic significance or at least a minimum of aesthetic enjoyment.

Precisely that would have been seen by Duchamp and his followers as super-ficial, unintellectual, or bourgeois.
I know. But I don't take that seriously, because I find these people trivial. Duchamp's works are interesting when you first look at them. But then it is redundant to look at them a second time. On the other hand, one can look at a Titian, a Picasso, or a Pollock again and again. Its substance endures. In contrast, with works by Beuys, for example, a photograph is satisfactory. With a good painting a photograph could never be an adequate substitute. A photograph is useful for one's memory. That's all.

Do you think that Duchamp's followers have conquered the art world in the meantime?
They certainly haven't conquered the art world. But they have taken their place in it in a pretty big way.

Does this have something to do with the fact that you stopped writing critiques at the end of the sixties?
No. I did really stop writing regularly at that time, but not for the reason that art was not saying anything to me anymore. There were other more personal reasons. In addition, there are always many good artists and new artists that are worth writing about.

Tom Wolfe asserted in his little book "The Painted Word" that after the appearance of pop art, the type of art you promoted didn't resonate anymore.
But good art survived and continued to be made. It is still here. And it's still being exhibited. And one can still write about it.

You probably don't find much that is worthwhile in the works of Andy Warhol.
No. He has talent. But I don't find his art worthwhile.

Why not? Was he too carefree?
No, that's not the reason. He had other ambitions. I find his art sappy. The big screen portraits and all these things. Who cares about them? Marilyn Monroe or Mao.

Do you think it senseless to sit and contemplate such a painting for hours?
I would not recommend to anyone that they view anything contemplatively for an hour.

Even a Titian or a Vermeer?
Definitely not a whole hour.

You said that Warhol had very different objectives. Would you describe them?
It is a little unfair to speculate about his motives. But I think he first wanted to get attention. That is easily said, because everyone wants to get attention from others. But I am not sure what else he was after.

One could speculate that he wanted to open the eyes of his contemporaries and show them the bad state of their culture.
He certainly did not want to do that. He definitely enjoyed our culture. I believe that I can state that with complete certainty.

Was he a cynic?
I don't believe he was a cynic.

Did he indulge himself in mass culture and find everything really as attractive as he said?
That was the way he enjoyed himself. Maybe you can call that cynical. But I believe that he himself was not cynical. I found his jokes quite entertaining.

But you believe that this is not enough in art. Art must aim for something more serious.
It must offer a greater pleasure. That is how I would express it. A deeper satisfaction. More aesthetic substance. All these things mean the same thing.

Many younger artists feel strongly that aesthetic pleasure only diverts from the real problems of this world. That art should offer more than a diversion.
When they are young, many artists are quite ignorant—in any case, those artists who say things like that. With that I don't mean that they haven't read enough. They just don't have enough experience. They are convinced that their art can help humanity in a much more direct way. Imagine that someone paints some kind of case of injustice, a case of police brutality, for example. He will want to do it in such a way that it becomes a good painting. In any case, that would be the objective of all the artists that I know. They would want to make an acceptable work of art, not just a statement of their goodwill toward mankind.

Certainly. Perhaps it is naive to denounce injustice with the help of art. But art can clarify for us the conditions of our perceptions. So then it does not simply satisfy our desire for aesthetic pleasure.
All right, all right.

Haven't you yourself, at least in your early writing, given art a critical function?
I have not done that.

I always believed that.
No. Art is there for its own sake. *L'art pour l'art.* That is my theory. Art justifies its existence only in what it can give us here and now in the moment.

What would you say to someone who primarily expects art to change our perceptions?
I would probably use very vulgar expressions which I would not want to use here.

Then let me ask the question in a different way. I have thought that you could, in a certain way, be in agreement with the German philosopher Theodor Adorno. Adorno thought that art should be something pure and untouchable, that it shouldn't get mixed up in the products of the culture industry.
He didn't say it in that way. But you are right, in any case, that he was also of the opinion that art should be looked at for its own sake. But I never talked to him about such things.

But you have met him.
Yes, I did. He liked my article "Avant-Garde and Kitsch" and other things. And I found a lot of what he wrote to be very good. We really had no basic differences of opinion.

Did you meet him when he was an immigrant here in New York?
Yes, I met him there for the first time.

In the forties?
Actually earlier. I met him through the American Jewish Committee at the end of the thirties or at the very beginning of the forties.

Let me again go back to my original question. I thought you could agree with Adorno that art keeps a critical function if it does not take on a social func-

tion. *Only in this way can art present an alternative to what is currently in vogue.*
One can certainly say that about art, in any case about good art. But that is not important for me.

Is that already too much interpretation?
Maybe that is not too much interpretation. But that is something that doesn't interest me very much. I have certainly heard and read these kind of statements often. And I am not going to contradict them. I will leave it up to the individual to believe them or not.

Aren't you denigrating art when you say that its only purpose is aesthetic pleasure?
No, because this purpose is a purpose in itself. It is in no way a denigration of art when one states that it is only there for its own sake. I only see a problem with those people who at first advocated the idea of *l'art pour l'art*. They assumed that art is at the same time the highest value. That is false.

You would say in any case that art does not need any kind of justification outside of itself.
Exactly right.

In the history of art criticism from Diderot and Baudelaire to many modern critics, the attempt was made again and again to ascribe some higher function to art. It should open our eyes, improve our lives, et cetera.
That is not so clear with Baudelaire but undoubtedly applies to Diderot. Diderot was a moralist anyway.

But you don't want to be a moralist.
No. But I admire Diderot for being one.

In any case, you don't want to be a moralist as a critic.
No, no. Ruskin was, for example, too much of a moralist, although he was an excellent writer. He could not stop raising the moral index finger. In my opinion, that was very forced on his part and very much limited his options.

Would Jackson Pollock share your opinion on this point?
Yes, absolutely.

Didn't he combine his art with some kind of higher objective?
No. And the others didn't either. Most of the artists that I knew in the late thirties and early forties would have found it opportune to say something like that at the time. But they didn't live by that. And they didn't act accordingly. They only wanted to make good art. That was the most important thing. They wanted to make good paintings and sculptures. That was all. Some artists, of whom the best was probably David Smith, the sculptor, were on the side of the Communist party and they tried to convey a political message with their work, but not much resulted from it. It was not the most important thing. And in the final analysis, the work of David Smith is very apolitical. That has been apparent since the end of the thirties.

In your eyes, this desire to make only good art has, in the meantime, been stopped in its tracks.
No, the desire is still there as before. Even these people who make these "installations," about whom we spoke previously, probably have exactly the same desire, though that is, as I said, a direction in art that I don't especially like.

Beuys was in the habit of saying that everyone is an artist. What do you think of that?
I believe that everyone can enjoy and look at everything in an aesthetic way. But I would not like to go into that any further.

In your opinion, who ranks among the most interesting German painters of the present time?
Kiefer. You are certainly acquainted with the diagonal format paintings which were shown here in New York. They were not bad. They were the best paintings from Germany that I have seen recently. However, when he deals with historical topics, then I find that—how should I say?—too piquant. That may sound a little strange when I call his treatment of German history piquant, but it seems to me that is exactly that.

Aren't Kiefer's paintings too theatrical for you?
What's wrong with theatrical?

I thought you would find that repulsive.
Why? Aren't you confusing me with Michael Fried?

You would contradict Michael Fried on this point?
Yes, I believe that the theatrical is not necessarily bad in and of itself.

Don't you see it as something impure?
I don't believe in impurity. No, definitely not. I have usually used quotation marks when I've spoken of "impurity." I really don't think much of purity. And the same with Adorno, by the way. The purity and untouchability of art. At a certain time, that was perhaps a very useful fiction, but really only fiction.

Were you a supporter of this fiction at one time and then gave it up?
No, I never believed in it.

What do you think of George Baselitz?
I don't like him very much. Frankly, his paintings aren't good enough. And the idea of painting them on his head is simply too arbitrary. That is not an enrichment of art. Not at all.

Have you seen the paintings of Gerhard Richter or Sigmar Polke?
I saw some by Richter in Chicago and I can't understand why he has become so well known. I must admit that I have seen only a few of his paintings. I am acquainted with the rest of his work only through re-productions. At the same time, he goes in different directions. I really need to see more of the actual paintings. For example, I know one of his original works in the Museum of Modern Art and it is not good. But since I have no faith in reproductions, I can't say much about Richter. Nevertheless, I'm amazed how much he is talked about. What I've seen is nothing special.

Richter is perhaps so well regarded because his paintings create a sort of alienation effect that many viewers feel is healing, especially in regards to their lifestyles.
Well, alienation can be felt very often, normally outside of art. I believe what you are saying here is, as the Germans say, "Quatsch." [*Quatsch* means "nonsense" in German.—*Trans.*]

Because art and life should be strictly separated in your opinion?
Yes, also for that reason. What does that mean, that art gives one a feeling of alienation? When one feels alienated because of a painting, it simply means that one doesn't like the painting. However, when one is reminded

of a real-life experience of alienation through a painting, that is something else. I don't know what I should say. I can't remember ever having experienced that.

I was thinking more along the lines of contemplating a painting and discovering that one does not understand it.
I didn't have that feeling. I could understand Richter's paintings very well. I don't find his art very difficult.

Does his work seem to you to be shallow?
I didn't think much of the four or five paintings that I saw.

What did you think of the wave of neo-expressionist painting in Germany?
In a certain way, Kiefer belongs to this wave. Otherwise, I haven't seen much. But in the past, there is someone among the Tachists that I remember by the name of Emil Schumacher. I saw some paintings by him over fifteen years ago but have seen nothing since.

Did you notice other German artists during the time when you supported Jackson Pollock and the abstract expressionists?
We did not see much at that time. Therefore I can't answer that.

Hans Hofmann also came from Germany.
But he became an American. Which German artists would you name from the forties and fifties?

I am not sure. Maybe there were not any important artists in Germany at that time. Artistic tradition was completely interrupted by the Nazis.
That's right. Outside of Schumacher, I can only remember Winfred Gaul.

Finally, I have a very unoriginal question. How do you see the future of art? What do you expect in the future?
Here I must return to my general concept of modern art. As I see it, modernism in the fine arts, literature, and music is, among other things, a bulwark against decadence and against the general decline of culture. You mentioned Baudelaire previously. One could also mention Manet and Flaubert. They all clearly recognized the danger of decadence in the middle of the last century. At that time, this danger was taken seriously for the

first time in the West. I am convinced that the avant-garde, whether the individual artist knows it or not, leads a battle against decadence. And this battle continues because the threat of cultural decline has not decreased since the middle of the last century.

With that thought, it is appropriate to end our discussion. Thank you very much for the informative conversation.
If it was informative, I am glad.

(1994)

CLEMENT GREENBERG:

THE LAST INTERVIEW

• •

Saul Ostrow

CLEMENT GREENBERG'S HARD-LINE OBSESSION with the purity of painting inspired ire and debate throughout decades of American art criticism. Inevitably his mandarin stance would reach an impasse. Saul Ostrow conducted this last interview, in which Greenberg settled old scores.

Clement Greenberg, who died on 7 May of this year, was the most influential and contested American art critic of the past fifty years. He held extraordinary sway over generations of art historians and critics. T. J. Clark, Michael Fried, Thomas Hess, Rosalind Krauss, Max Kozloff, Hal Foster, Benjamin Buchloh, Harold Rosenberg, and Robert Goldwater, to name just a few, have grappled with Greenberg's paradoxes: his support of and disillusionment with Marxism, socialism, and Trotskyism, and, starting with his seminal 1939 article "Avant-Garde and Kitsch," his call for a "historically conscious, avant-garde culture" that "specializes in itself"— an avant-garde that rejects, in turn, both capitalist and revolutionary politics. Greenberg's mandarin definitions of artistic "quality" and "purity" were defining traits in his theory of Modernist aesthetics.

Greenberg was an editor of *Partisan Review* from 1940 to 1942, and he wrote on art for the *Nation* from 1942 to 1949. His plain, outspoken style engaged a massive readership, and much of his writing on art first ap-

peared in nonacademic journals. Throughout his career he also wrote on literature and Jewish cultural issues for the *Contemporary Jewish Record* and *Commentary.* Greenberg's judgments were personal, blunt, and self-fulfilling. "I am willing to like anything," he wrote, "provided I enjoy it enough. That is my only criterion, ultimately."

He fiercely championed the artists he liked—most notoriously Jackson Pollock and Barnett Newman, and later color-field painters, particularly Morris Louis, Helen Frankenthaler, and Kenneth Noland—as exemplifying modernist aesthetic ideals. "If I happen to enjoy Pollock more than any other contemporary painter," he said, "it is not because I have an appetite for violent emotion, but because Pollock seems to me to paint better than his contemporaries." He dismissed other artists with equally forceful conviction.

Famously, Greenberg billed Immanuel Kant as the "first real Modernist." From 1959 until his death, Greenberg repeatedly linked Kant's ideals of intuitive experience and purity of form to modernism. Artistic "quality," Greenberg wrote in *Modernist Painting* (1960), could be judged by the degree of "purity" art achieved in its own medium. To him, modernism was the "intensification, almost the exacerbation" of Kant's self-critical method. Greenberg's ideal pursued "the effects exclusive to itself."

During the 1960s, frustrated artists and critics questioned Greenberg's dismissal of minimalist sculpture even as he embraced similar aesthetic expressions within painting. Increasingly, people saw his opinions on purity and quality as a self-referential system that admitted no other viewpoint or change in aesthetic standards. In the art and criticism surrounding conceptual and postmodern aesthetics, he had few supporters; if anything, much postmodern theory grew out of dismantling his arguments.

Greenberg's seeming insularity was magnified by his decision in the mid-1970s to produce a summary of his philosophical views, rather than to explore new theoretical ground. This, and his failure to support any contemporary artists after Jules Olitski, resulted in a silence broken by occasional perfunctory public reassertions of his stated positions. Still, in "Avant-Garde and Kitsch," Greenberg's initial call for "the reduction of experience to expression for the sake of expression, the expression mattering more than what is being expressed" remains a cornerstone in modern art theory.

Saul Ostrow first interviewed Greenberg in 1989 on the fiftieth anniversary of "Avant-Garde and Kitsch." The two met for numerous subsequent

discussions. Here, in his last interview, Greenberg passes judgment on Kant, Pollock, T. S. Eliot, Theodor Adorno, his own father, Édouard Manet, his protégés, and his most virulent critics.

—*World Art*

SAUL OSTROW: *In the fourth volume of your collected works, your essay "How Art Writing Earns a Bad Name" cites Rosenberg's "Action Painting."*
CLEMENT GREENBERG: Well, I thought that term was so misleading.

Because people would misunderstand what Pollock was doing if they understood it in Rosenberg's terms?
I thought that people would take Rosenberg's version as truth. It was wrong. The term "action painting" became popular, it was recognized. It was used more and more and it wasn't any good. It isn't used with the assurance the way it was used fifteen, twenty years ago. It's pretty much settled into "abstract expressionism" and that's not good either.

What did you think was at stake? What did it matter if the new American painting was called "action painting" or, as you proposed, "painterly abstraction"?
Nothing was at stake, except perhaps the truth. Harold was a commentator rather than a critic. In private, he had contended that he didn't like Pollock's paintings and that de Kooning was the real painter, which was the view pretty generally held on Ninth Street at the time. I remember that Barney Newman, about '50, '51, asked me, "You don't really think Jackson can paint?" and he was for Pollock. But for him and others Jackson did something else; it wasn't good painting. And then you could see de Kooning's draftsmanship, that beautiful hand, all that stuff. By the time Bill was discovered, though, he showed that he had lost his stuff by '49, '50. He went over well, though. I thought when I wrote that he had lost it that I was asserting the truth, protecting the truth, reestablishing the truth; I thought that's what I had to do. It was Barney who went on about the fact that how you painted the picture was all that mattered, not that it was there—the "painting" itself wasn't important. That was Barney's pompous bullshit, and this infected Jackson.

So on one ride home, back to East Hampton, he was with Harold [Rosenberg]—this is Jackson's own story; he was sheepish in telling me

this—retelling this stuff that became action painting, saying it didn't matter how good the painting was, what was important was you'd done it, you had done the act of painting. Jackson himself knew it was bullshit, but he was ready to accept any explanation for what they did, because they were hard up for words about their own art.

Do such catchphrases earn art writing a bad name?
In part, and prose like Tom Hess's. I included Tom in that piece—and Herbert Read, who was a dullard. Did I include him in that piece too?

You did, because he takes credit for having been an early champion of abstract expressionism in England. He claimed that the English recognized its importance before the French.
It's not true. No, no, it isn't true. They didn't. What happened was, Pollock had his show in Paris. It created a noise and the British were impressed by that, and said, "Oh, well, the French are taking it seriously, it must be of prominence." This nice British man wrote about it. He wrote about how he knew "the British couldn't paint, but they knew that the Americans could paint still less." He'd come over here and reported that the Americans didn't know that abstract painting was over and went on to say that he found the good art on this side of the Atlantic in Cuba, and maybe French Canada. I think I responded to him in the *Nation*.

He wrote this in the early fifties. What was his name? As I get older I have more trouble with proper names. Well, I scolded him by reminding him that what he was doing was journalism, not criticism. [This is probably a reference to David Sylvester.]

And where do Meyer Schapiro, Alfred Barr, and Tom Hess come in?
Meyer didn't have much to do with it. Look at what he wrote about. He had something of an eye, but he was too much of a genius in his own right. In the end, what did Meyer have to say about contemporary art? Nothing. In the end, Meyer was too much for himself. And Barr wasn't heard from that much. Though he was respected, nobody paid much attention to what he said. They weren't that sold on his view; it's only in retrospect that he plays a role. Alfred had the force of his personality, but he wasn't a genius like Meyer. You could disagree with Barr, but not with Meyer; he would use his intellect against you. It never happened with me, but with other people it did. And then Meyer wowed them in '49 at the

Life Magazine Roundtable. He simply had the researchers rolling in the aisles when he explained how you could think of some of Picasso's distortions as viewing the human body from inside. Meyer found all he needed to do was explain abstract expressionism's distortions. The problem is that they all tried to explain too much. People try to explain too much.

And Hess's existentialism?
Phew! How did that fit in? Existentialism. Existentialism came from Paris after the war and sounded jazzy. At the time, they would co-opt anything.

The first time I interviewed you [in 1989], I asked if "Avant-Garde and Kitsch" was written with a sense of urgency, and you said, "There was no urgency." Did you feel all through the thirties, forties, and fifties that you were writing in a void?
That's my failing, and I've been criticized at times for it, but that's the way it felt. Everything developed autonomously. We didn't think anybody was reading us. Our notion of avant-garde was that of the old-time, modernist enterprise, where you were nowhere, but kept the flame lit, or whatever. This was the tradition. It was so you went on record, and as an art critic you hoped to get someone to agree with you somewhat, or look at what you'd done, to see what you thought was important. I remember that at some point after the war, at *Partisan Review*, we discovered the *Times* would print you, that they wanted our views and so forth, and colleges would ask you to come and talk. That was new, new, new. It was a new age, a new era.

A theme that runs through your writings is the effect of the cultural ambitions of the "middlebrow," its lowering of standards, et cetera.
Mm-hm. Yeah, I didn't go into that. It wasn't clear enough in my head in 1939 and that's what was wrong with "Avant-Garde and Kitsch." I made kitsch the enemy when the enemy was really the middlebrow, not kitsch. Appealing to them was not the greatest sin an artist could commit, but it was the real threat; the real threat to high culture was middlebrow taste. My view of kitsch was somewhat crude, and in actuality I didn't develop it much. I started with a new model afterward.

But in the late sixties, early seventies, the middlebrow comes back in pieces, like in "On Decadence," where you begin to make explicit your views of his-

tory, culture, tradition, and taste. Why didn't you include these late pieces and the seminars in the "Collected Works"?
Because they did come too late. The "Collected Works" end with 1969, and so anything after that wasn't included.

But it's really pretty much in the late sixties that you begin to explain yourself and defend the idea of quality. The issue of quality really comes very late in your writing.
It came late for polemical reasons. People were saying quality didn't matter, they had stopped paying attention to it. In the *Times,* recently, somebody wrote that quality was an old, outmoded notion.

It was Michael Brenson [then art critic for the New York Times]. He was against a fixed definition of quality. He thought we should start talking about it again, only this time in multicultural terms. In that piece, though, he does imply that you had given quality a bad name because you were unwilling to define it and yet held to it as a rigidly fixed criterion.
Maybe I did, but I challenge anybody to define it. I couldn't define quality; it was something you just see, experience.

But you write about nonart having achieved the look of art—the blank piece of paper, the chair, the door. It's at this point that you're willing to state that the blank canvas is already a painting, but the question is, is it a successful one?
I didn't say they had achieved it. They had assimilated the status of art. You can experience anything aesthetically, so you can't stop to define art aesthetically.

It's at this point, though, that the argument of quality comes in, as being that which is unquantifiable.
Well, of course it is. Back in the eighteenth century, before Kant, they knew it was unquantifiable. It's defined by tradition.

This point brings you very close to Adorno's stance. There are a number of parallels between the two of you in terms of the role of the avant-garde in maintaining tradition, et cetera.
I had high regard for him. We saw eye to eye on a lot. He was working for the American Jewish Committee, and I was at *Commentary*—they shared the same floors and the same causes at the time. I'd seen him around, and

we would talk around there. He was a nice man, too, not arrogant at all. I got his book. I read half of it, but Adorno has a running commentary going rather than a point-by-point statement of position. In principle he's good, though he had nothing to do with visual art, really.

How to put it—he also had a dislike for jargon.
I took that for granted. You weren't at the Thread Waxing Space with [the critic] Bob Morgan [12 November 1993, New York City]. I like Bob, but he fell into jargon—"dialectics" and all that. He shouldn't have.

He's an old friend. We've been arguing with each other for years. He tends to use those terms as a shorthand.
Shorthand is supposed to be legible.

That aside, before you met Adorno, were his writings known to you? Did you know about the exchange between Ernst Bloch, Georg Lukács, Walter Benjamin, and Adorno in the thirties?
I'm not sure of what you're talking about. I might have gotten wisps of that from *Das Wort*. It was a German émigré magazine that was sent to me. There was nothing in particular, but the flavor of some of the writing there had a lot to do with my "Avant-Garde and Kitsch." This was in, oh, '57, '56, maybe, Adorno, though, I read once he was over here. He was published in German, and then afterward in English. I was familiar with Adorno before I went to Germany sometime after the war, in the fifties.

T. S. Eliot was very important to you and left a great impression on you. That carries through the whole body of your writing.
Yeah. Now I read Eliot and I can't stand him, as good as he is. I can't stand his tone. It's this kind of manner that is above everything—not aristocratic, but above everything, unfortunately. I mean it's his tone. The flavor of Eliot stinks. There's a sniffing in "Notes to a Definition of Culture." There's a sniffing out, not even an indirectness.

He's too much of an aesthete? Is it that it lacks conviction?
No, no. I'm an aesthete too and Eliot's got his convictions. I'll read you a paragraph from it ["Notes to a Definition of Culture"], you'll hear it.

Were Trotsky's articles on art discussed much?
No. I didn't agree with him. The Trotskyists of course agreed with them,

so there wasn't anything to discuss. I had great admiration for Trotsky and I still do, though it's qualified as I get older. The same with Eliot.

Another question in terms of influence. Did Dwight Macdonald, the editor of "Partisan Review," have any influence on you?
Dwight Macdonald—he was *one* of the editors, not *the* editor.

Did he have an influence on you?
No. How could there be?

By conversation, your politics. I read in Serge Guilbaut's book, "How New York Stole the Idea of Modern Art," that the two of you were holdouts in terms of supporting the United Front against fascism and the U.S. entrance into the war.
That was back then and I was being stupid and a purist. It was my brother—Sol—he's dead. He had me cowed. I was cowable in those days; I always felt guilty about that. I read Sartre later, with his Stalinism, and I knew just how he felt. He was guilty. Somehow he was in the wrong. Somehow he had reasoned that the Stalinists were showing him the true path. I felt that way in the thirties.

So where does the Kant come in? Did it have to do with your disillusionment with the Left?
No, nothing like that. The Left had nothing to do with what I wrote about art. Kant, that was my own; I came to it in the middle of the war—'42. I felt my experience confirmed Kant.

Your insistence on the autonomy of art, the autonomy of the avant-garde, was formulated early on. "Avant-Garde and Kitsch" is 1939. Wasn't your emphasis on its autonomy a political stance? A form of resistance to bourgeois cultural dominance?
Oh, no. No, that's shit. The avant-garde and so forth is unpolitical for the most part. It's not a resistance to politics or anything else, no. It was, let's say, a dissent from the bourgeois order. When I was a senior in college, there was an avant-garde; they were the chosen few, a minority, and of course they were against bourgeois forms—and it was the correct thing to be. The truth in it is that modernism and the avant-garde were traditionally a form of dissent. That's the way it looks to me.

I guess when one begins to put the parts together, culture's autonomy is not just from capital.
It's from the order; you know that. It's from the way of the world, and God, I hated the way of the world. It was my father's world. . . . Business, his order, and what I had to do in order to fit in.

So you're talking about your own autonomy?
Yes, yeah, though I didn't want to dignify it as my autonomy. In my last year at college it was taken for granted that you separated yourself, your inclinations, your tastes. The best stuff separated itself; that's the way it had been since the 1840s or '50s, and you could tell the difference.

I remember you talking about hating Tin Pan Alley.
I didn't say I hated Tin Pan Alley. No, I liked the music. I know that I put that crudely in "Avant-Garde and Kitsch." I know I used it as a negative example.

I remember you saying that what you hated the most about such things was the repetition.
I guess I did say that. So I hate Muzak.

Is it the same with painting? Did you hate the repetition?
I didn't look at painting back then that seriously anyway.

How was it that you came to art? I mean, your background was literature. You were writing on Eliot and Brecht.
That's true, too. I had lost touch with art—not that I was ever that much in touch with it before—and then, after the army, that was '42, knowing Lee Krasner, I got acquainted with what was going on on Eighth Street, and it seemed to me that here I was more at home than with literature. I felt comfortable. It seemed more vital, more sympathetic to me than literature, with its damned poets like Delmore Schwartz—personally I'm not against him—I felt at home when it came to painting, the way I've never felt when I've tried to write verse.

You have a certain skepticism about interpretation.
Right. When Susan Sontag wrote a piece called "Against Interpretation," I said to myself, finally Susan's on the right beam. I'm not against inter-

pretation but I've found that, for me, value judgments were the exciting thing: that was the crucial thing.

That actually led to the misunderstanding that you believed art should have no meaning outside of its quality?
I never fooled around with meaning.

You once made the argument that anything could be said and appear to make sense. [laughing] It's a funny idea, that a critic would be skeptical about language.
Yeah, I did say that. Robert Goldwater wrote that what was so good about Franz Kline was that he had "an entirely unsentimental 'grace under pressure.'" He was quoting Aaron White ["Complaints of an Art Critic," *Artforum*, October, 1967]. I said, you could say that in front of anybody's work, that doesn't help a lot. If you try to talk about it, you just end up repeating clichés. All that has to do with characterization rather than interpretation. It explains nothing. Words do that, good or bad. That's the question. Yes, there's good and bad art: that's the most pertinent thing.

What you've left unsaid has led people to either make suppositions about what you have said, or assertions about what you should have said. I thought maybe you might say something about meaning at this point. I mean, you give art a social value implicitly but never explicitly.
Yeah. Last is least but last . . . there's a British economist who said people, especially academics, when they read "is," they say "should." They replace it with "should." Well, the artist is charged with making good art. That's it. If it's socially aware, all right, but art solves nothing. Literary meaning seldom decides the qualitative differences between one work and another, so art's a satisfaction; it's something you tend to derive satisfaction from.

But you're not popularly thought of as a sensualist.
It doesn't necessarily make me a sensualist. An aesthete? Yes. Sensualist is the wrong word. Well, you've got to be sloppy to bring this up—music, verse, painting, are sensuous things. You've got to bring in the concrete, and I find it tough to do that. But I was listening to Pavarotti singing from [Central] Park the other night. That's a sensuous pleasure. Aesthetic pleasure transcends sensuousness. It's a state of pleasure that is more abstract, though abstract is a misleading word.

Michael Fried tries to build part of his argument against theatricality on just such a distinction. For him, theatricality forces self-consciousness onto the viewer.

He's picked up on something that's beneath him. He goes on about the importance of whether the subject is facing you, or whether the subject is absorbed in some activity. I don't think he sees that well anymore. God knows, Pavarotti's theatrical in the best way, without being too show-offy, but an Italian tenor is supposed to be theatrical. And there's Pavarotti doing it without any effort, no effort at all. That's what is of importance.

In terms of the sensuous and the pleasurable, you seem to take pleasure in the intellectual and optical?

They meld. If I could separate them, I would be a greater philosopher of aesthetics than there ever was. It's about distinguishing experiences. Aesthetic experience is intuitive; we've never gotten inside intuition. I can't.

You've written consistently of a materialist history of painting that goes toward flatness, yet in "Modernist Painting," you imply that intuition is essential to art—but you've never really written explicitly about the role of the intuitive. Is it because, like quality, the intuitive can't be talked about?

Why did I have to talk about it? Why did I have to? Aesthetic experience is intuitive. There's nothing new there, and you can always get behind the reasoned decisions of most artists and say it had to be intuitive in the end. I took intuition for granted. You can't do anything about intuition. Who was it—oh, someone said, I forget, that Immanuel Kant went into intuition. I said, like shit he did, he took it for granted, that's all. He didn't get inside it, nobody has yet. Intuition as a word doesn't seem to do enough, as a term, as a concept. But there it is, we're stuck with it. I'm stuck with it.

Is part of your dislike of monochrome and minimal art because they attempted to be systemic? To do away with the intuitive?

Who said that I dislike monochrome? Why should I dislike monochrome? I could never have said that. I couldn't have said that. I may have said that in a particular case, but not as a general case. Generalizations like that are impermissible.

Do you like anybody's monochromes?
Let's say Sam Francis. There's too much to choose from. Again, you couldn't say that about me.

I think it was in relation to Stella. You said monochrome was too easy a solution.
I never said that about Stella. It's because Stella's color is so awful that he should have stayed with monochrome. He was better off. What I said is: they're just not good enough.

To go back to "Modernist Painting," in terms of my reading of it, you assert that the job of the artist is to recognize the medium's limitations and paint despite them.
I didn't proscribe or command—but if you want to make a painting, yes.

So after abstract expressionism, with the advent of post-painterly abstraction, intuition, like spontaneity and aesthetic experience, was considered arbitrary, not specific enough. There was a serious attempt to systematize production, de-emphasize the subjective, and articulate the objective, and it's work that you didn't necessarily love. The real question is about your rejection of the work of the minimalists.
It's because their work was banal, uninspired. I think the minimalists just wanted to be far-out. The first pieces of the minimalists were influenced by Newman. They thought, "That's the answer, we'll do something like Barney does. He did it in painting, we'll do it in sculpture." They recognized that the development of modernist art, since Manet, went to the edge, and it seemed to them this was being far-out. For them, Barney Newman was far-out. That's taking a model, as it were. They got nothing in the end from being systematic. Systematized is when you start to go around the color wheels. You don't have much success when you go around the wheel.

Artists often do give themselves a rule—we give ourselves a rule without being aware of it consciously. For example, after the thirteenth century, you couldn't paint flat the way the Italian preprimitives did, pre-Giotto. You could no longer do that and reach the highest, you had to go with Giotto. Not that they did so well with Giotto; it took them awhile. So the strongest art became the most illusionist—pictorial art and sculpture too. And that lasted and held true until the middle of the nineteenth

century. Then modernism gave itself a rule: we can't go into the illusion of the third dimension with that freedom we used to. That rule became more and more binding. It's what Picasso and Braque wrestled with.

Let me put it this way: as you know, given time, there usually is a direction in which the best art goes—not all the best art, necessarily, but most of it. It works out that way.

In one of your seventies essays you write about how art's history is created by trial and error, that it's not the straight line you just described, that it's got all these zigs and zags.
I have a tendency to say that it is a straight line.

Well, you draw a straight line through what you consider the high points, yet the line doesn't pass through dada, futurism, constructivism, and surrealism.
Yeah, that's the way it works out. It's a matter of record, not of principle. There's nothing wrong with those things by definition, but the practitioners aren't good enough. You can't say something is wrong, by definition, or less. They're not the high points. It's a matter of record, not of principle.

Let me try this out: the big difference between you and, let's say, Rosalind Krauss and her followers is that they are more interested in the idea of art than the experience of it.
Yeah, yeah, but they don't matter. In the long run, in a showdown, they don't matter.

Clem, was the group consisting of Michael Fried, Ken Moffett, Rosalind Krauss, you, and others ever formally composed? Did you get together and discuss issues among yourselves? Or was it just everyone for themselves? I mean, you were recognized as a circle supporting similar artists.
Yes, we were a circle, but it wasn't formal. We didn't sit down and decide to agree to support someone. Being programmatic was unthinkable.

So it was a group of people with kindred concerns?
And not all that much communication.

The reason I ask is because in "Artforum," when Krauss denounces formalism as being the product of a small-group mentality in which everything looks fine

as long as you're talking with like-minded people, she made it sound as if you were all part of an organized group.
And she's breaking with us. I remember that. There was no group, there was just me. That's all there was—me. But you know Rosalind's a fraud. She was very facile, she writes well, but she's a fraud. People who were friendlier with her than me would say she was always asking what's the latest thing, the latest squeak?

One of the ironies is that she criticized you at the time, and then again recently, for being authoritarian and for having built a coterie, and yet she has done just that herself. She has built a circle around herself.
Oh, really? She has a coterie? I don't follow that.

Maybe we should end on this question: given your own position, can you imagine a moment of qualitative change, where one tradition comes to an end and a new tradition emerges?
I can conceive of it. Whether I can imagine it, I don't know. I can conceive of it, yes. You don't prescribe art, though you have to be ready for someone who comes along who's good, and I have to accept that. That's the categorical imperative.

In which case, why didn't you recognize it when you had won, that what you had supported had actually effected a qualitative change in the nature of art, rather than just quantitative change? Why didn't you recognize that the situation had changed, conditions had changed?
I had won? Well, *had* I won? David Smith, Pollock, and so forth, they were in a tradition. They had developed it, they hadn't changed it. They extended it. Say, Giotto is a turning point in art—he didn't change it. Well, he changed it, but he didn't wrench it. The intention of art, the best art, changes—that's part of the livingness of art, but it doesn't transform, it doesn't transform.

So, rather than transformation or anything like that, it's regenerative?
Whatever. You choose the word.

(1994)

• •

NOTES ON PREVIOUS PUBLICATIONS

• •

"Counter-Avant-Garde" was originally published in *Art International* 15 (May 1971): 16–19. This essay is a revised and much expanded version of an Adolph Ullman Lecture given at Brandeis University in Waltham, Massachusetts, on 13 May 1970.

"Looking for the Avant-Garde" was originally published in *Arts* 52, no. 3 (November 1977): 86–87. This essay is a much revised version of a talk given at the Grand Palais in Paris on 15 February 1977 under the auspices of the Association pour le soutien et la diffusion de l'art.

"Modern and Postmodern" was originally published in *Arts* 54, no. 6 (February 1980): 64–66. This essay was first presented as the fourth Sir William Dobell Memorial Lecture in Sydney, Australia, on 31 October 1979.

"Beginnings of Modernism" was originally published in *Arts* 57, no. 8 (April 1983): 77–79. This essay is the revised and expanded version of a talk given on 3 April 1983 at the Claremont Colleges Comparative Literature Conference on Modernism in Claremont, California.

"Necessity of 'Formalism'" was originally published in *New Literary History* 3, no. 1 (fall 1971): 171–75. It has also been published in R. Kostelanetz (ed.), *Esthetics Contemporary* (Buffalo, N.Y.: Prometheus Books, 1989), 191–94.

"Can Taste Be Objective?" (Seminar 3) was originally published in *Art News* 72 (November 1972): 22–23. It was also published in Clement Greenberg, *Homemade Esthetics* (London: Oxford University Press, 1999), 23–30.

"Abstract, Representational, and So Forth" was originally published in *Arts* 48, no. 7 (April 1974): 50–51. An earlier version appeared in *Art Digest* (November 1954) with the title "Abstract and Representational" and was based on a lecture delivered the same year at the Ryerson School of Art, Yale University. The essay was then revised and expanded for publication in *Art and Culture;* it later appeared in Herschel B. Chipp (ed.), *Theories of Modern Art: A Source Book by Artists and Critics* (Berkeley: University of California Press, 1968), then was published in its revised form in *Arts.*

"Detached Observations" was originally published in *Arts* 51, no. 4 (December 1976): 86–89.

"Seminar 6" was originally published in *Arts* 50, no. 10 (June 1976): 90–93. It was also included with the title "Convention and Innovation" in Clement Greenberg, *Homemade Esthetics* (London: Oxford University Press, 1999), 47–58.

"States of Criticism" was originally published in *Partisan Review* 48, no. 1 (1981): 36–50.

"Intermedia" was originally published in *Arts* 56, no. 2 (October 1981): 92–93.

"To Cope with Decadence" was originally published in *Arts* 56, no. 6 (February 1982): 120–21.

"Old India: Her Monuments" was originally published in *Art International* 16 (November 1972): 19–22.

"Influences of Matisse" was originally published in *Art International* 17 (November 1973): 28–31. It was also included in the exhibition catalogue *Henri Matisse,* published by Acquavella Galleries for the benefit of the Lenox Hill Hospital, New York (New York: Acquavella Galleries, 1973).

"Four Scottish Painters" was originally published in *Art Monthly* (London) 13 (December 1977): 12–14.

"Picasso" was originally published as "Picasso: A Symposium," in *Art in America* 68 (December 1980): 9–10.

"Clyfford Still" was originally published in *Arts* 55, no. 2 (October 1980): 114–17.

"The Golden Floating World of Sotatsu" was originally published in *Vanity Fair* (September 1982): 80–85.

"Glass as High Art" was originally published in *Glass Art Society Journal* (1984–85): 15.

"Art and Culture" was originally published in *Partisan Review* (1984), in commemoration of the fiftieth anniversary of this publication.

"Drawing" was originally published in *Syracuse Scholar* (fall 1985).

"Response to 'New York in the Eighties'" was originally published in *New Criterion* 4 (summer 1986): 18.

James Faure Walker's interview "Clement Greenberg" was originally published in *Artscribe* 10 (1978).

Trish Evans and Charles Harrison's interview "A Conversation with Clement Greenberg in Three Parts" was originally published in *Art Monthly* (London) in 1984.

Robert Kehlmann, "An Interview with Clement Greenberg," was originally published in *Glass Art Society Journal* (1984–85): 29–34.

Karlheinz Lüdeking's interview with Clement Greenberg was originally published in German as "Clement Greenberg: Modernismus oder Barbarei," *Kunstforum* (Berlin) (1994): 230–35.

Saul Ostrow, "Clement Greenberg: The Last Interview," was originally published in *World Art* (November 1994): 24–32.

CLEMENT GREENBERG (1909–1994) was one of America's most important art critics. His book *Art and Culture,* published in 1961, established him not only as a major intellectual but also as a controversial figure in American art. His formalist aesthetics began to wane by 1970, but he has remained the single most powerful voice in defining modernist art in the second half of the twentieth century.

ROBERT C. MORGAN has written and published more than a thousand articles and reviews in a vast range of international magazines and professional journals. He is the author of books and catalogues on numerous contemporary artists, as well as *Art into Ideas: Essays on Conceptual Art, Between Modernism and Conceptual Art,* and *The End of the Art World.* He lives and works in New York, where he is adjunct professor at the Pratt Institute.